THE NUDE FIGURE
A Visual Reference for the Artist

THE NUDE FIGURE
A Visual Reference for the Artist

MARK EDWARD SMITH

Watson-Guptill Publications/New York

Senior Editor: Candace Raney
Project Editor: Alisa Palazzo
Designer: Nancy Johnson/Thumb Print

Copyright © 1998 Mark E. Smith

First published in 1998 in New York by Watson-Guptill Publications, a division of BPI
Communications, Inc., 1515 Broadway, New York, N.Y. 10036

Library of Congress Cataloging-in-Publication Data
Smith, Mark (Mark E.)
 The nude figure : a visual reference for the artist / Mark Edward Smith.
 p. cm.
 ISBN 0-8230-3232-9 (paper)
 1. Nude in art. 2. Anatomy, Artistic. I. Title.
 N7572.S65 1998
 704.9'421—dc21 98-3379
 CIP

Printed in the United States of America

First printing, 1998

1 2 3 4 5 6 7 8 / 05 04 03 02 01 00 99 98

For all artists everywhere

CONTENTS

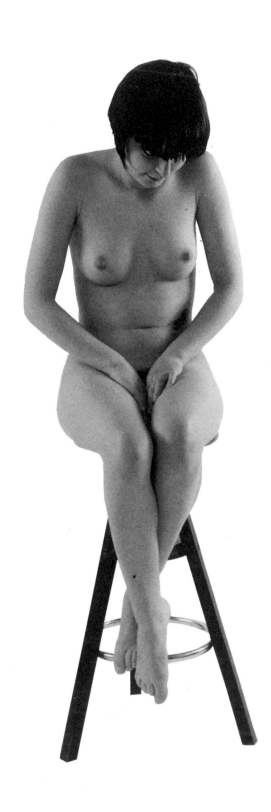

INTRODUCTION

My first book on the figure, *The Figure in Motion* (Watson-Guptill, 1986), captured movement of the human body, especially in poses that would be impossible for a model to hold. In this book, I have tried to show the human form from various points of view, both static and dynamic.

Each section covers a basic type of pose—either standing, seated, kneeling, reclining, crouching, in motion, or unusual—from various angles and under different lighting and background conditions. For example, the figures on black backgrounds produce quite a different feeling than those on white or light backgrounds, and this affects the viewer's perception of the form. In addition, many poses were inspired by the works of great painters and sculptors, including Andrea Mantegna (1431–1506), Francisco Goya (1746–1828), and Antonio Canova (1757–1822) among others.

The final selection of photographs was culled from more than ten thousand images. While choosing which pictures to include I tried to keep in mind that this book is oriented toward artists and to not let my personal aesthetic preferences interfere with anatomic visibility and clarity, which are both of great importance to artists working with the human figure. To that end, I also chose to photograph in black-and-white because this film gives better definition to the pure form and creates less distraction than do color images and films. Note that there are no close-up details of sections of the body but only photographs of the entire figure, in order to better evidence the relationship between the various elements of the body.

While this book doesn't replace the benefits and value of working from a live model and does not record every position into which the body can move, it serves as an excellent on-hand guide and as a source for ideas. It can provide suggestions about possible poses and can be used as a reference when a live model is not available. Above all it strives to reveal the beauty and wonder of the human figure. I hope these images will be of use to you in your art.

STANDING
POSES

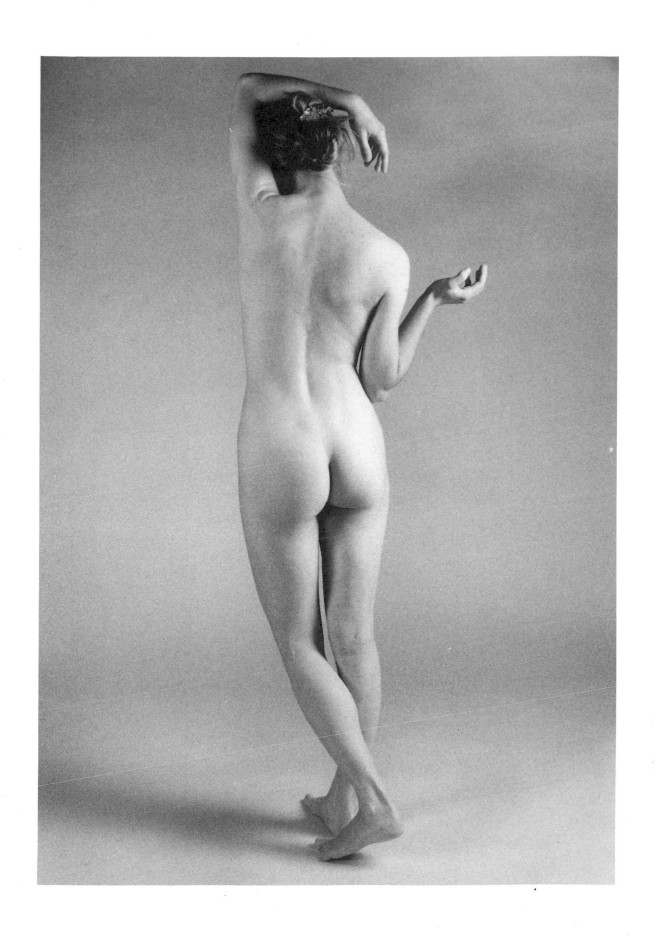

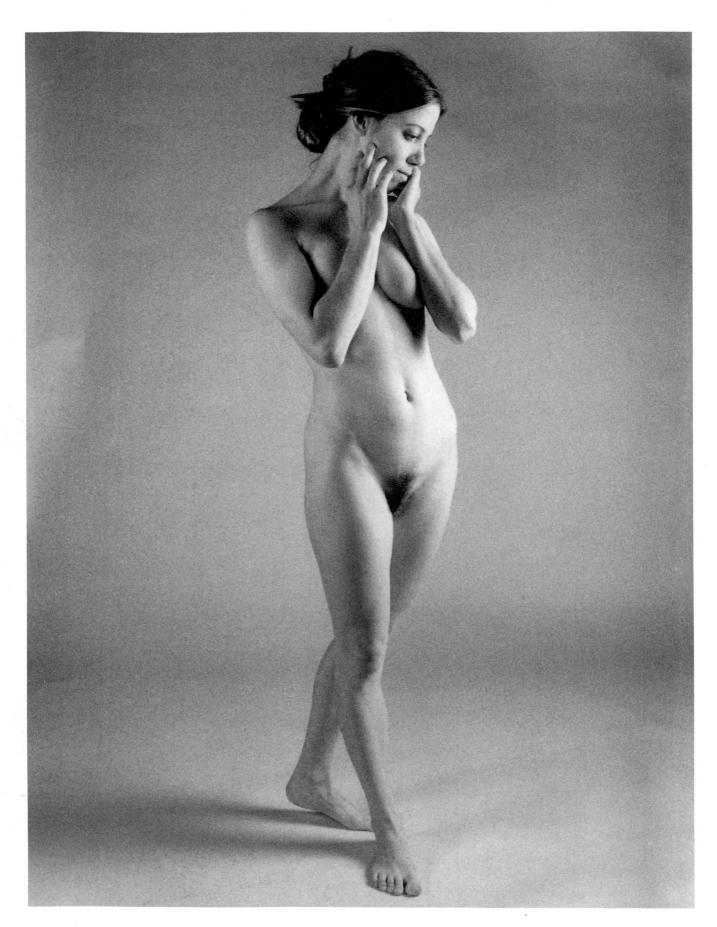

STANDING POSES

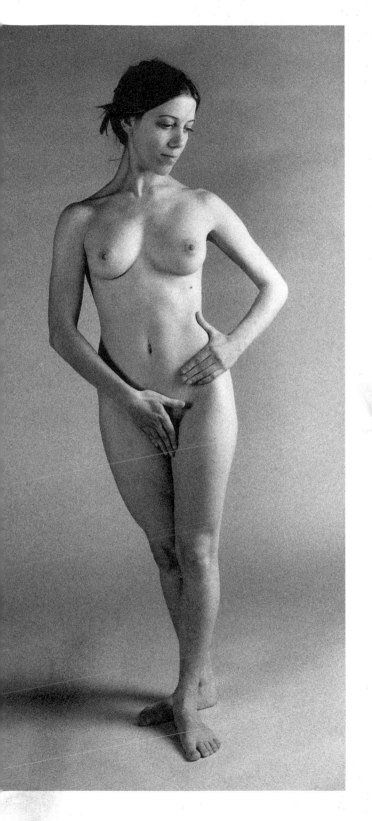
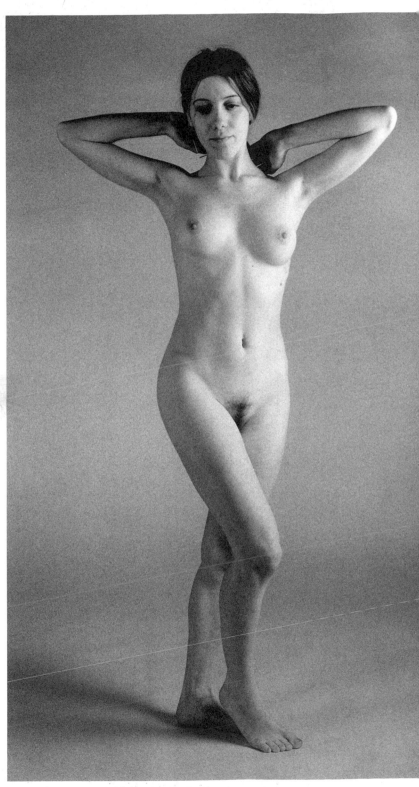

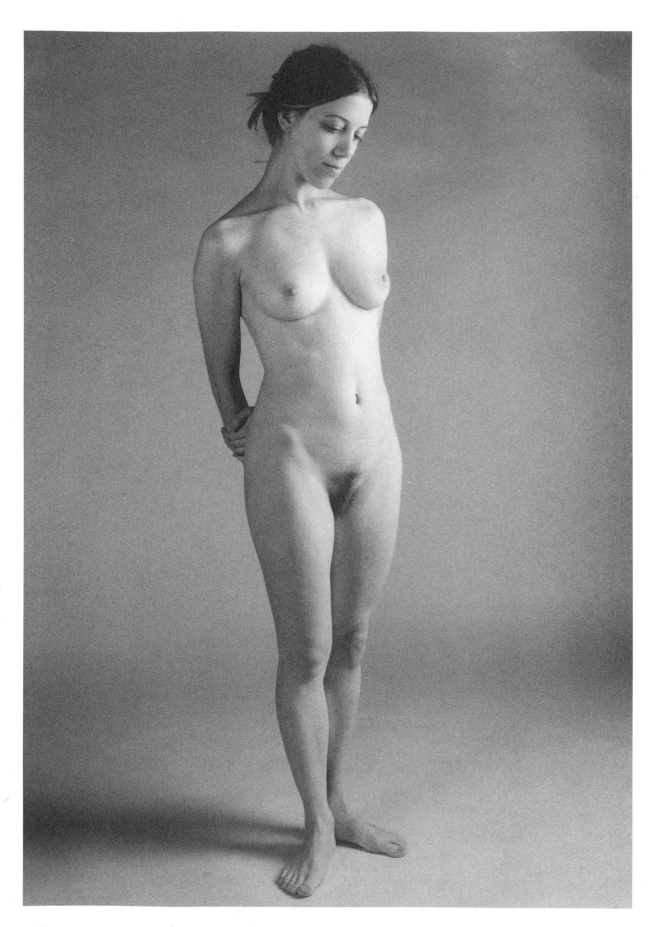

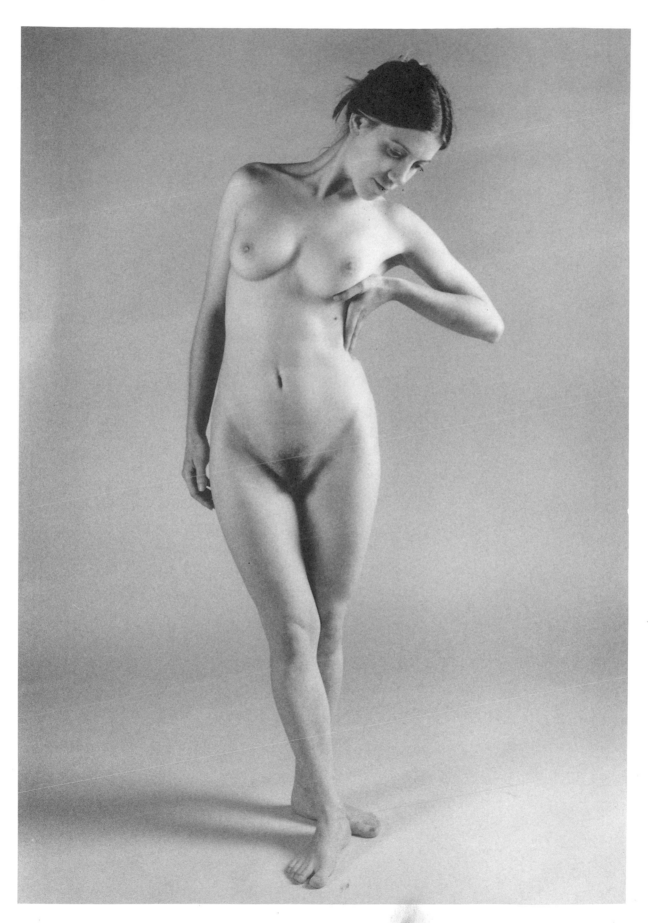

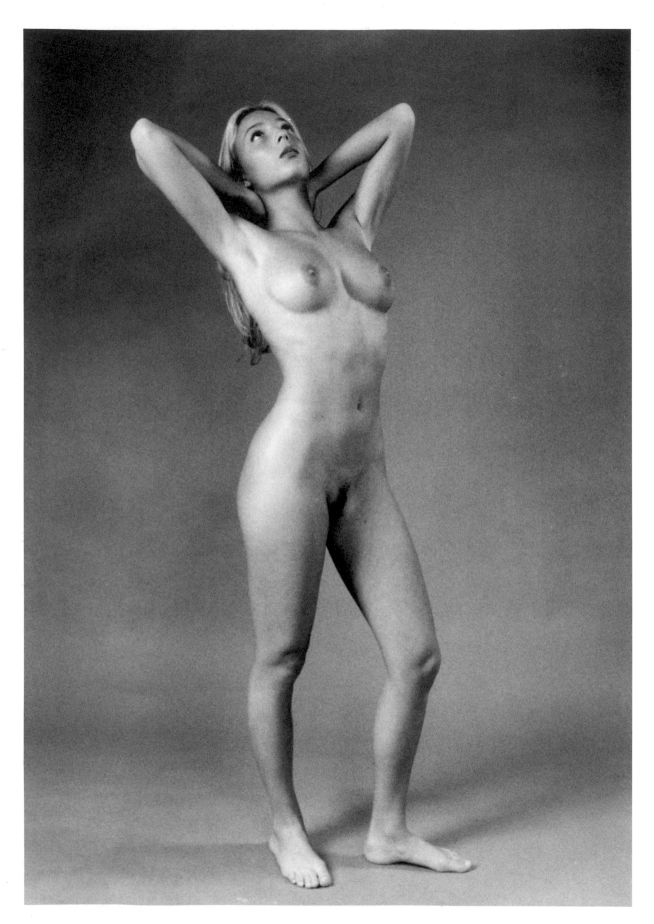

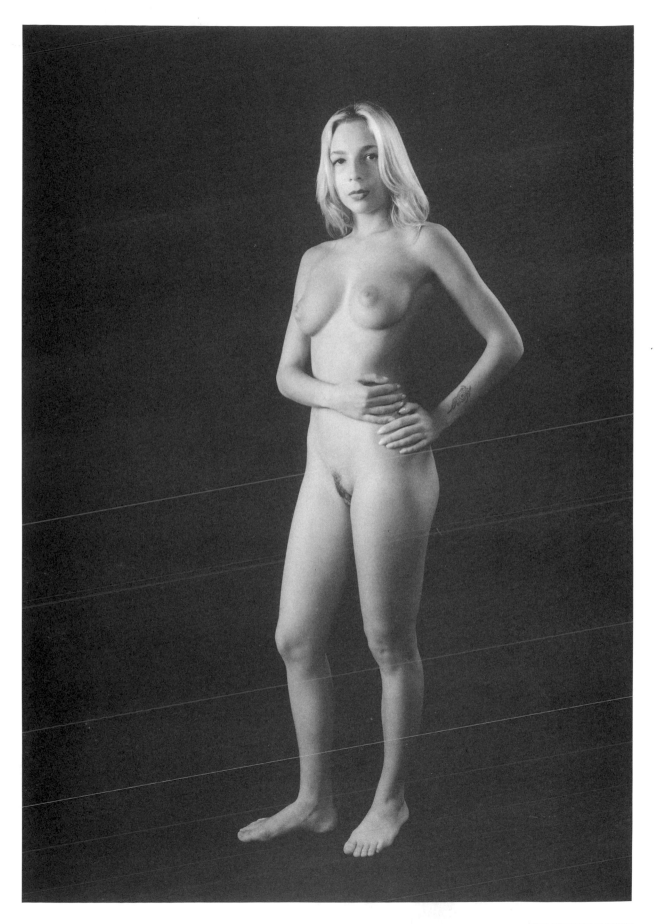

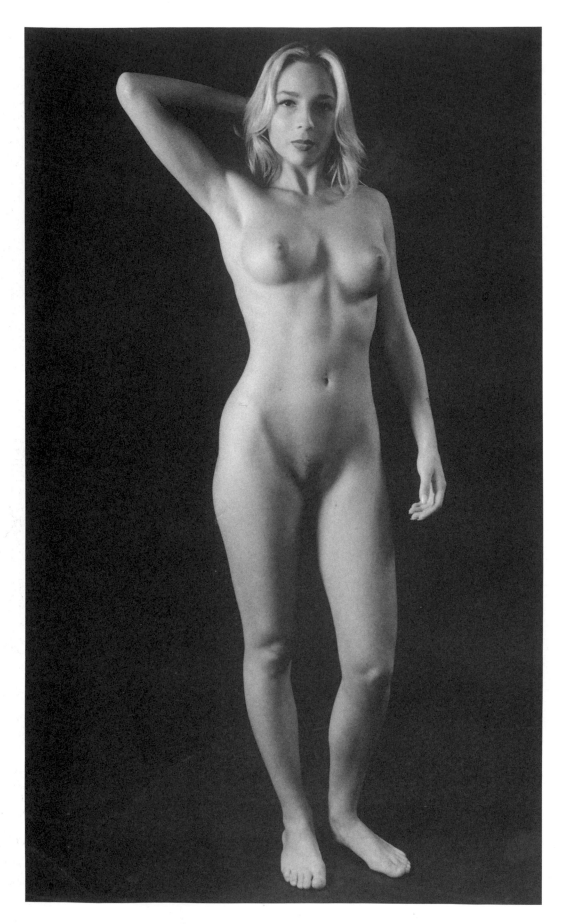

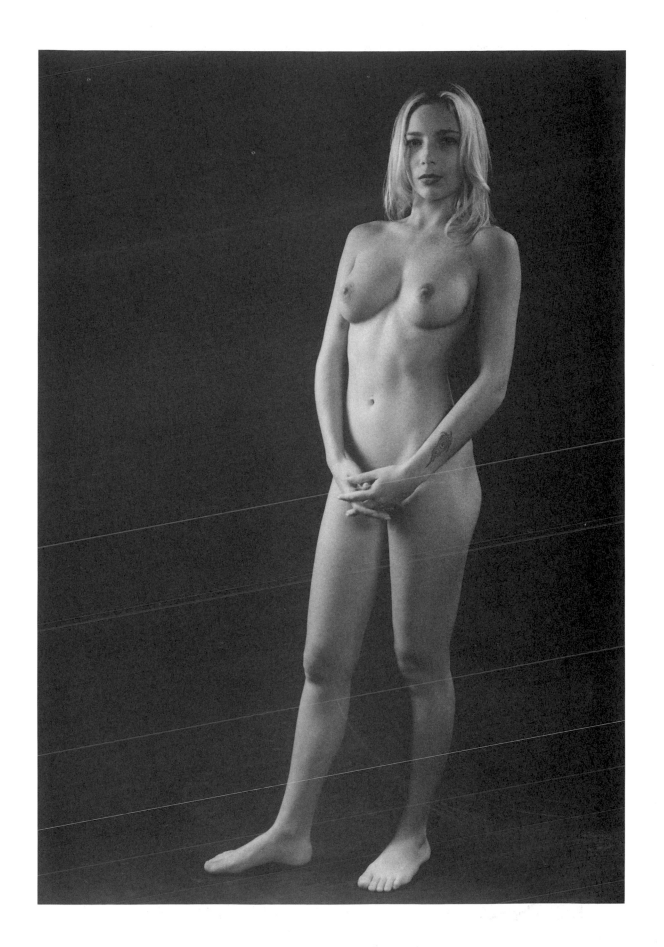

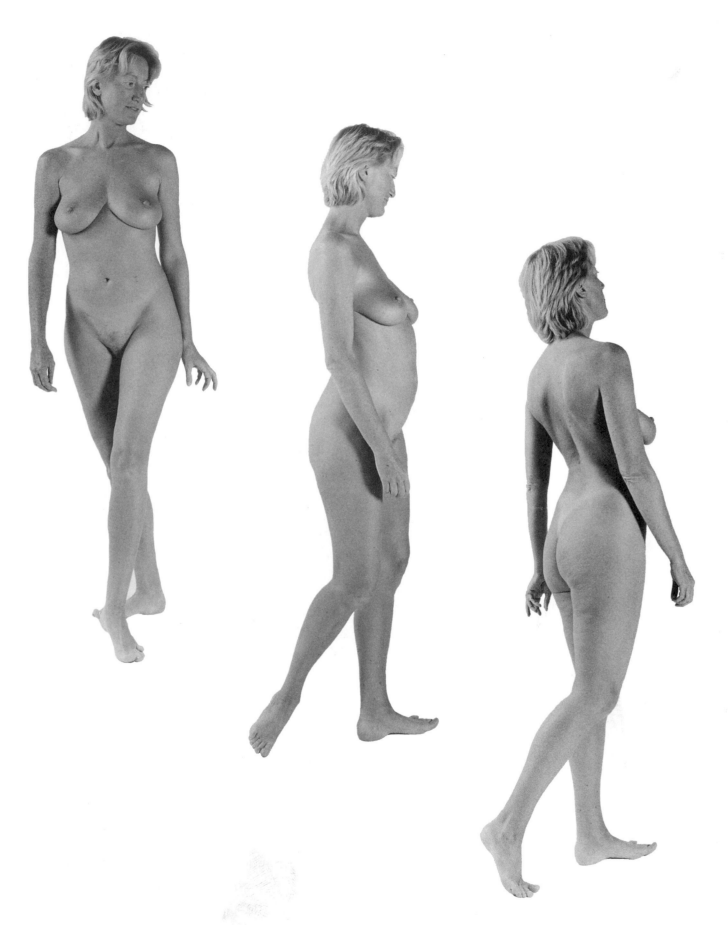

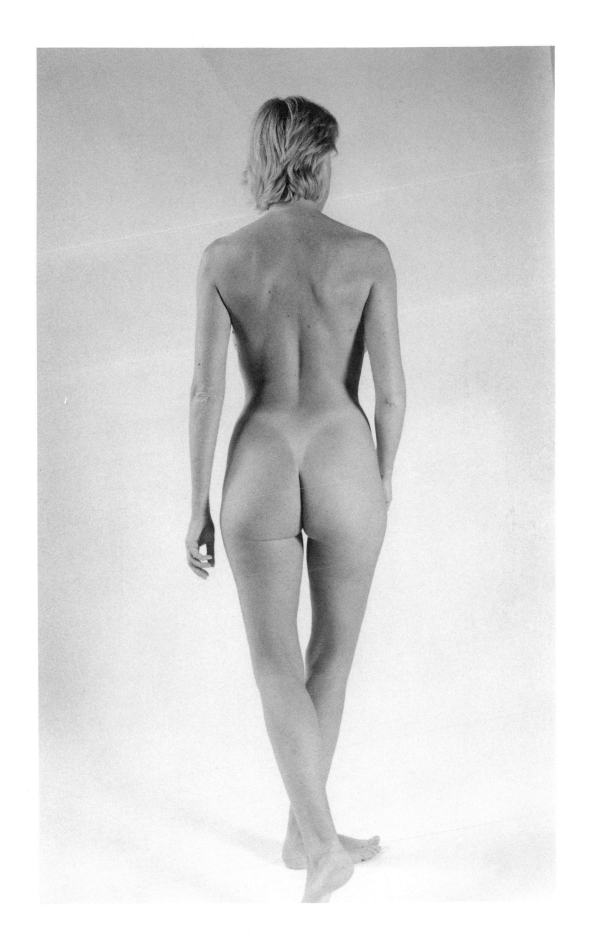

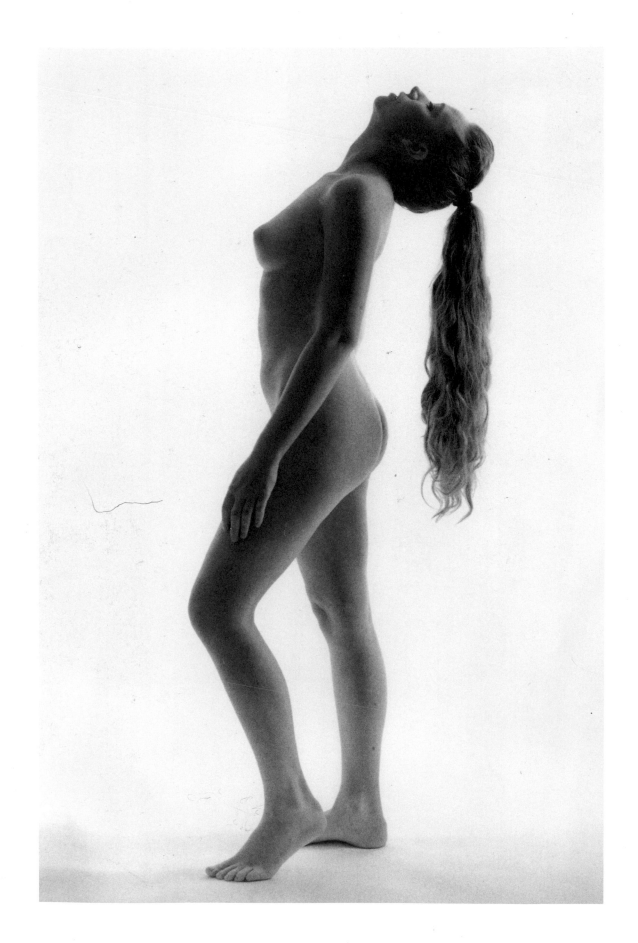

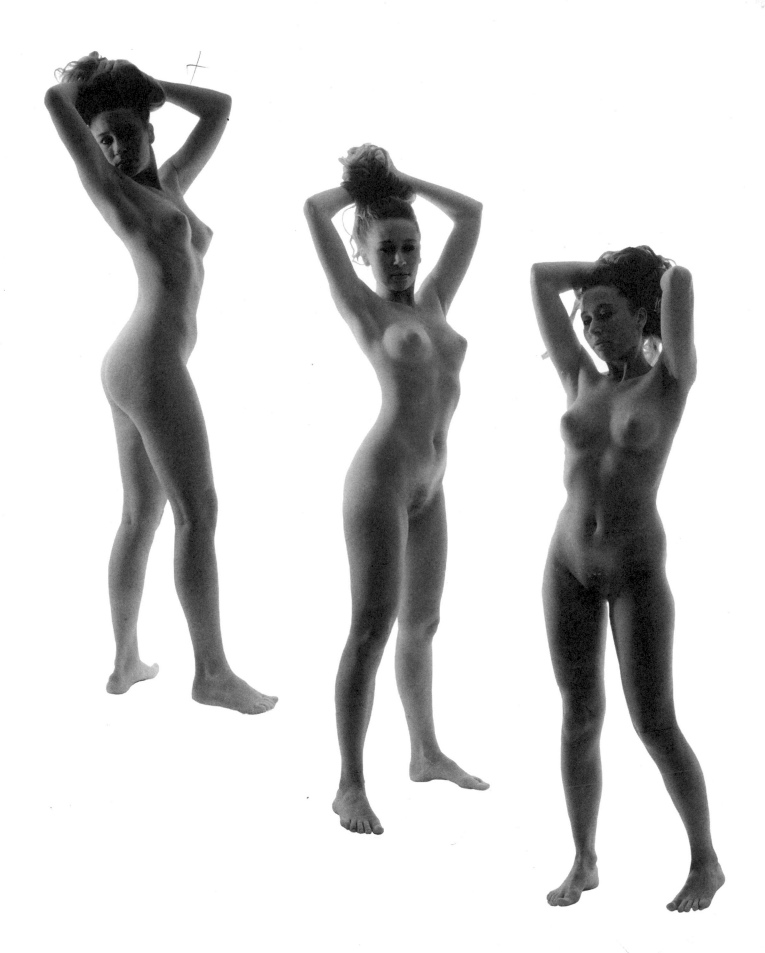

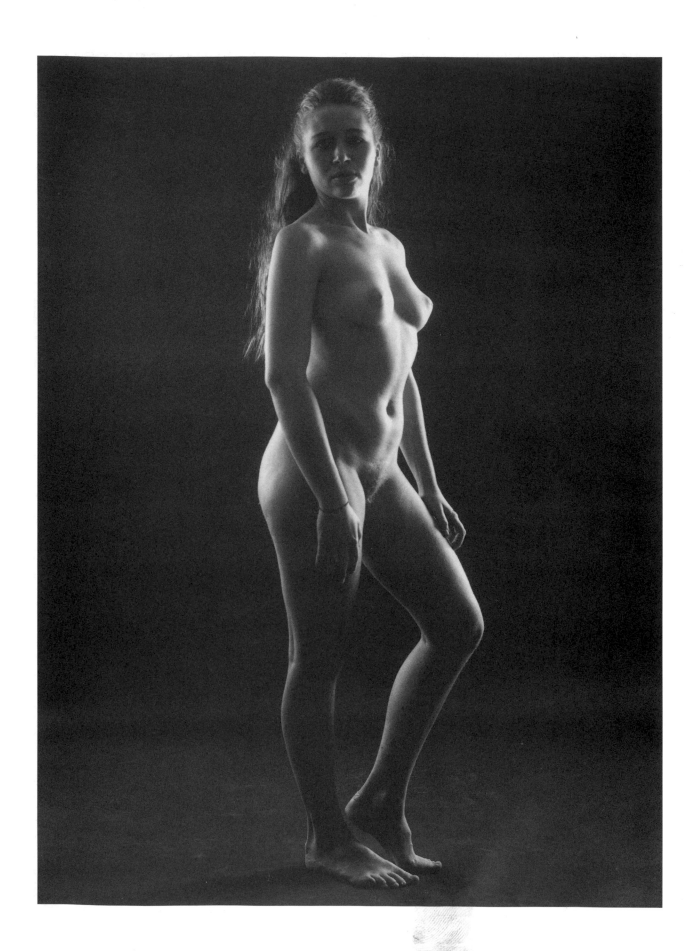

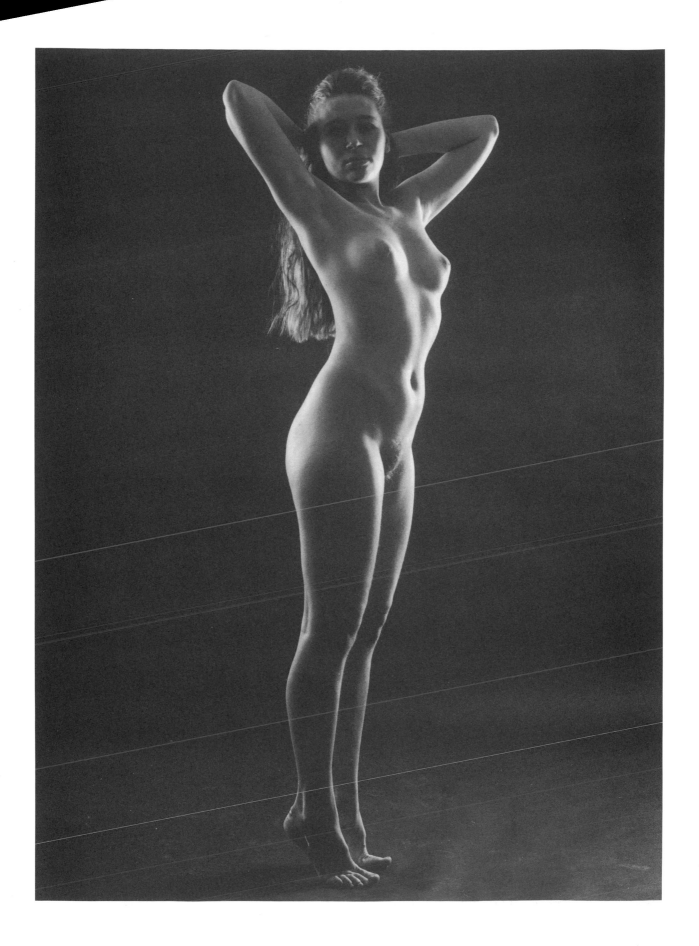

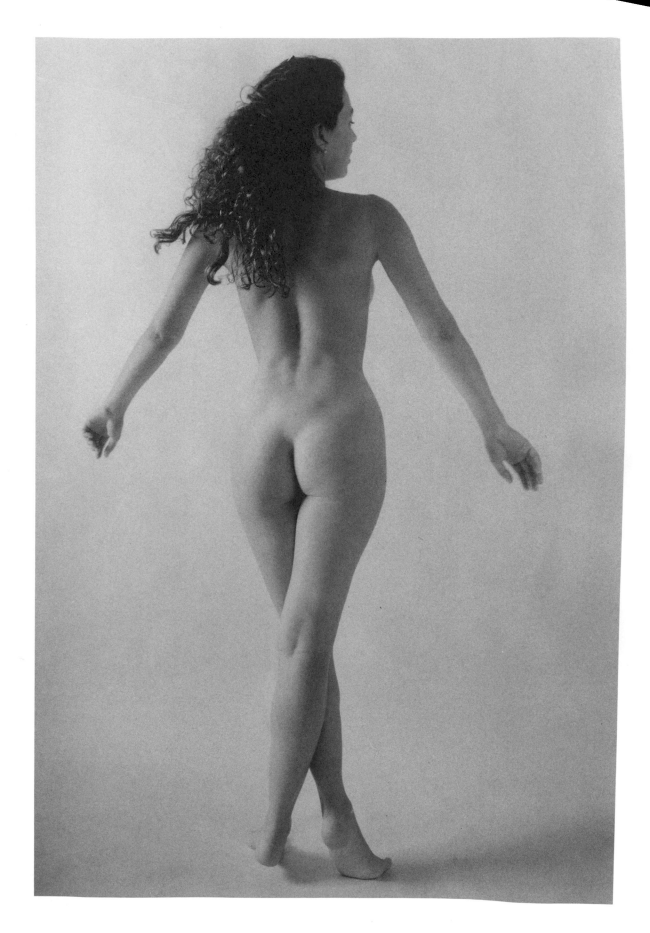

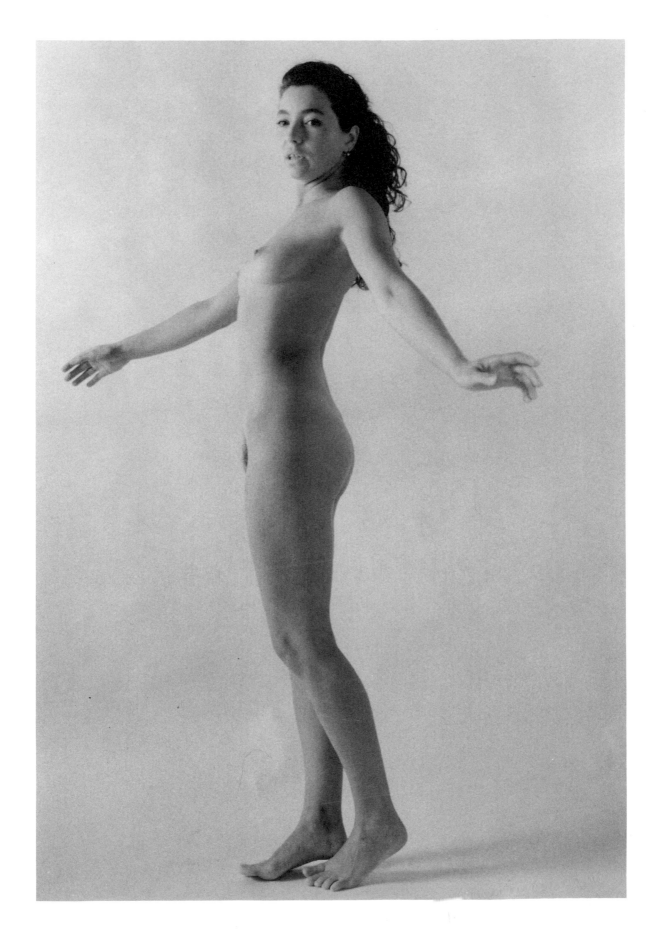

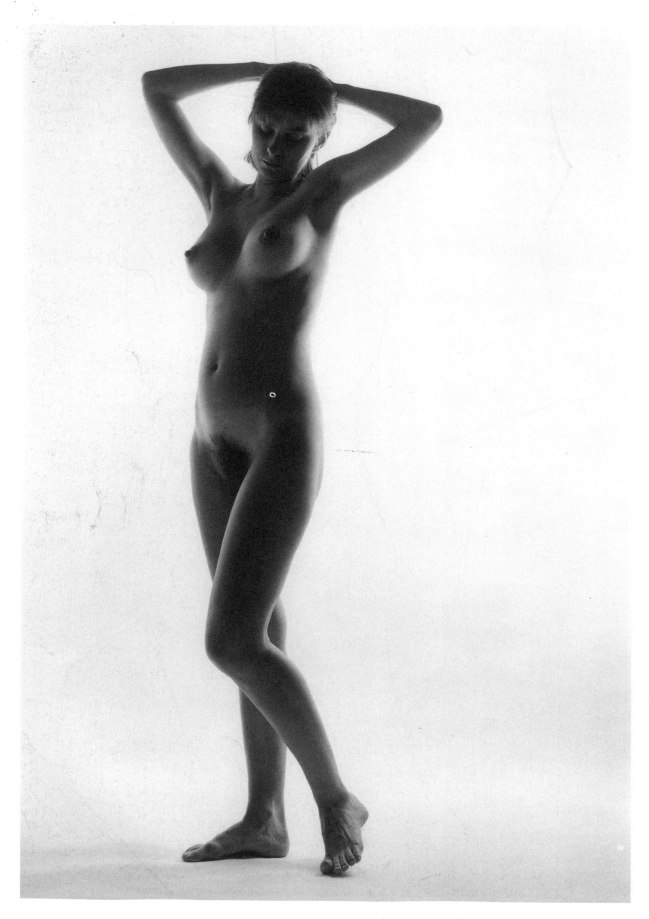

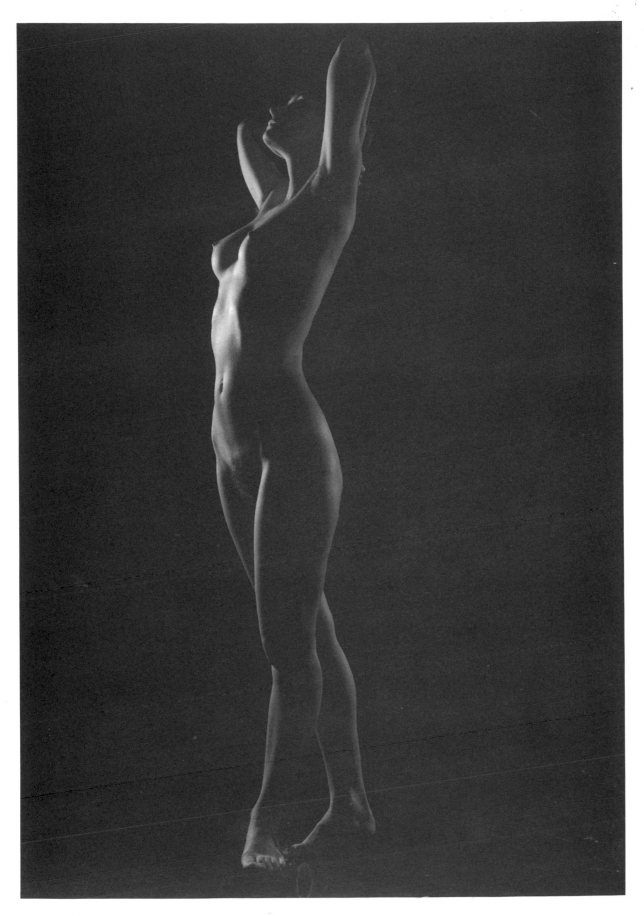

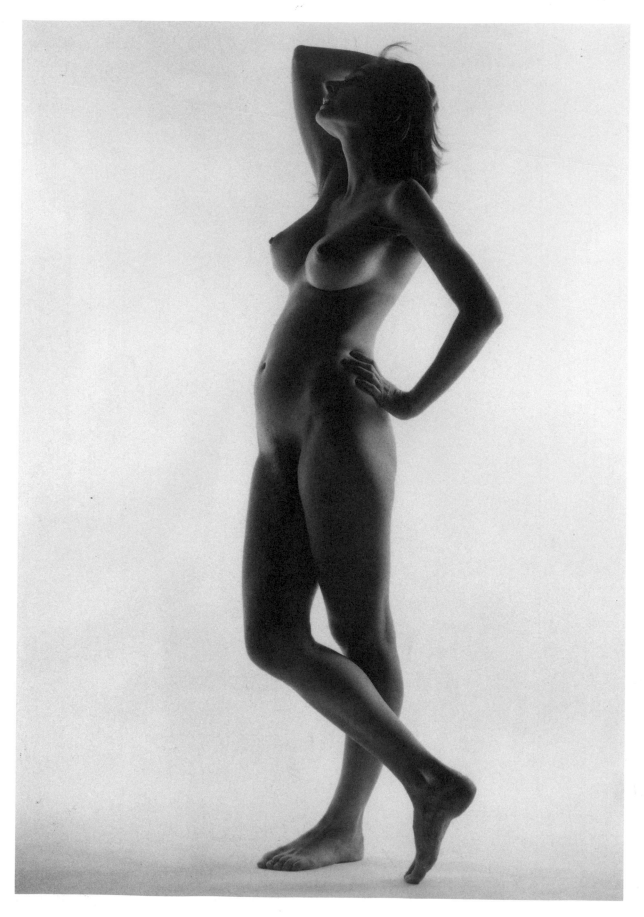

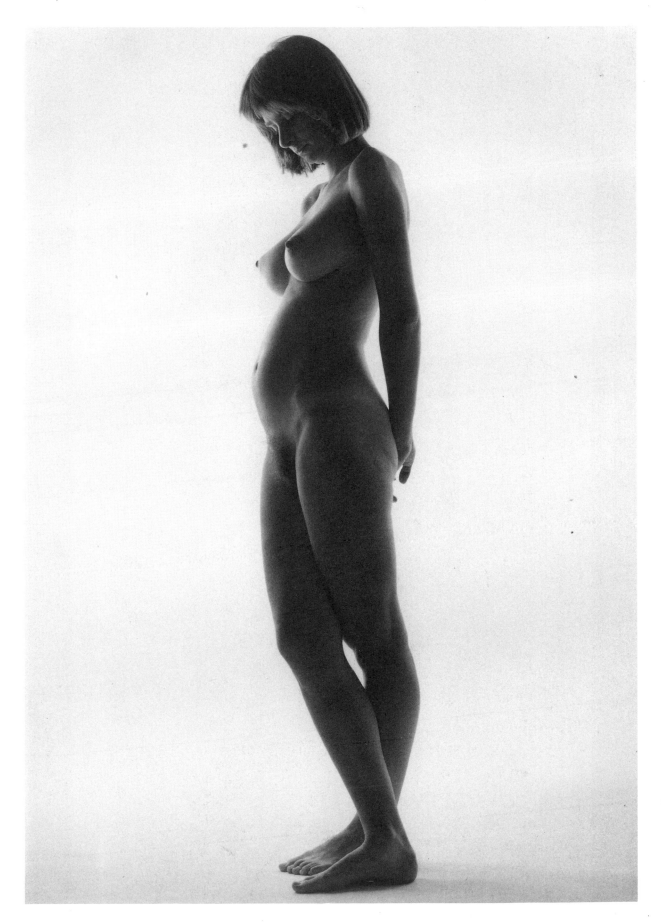

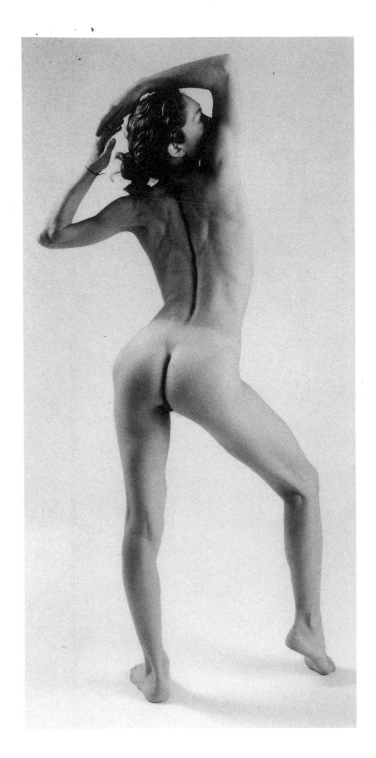

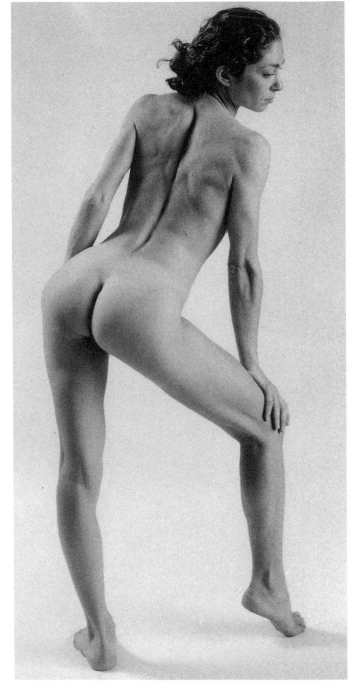

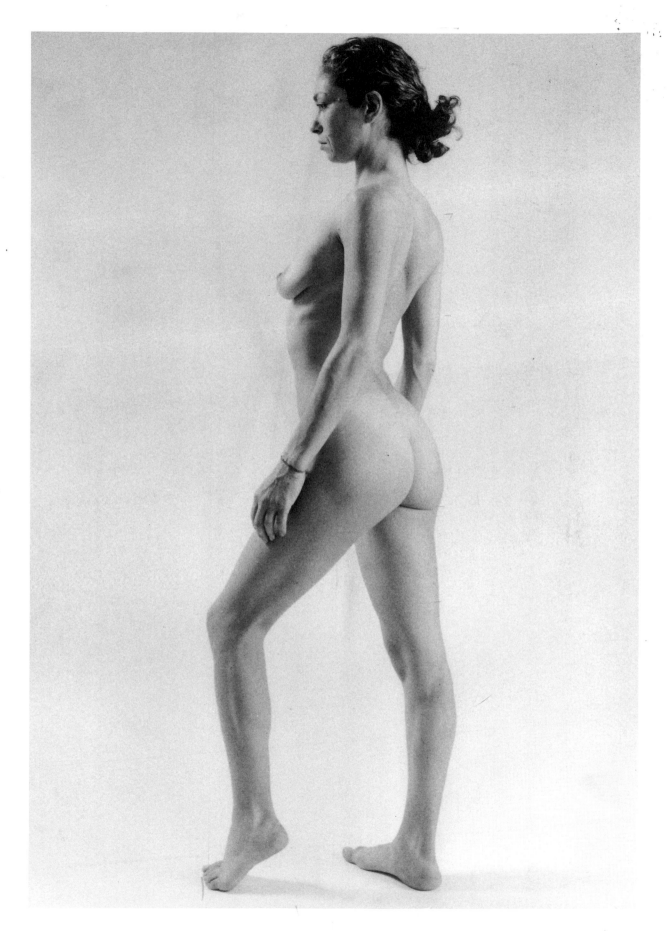

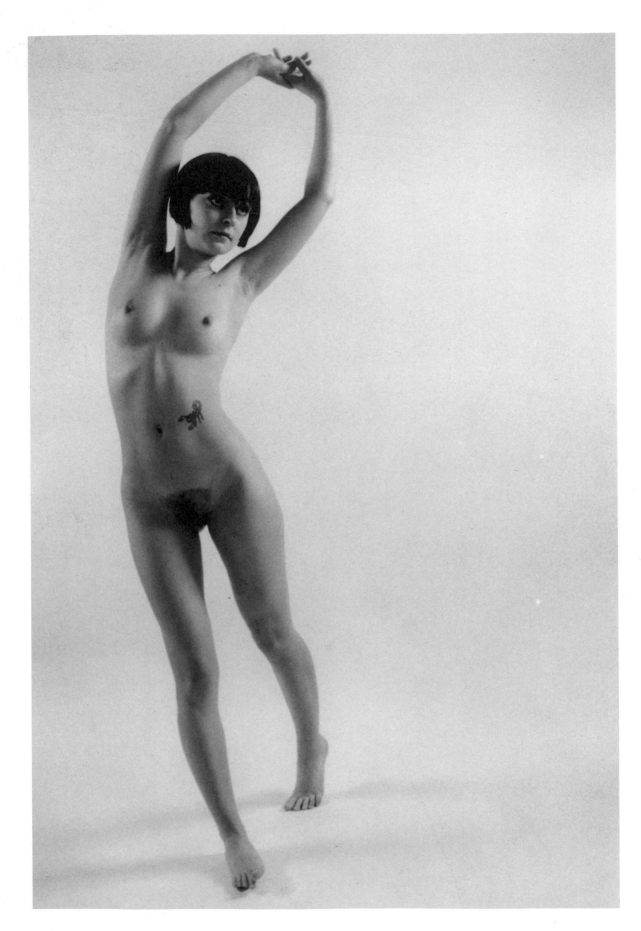

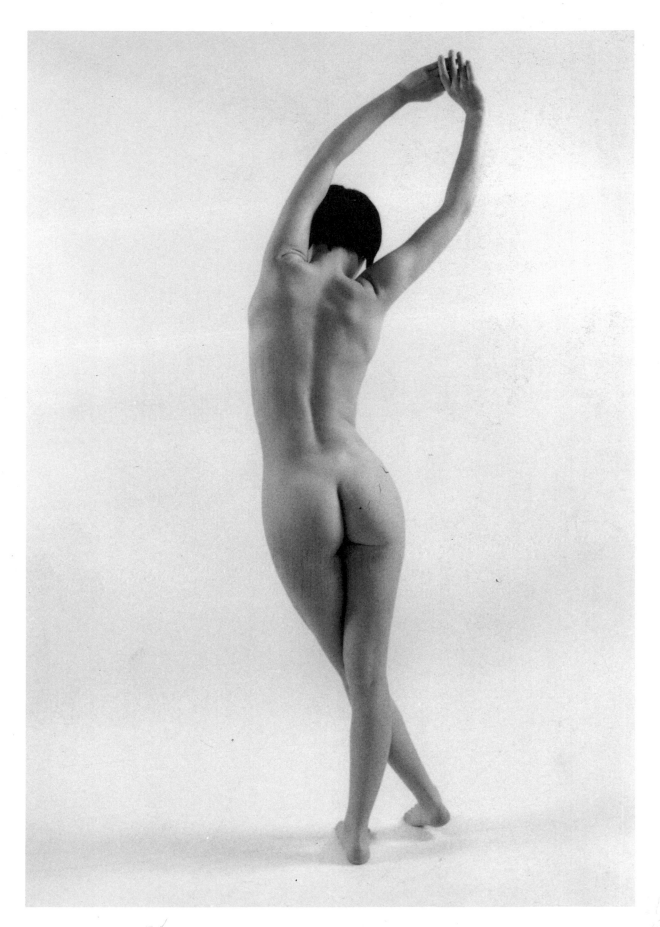

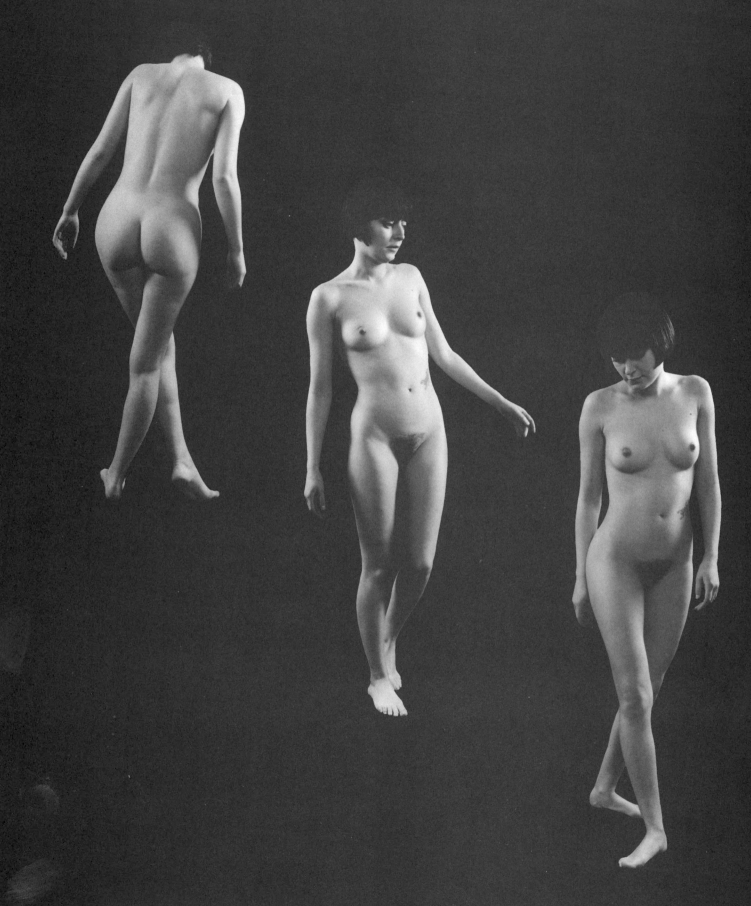

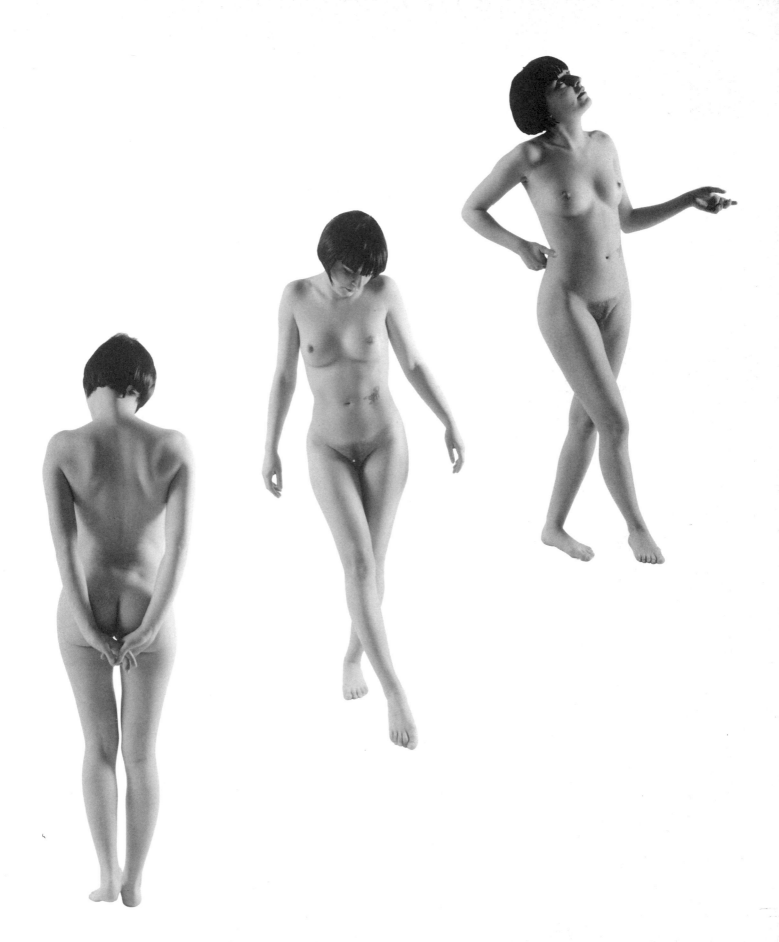

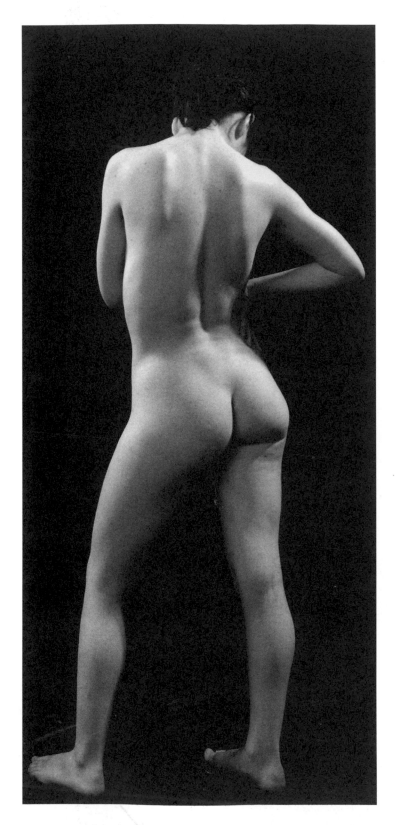
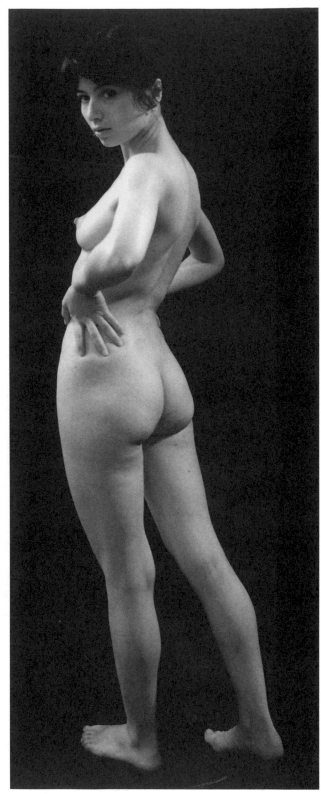

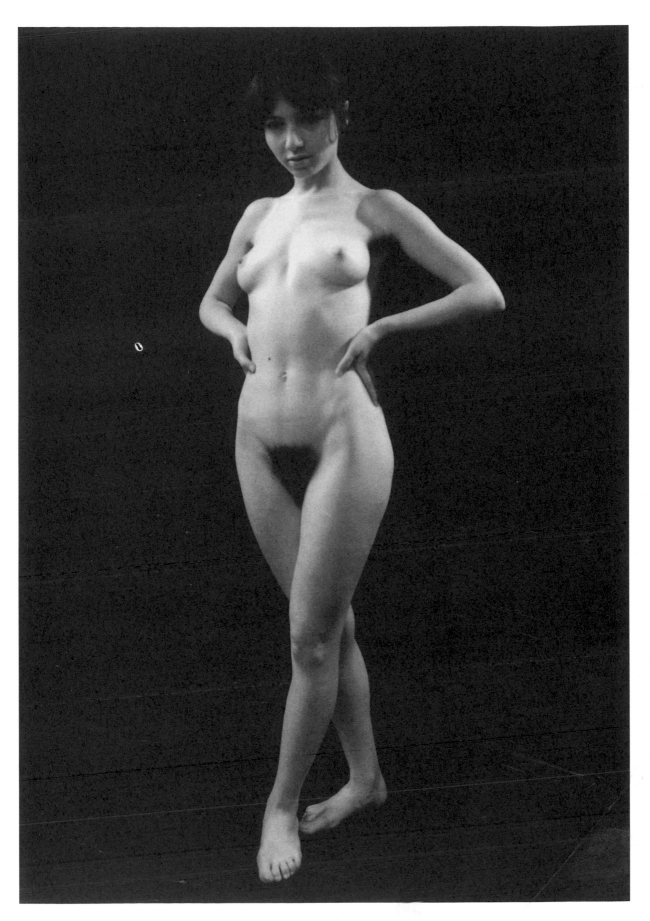

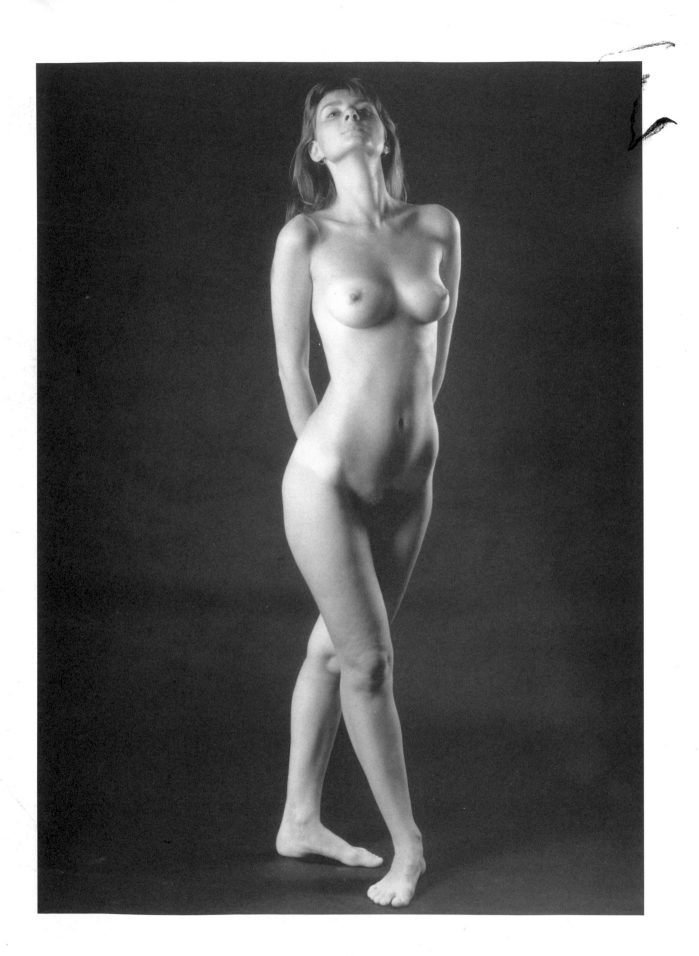

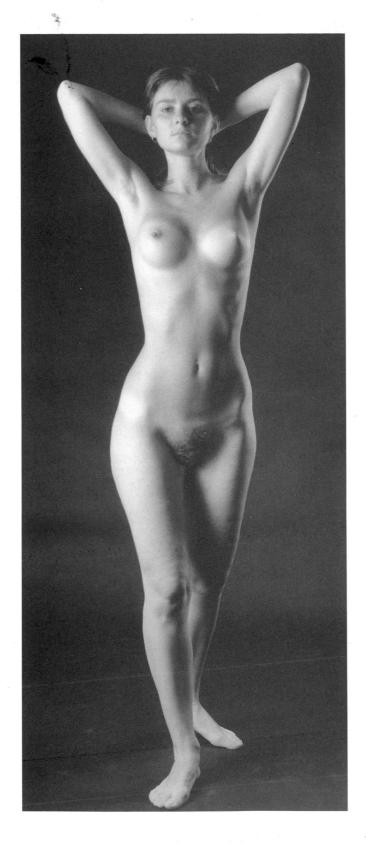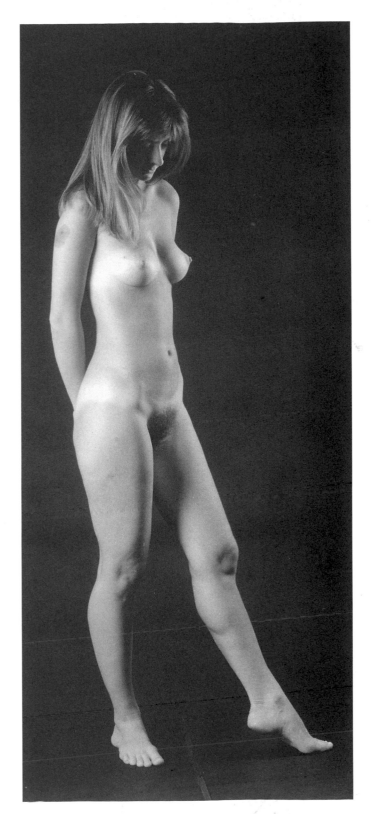

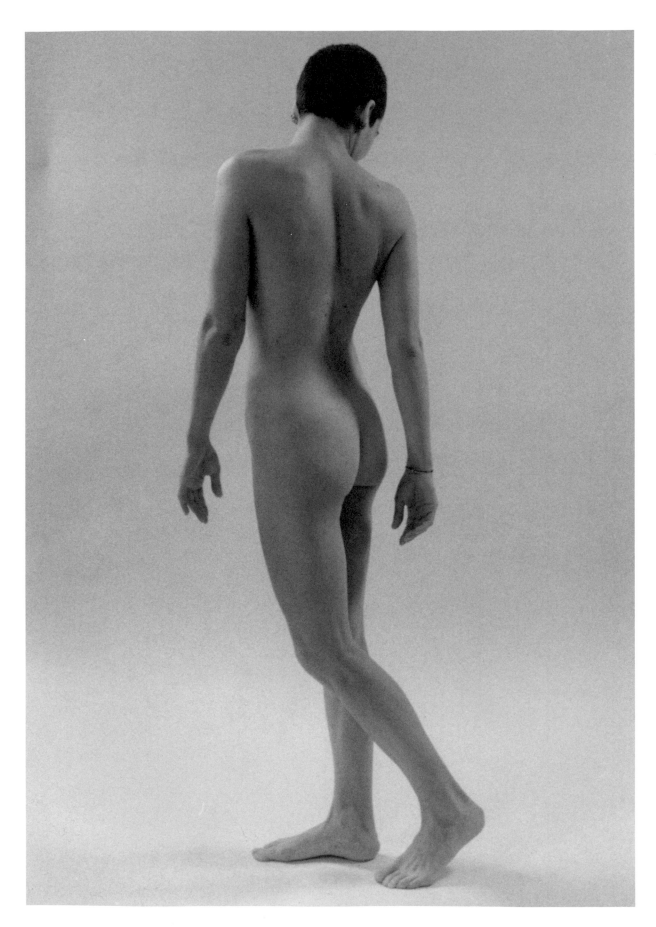

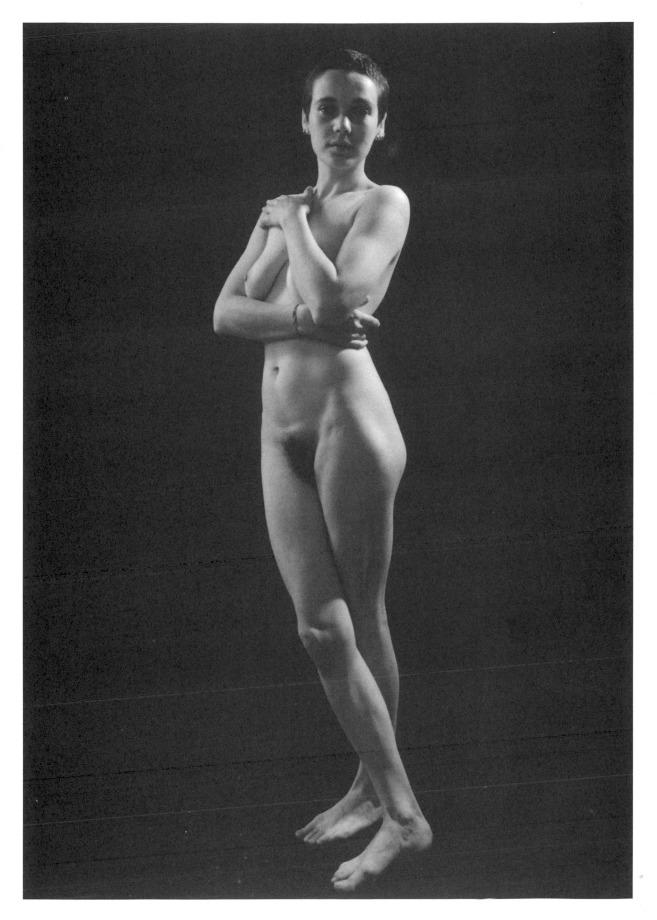

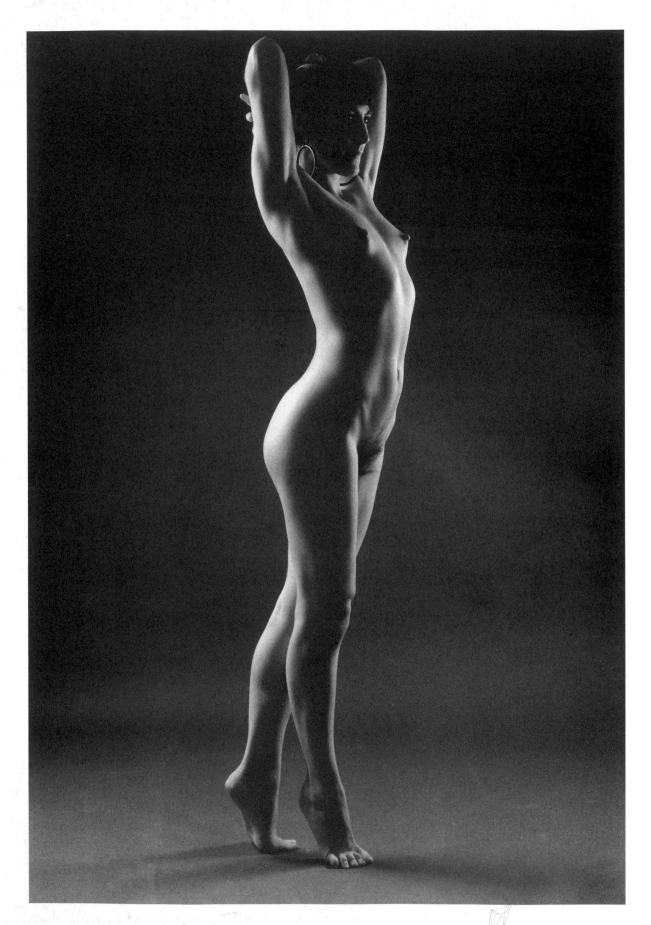

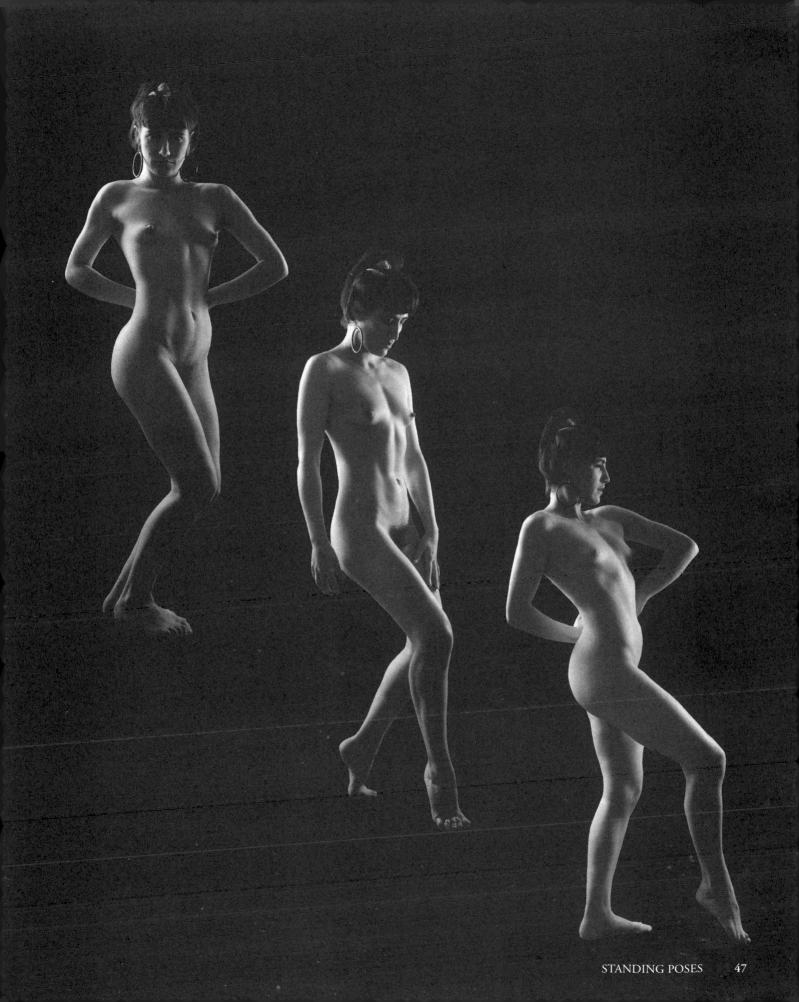

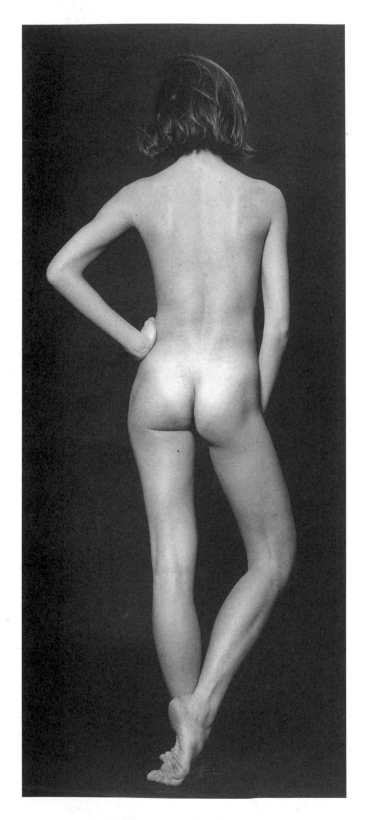
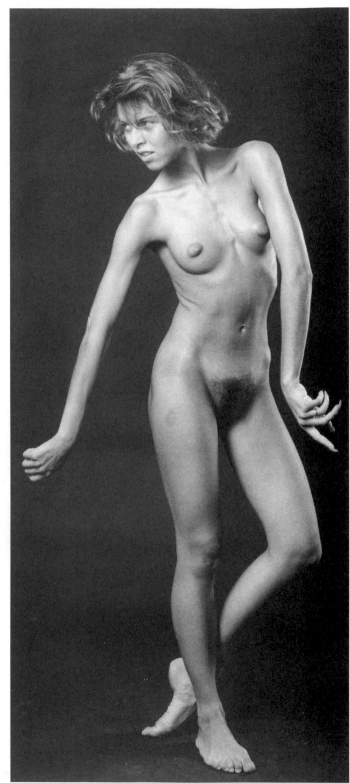

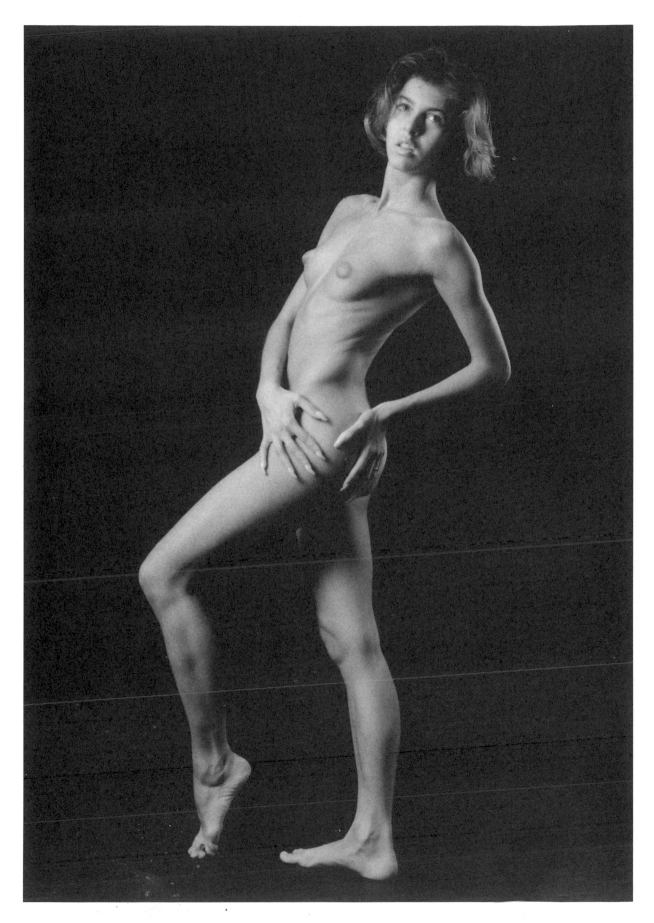

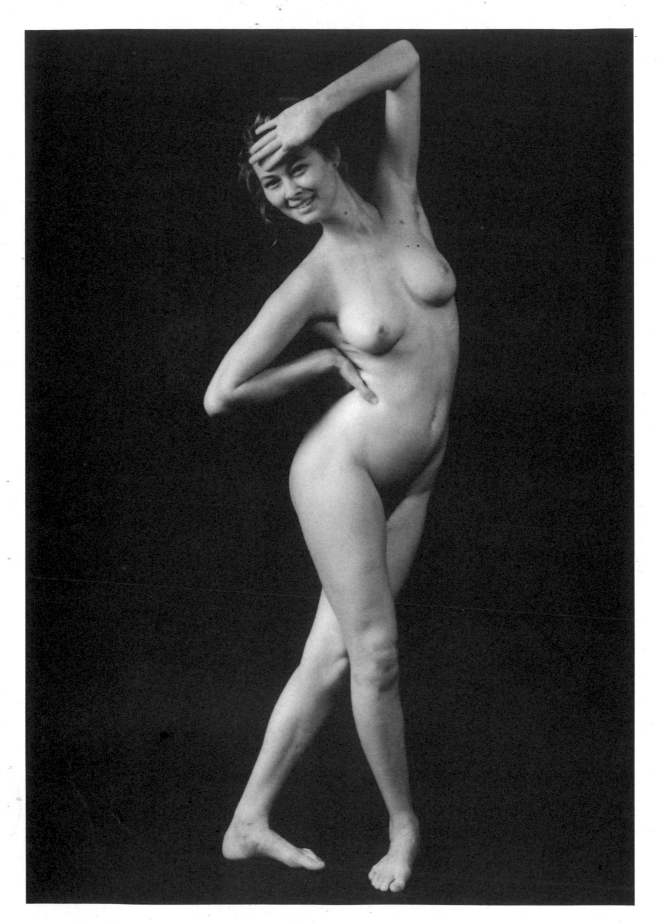

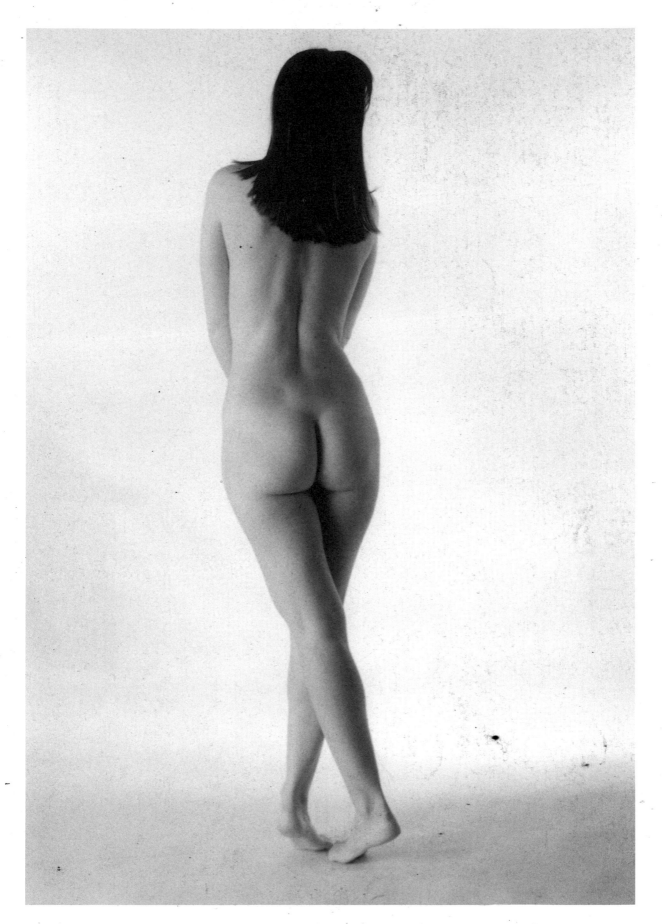

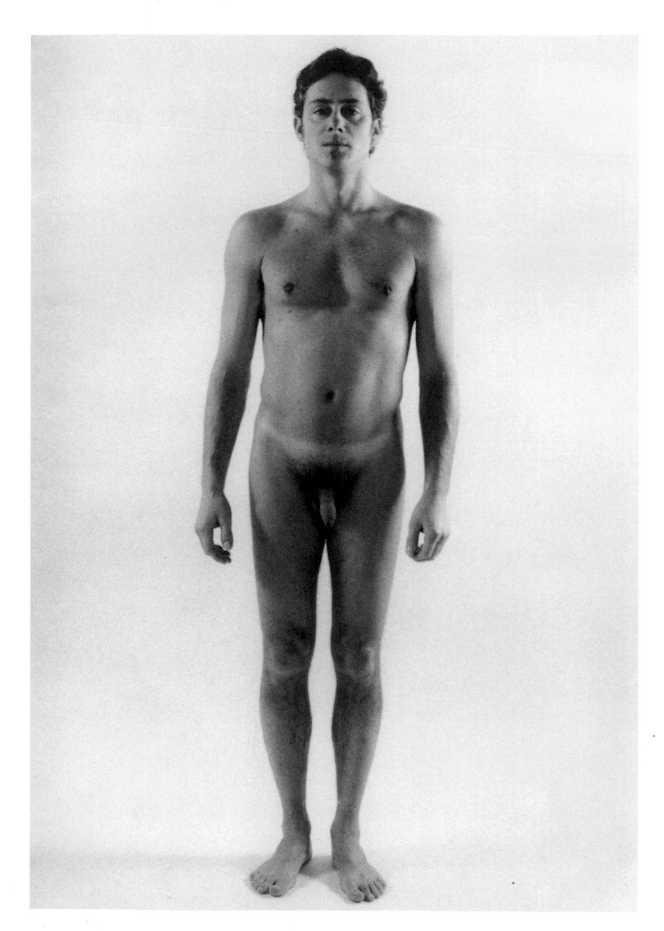

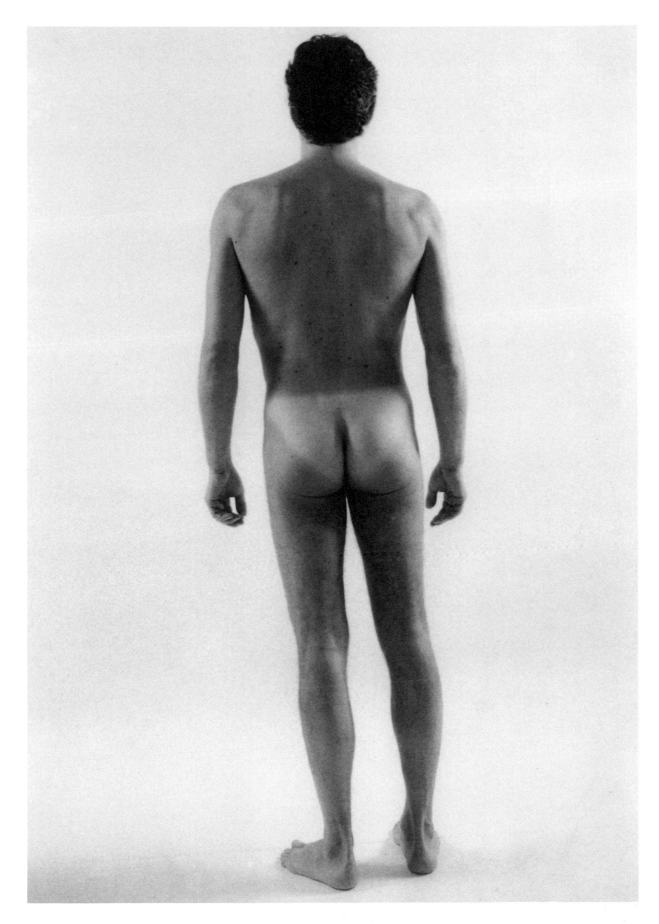

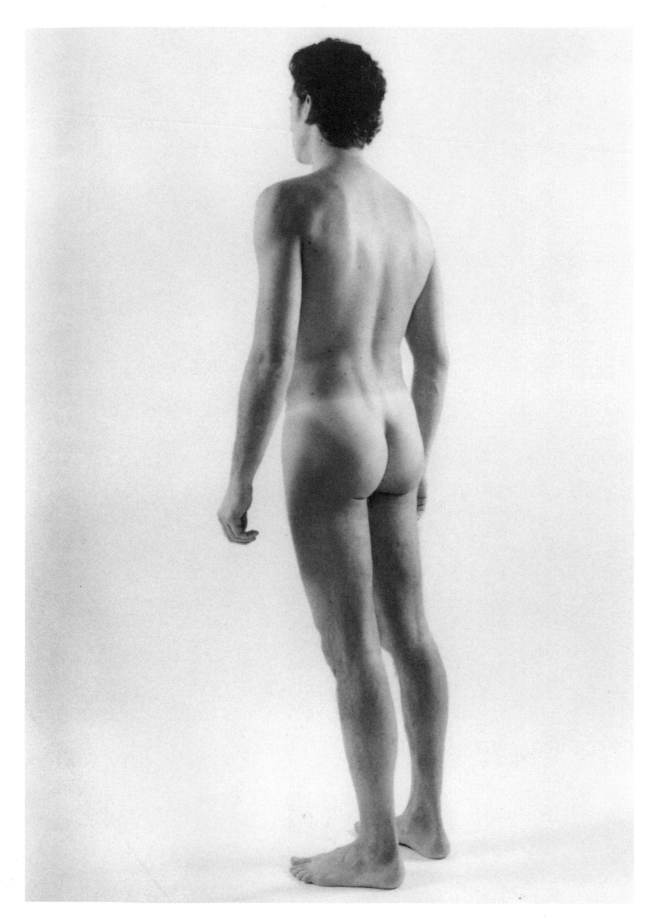

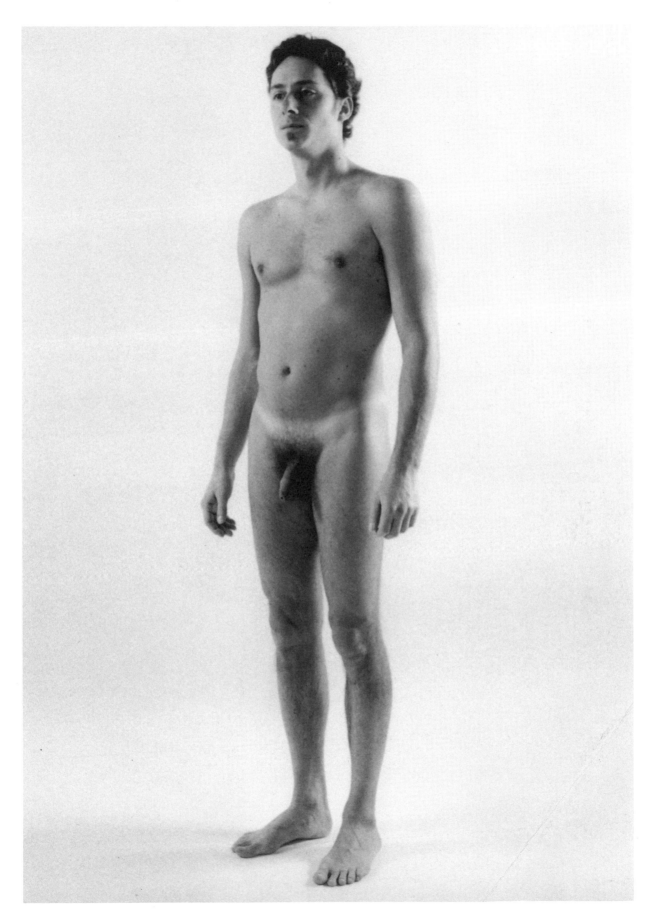

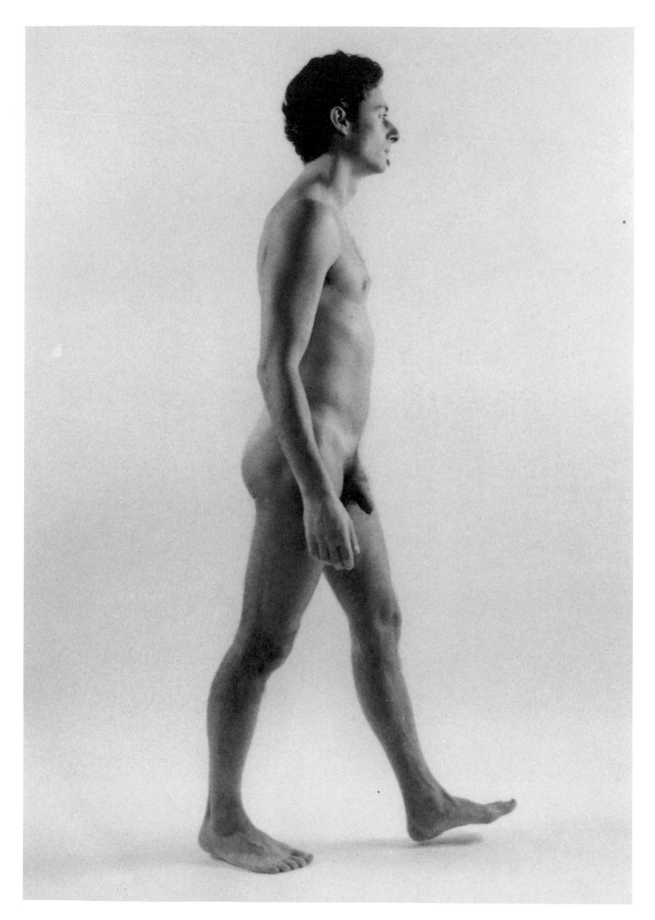

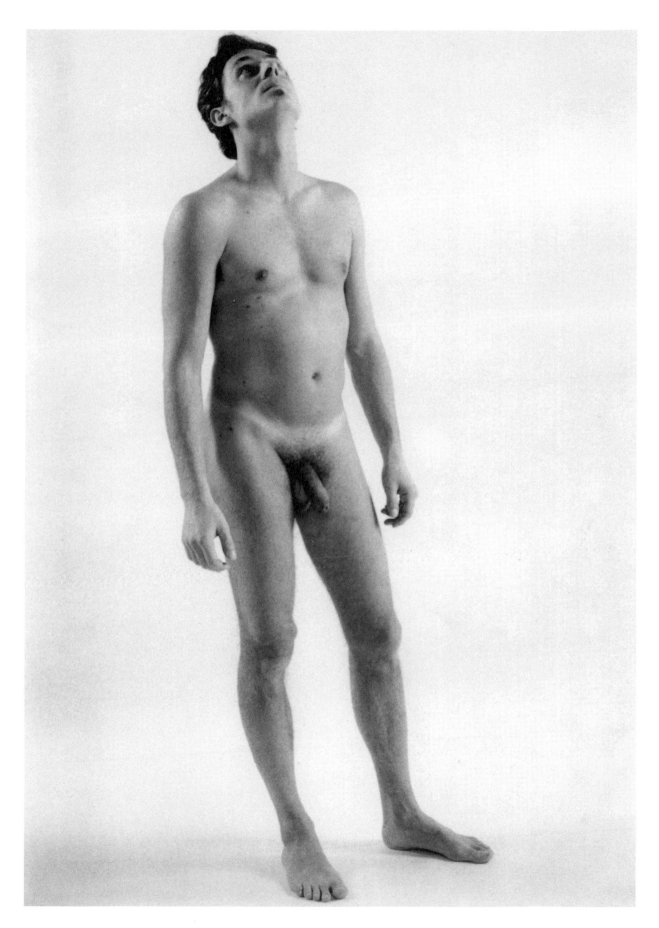

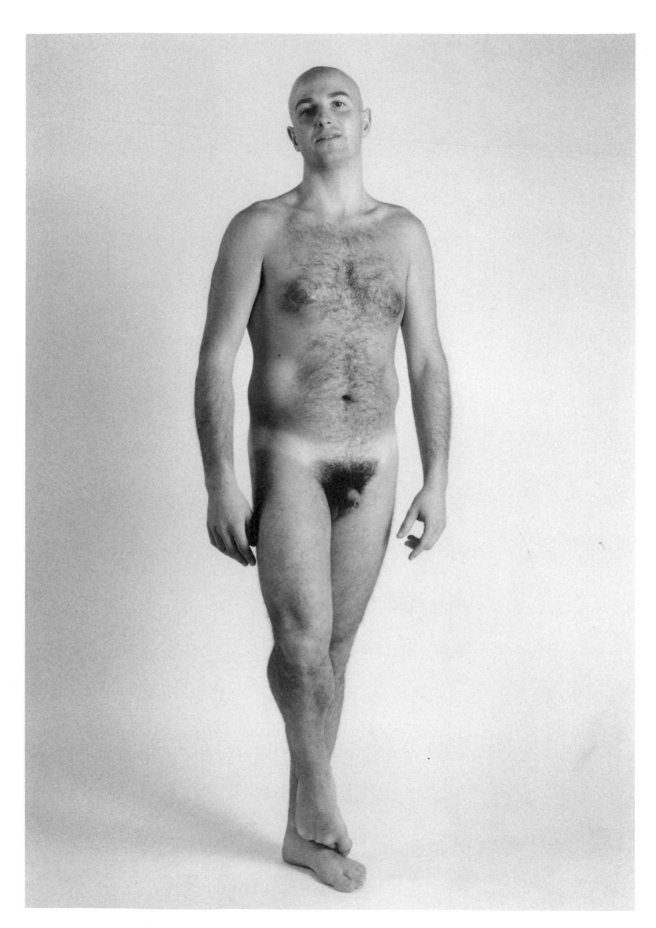

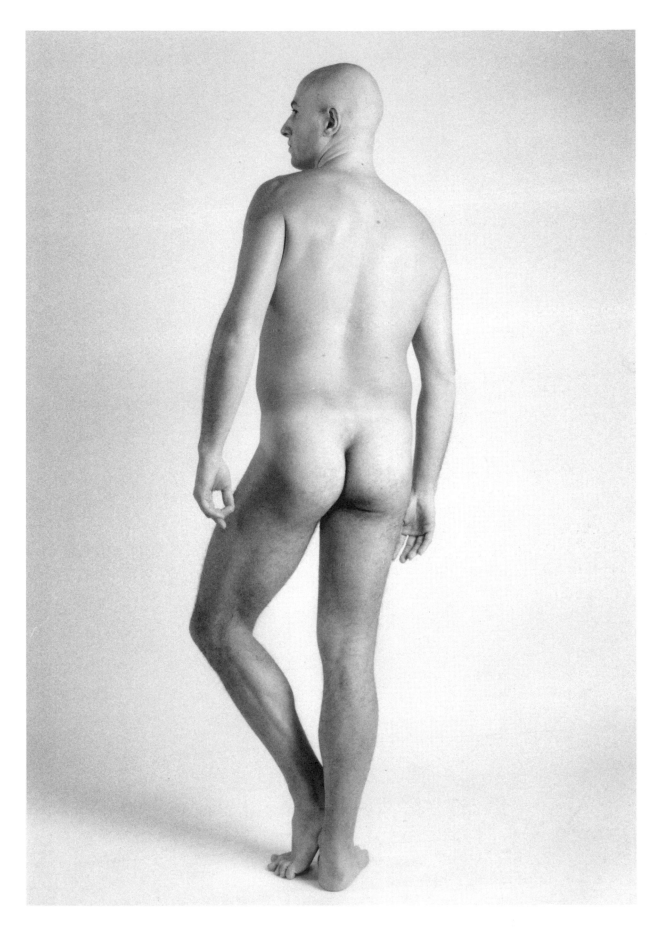

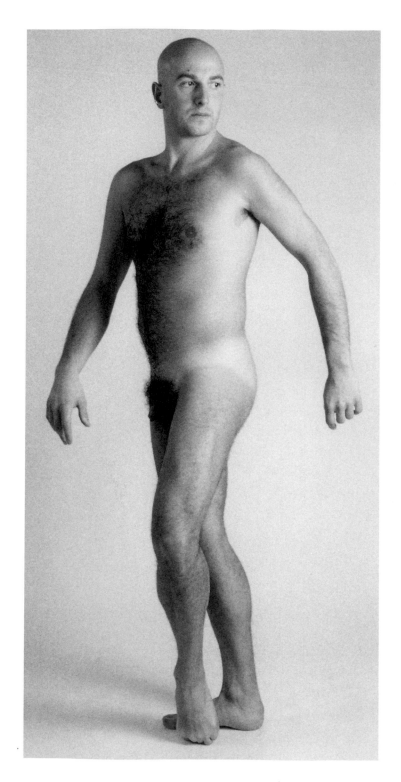
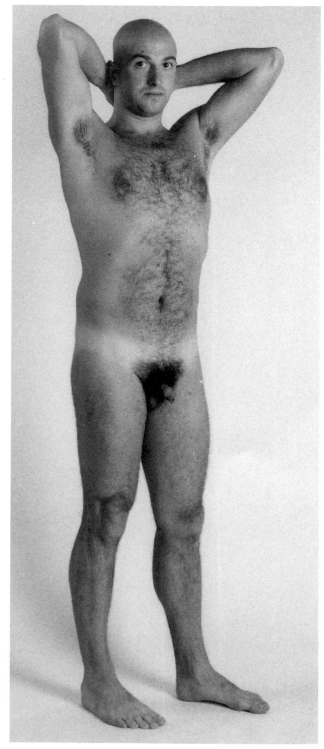

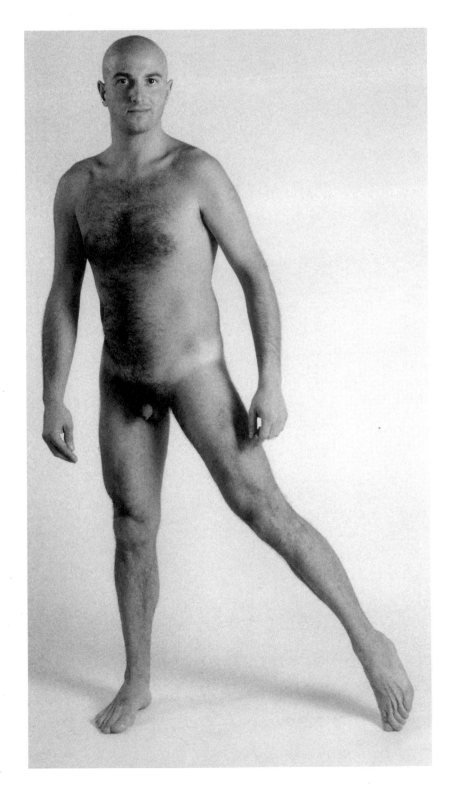

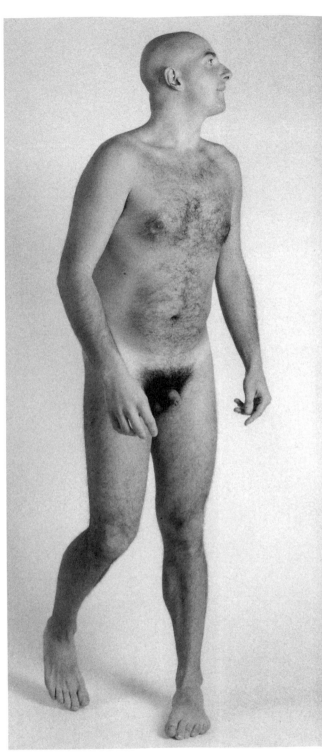

SEATED
POSES

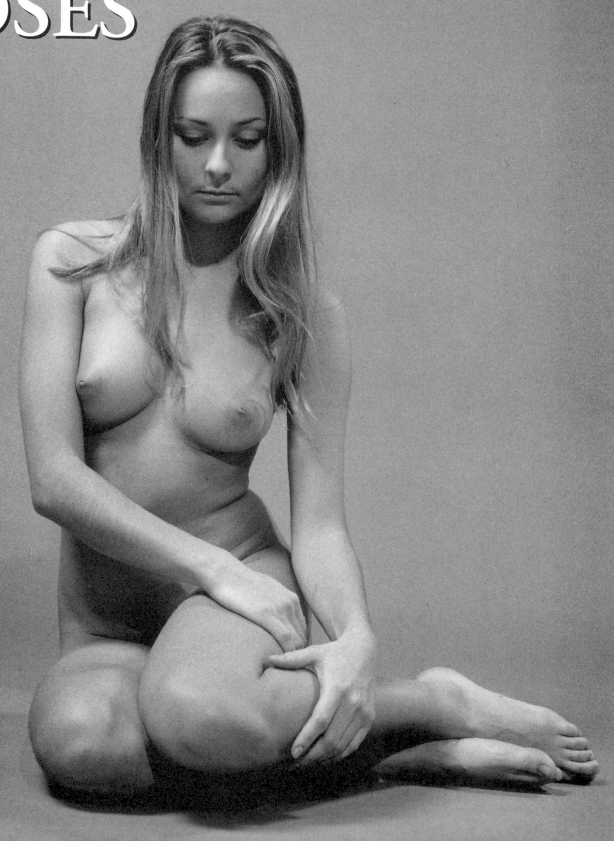

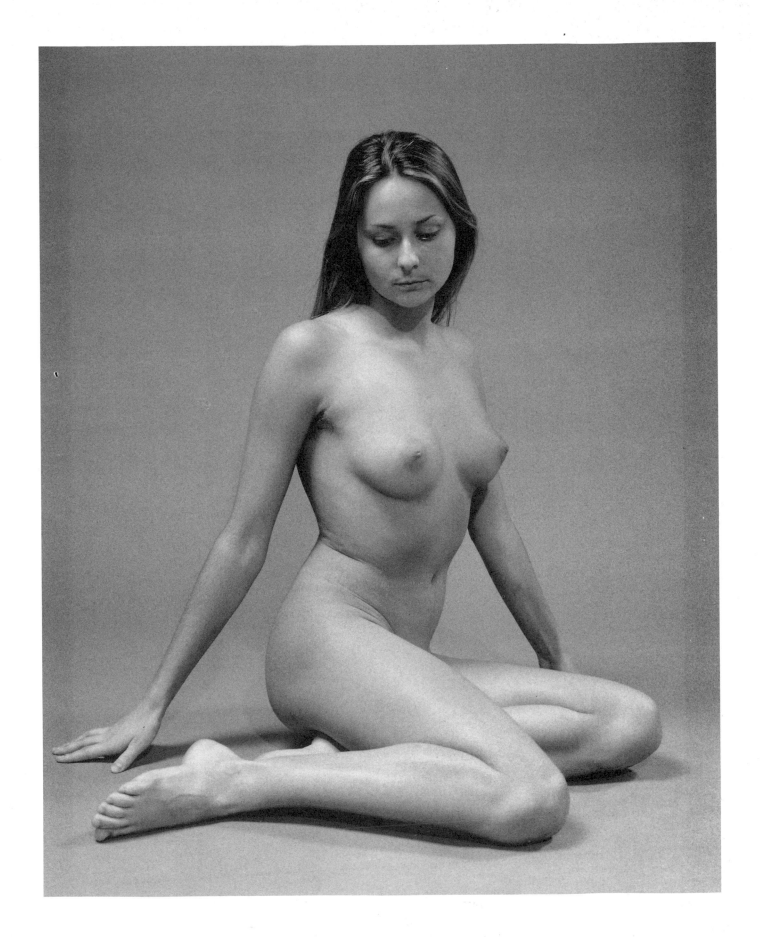

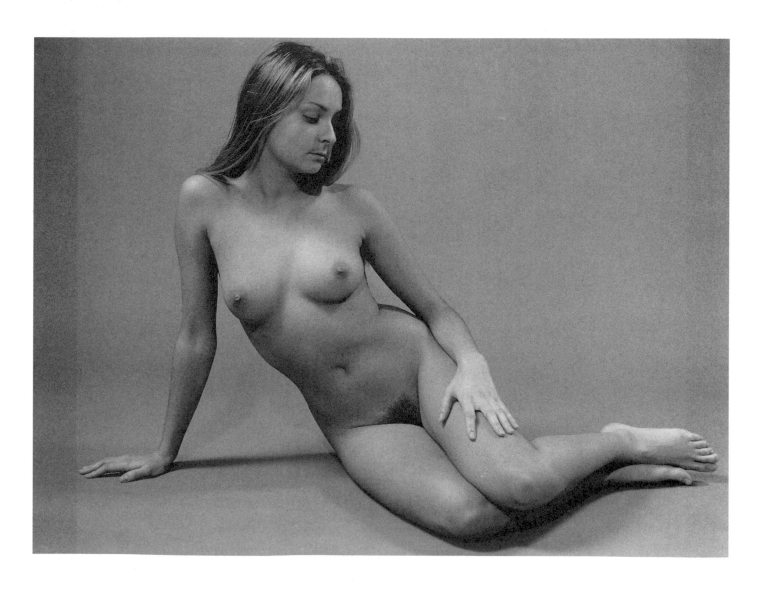

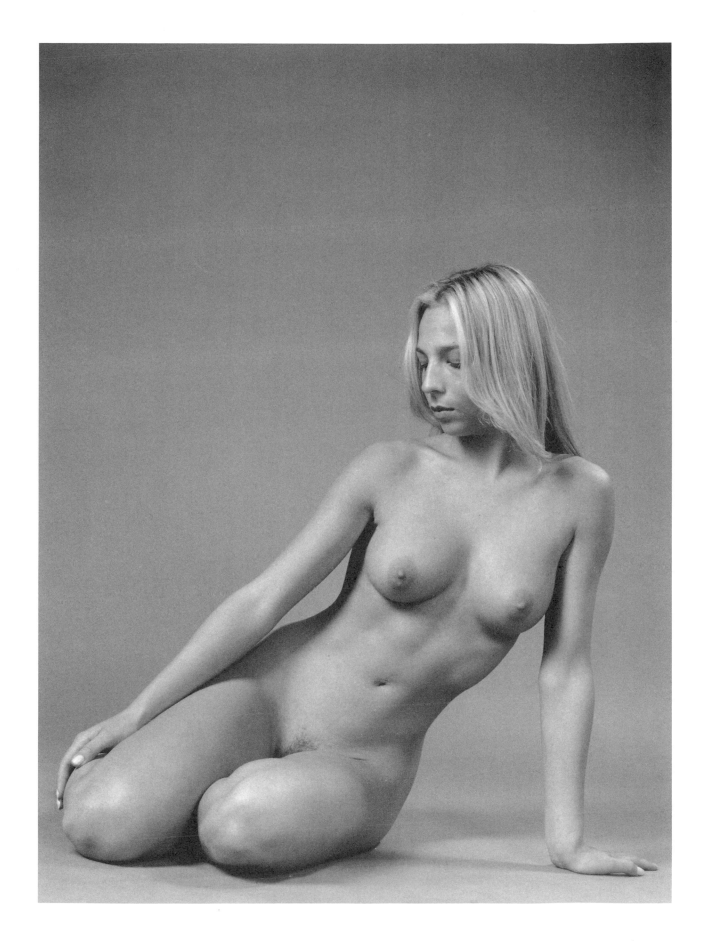

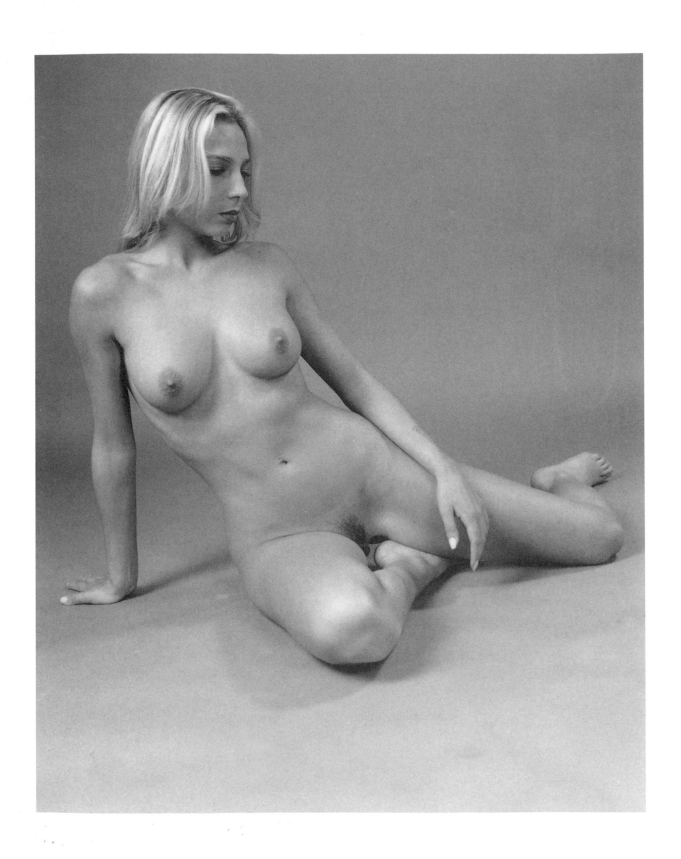

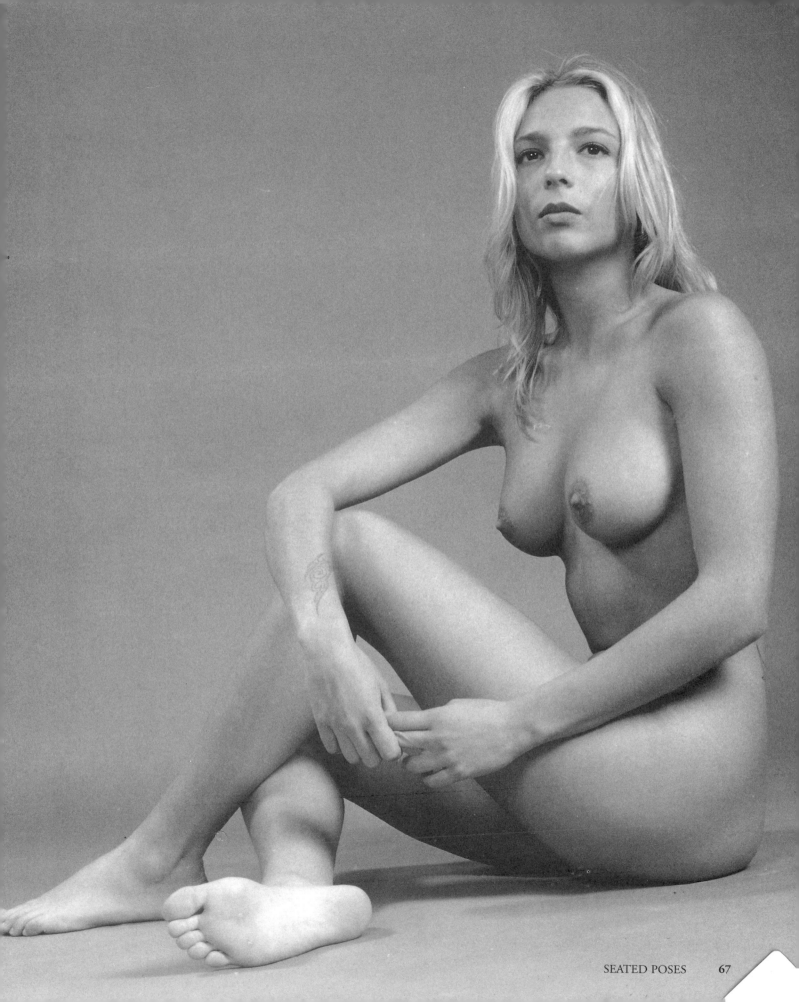

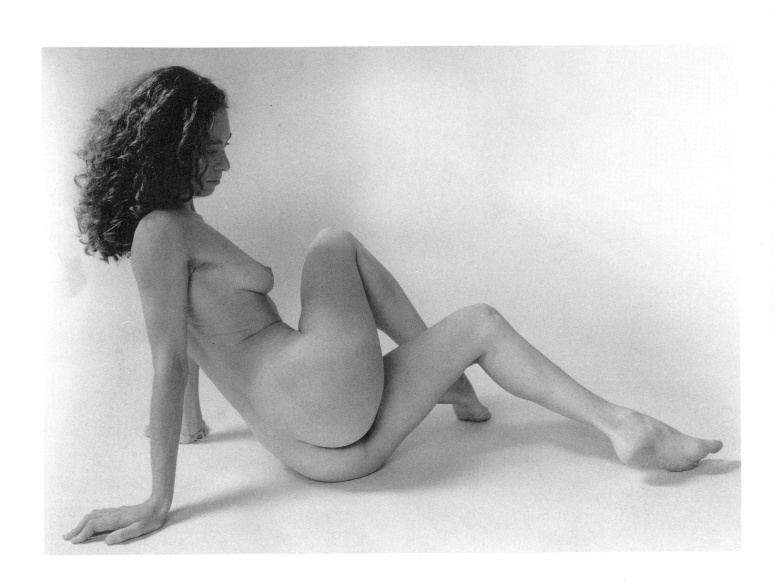

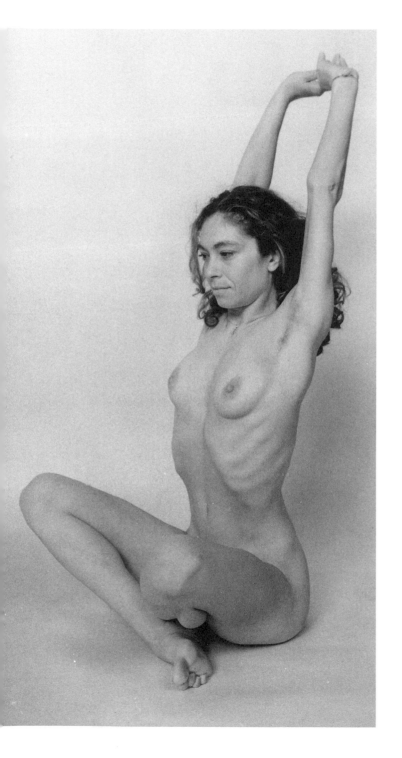

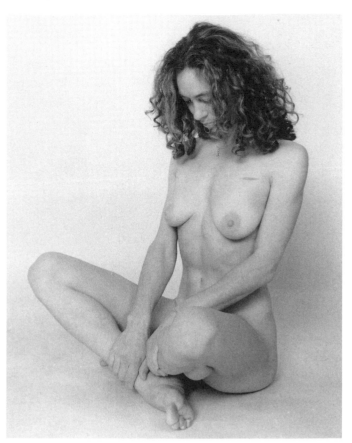

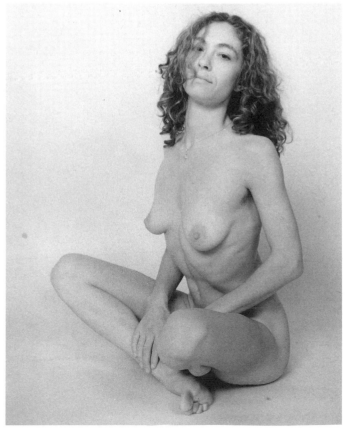

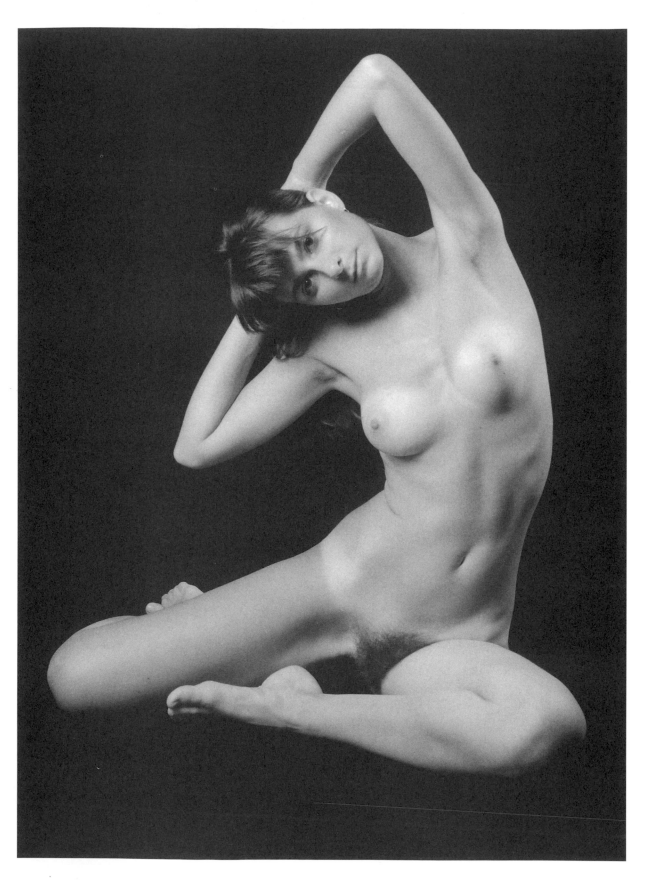

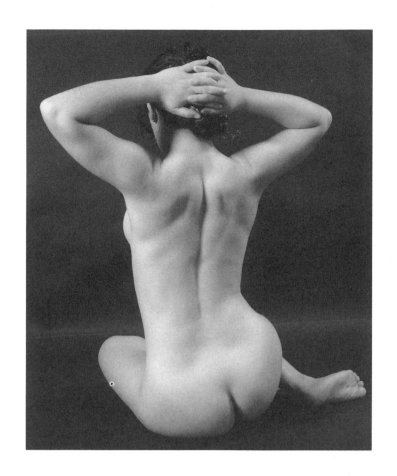

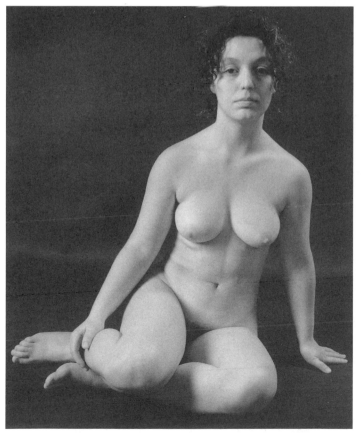

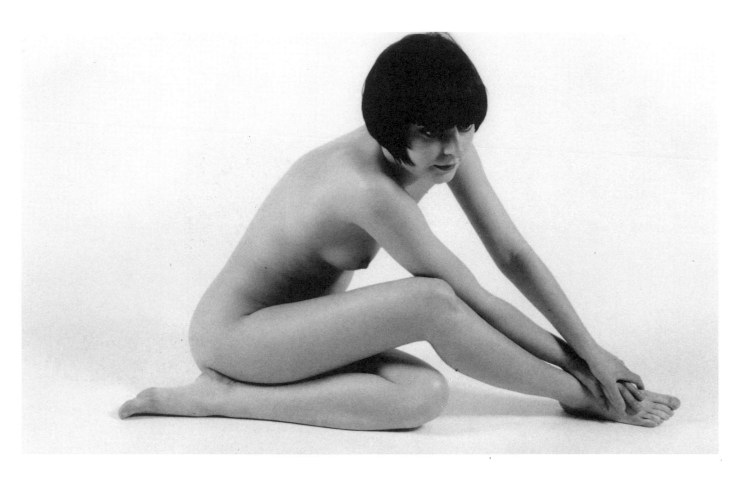

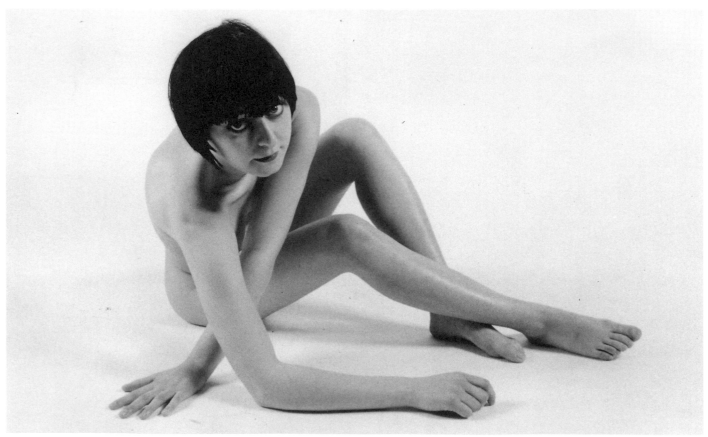

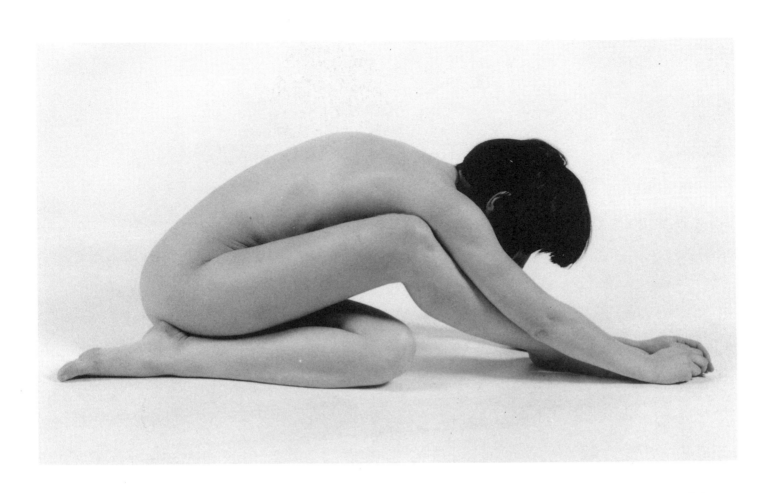

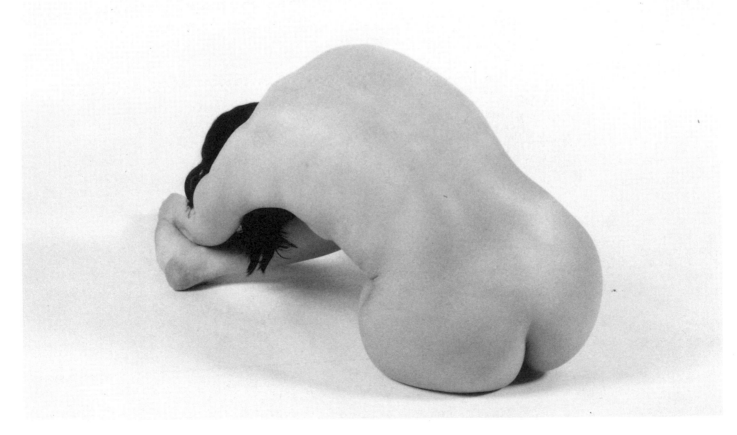

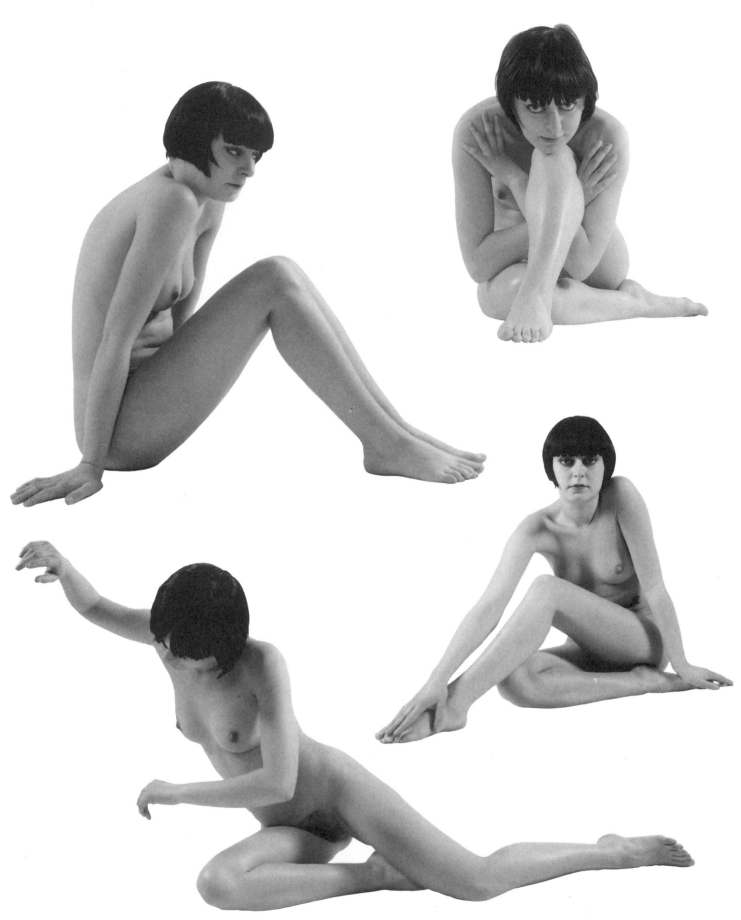

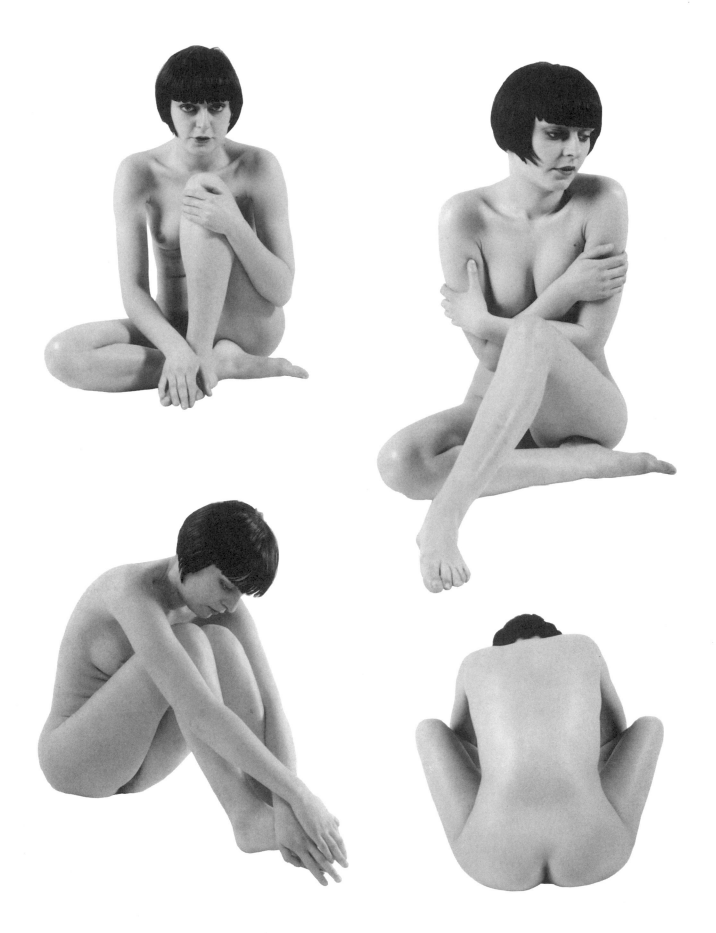

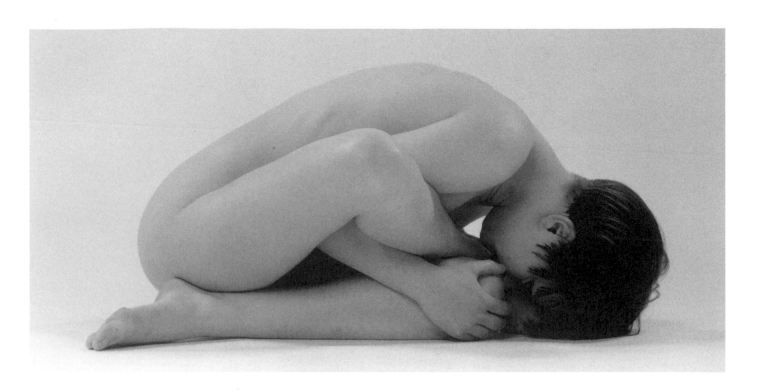

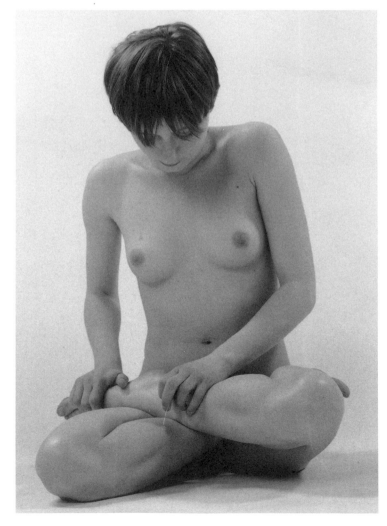

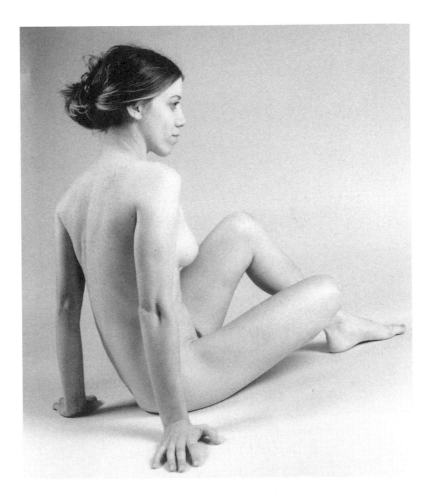

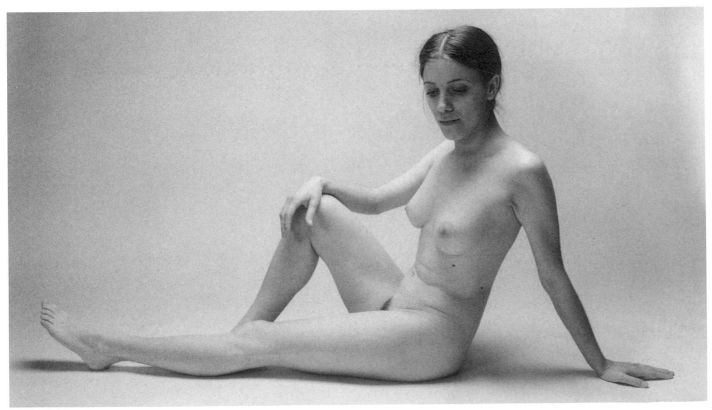

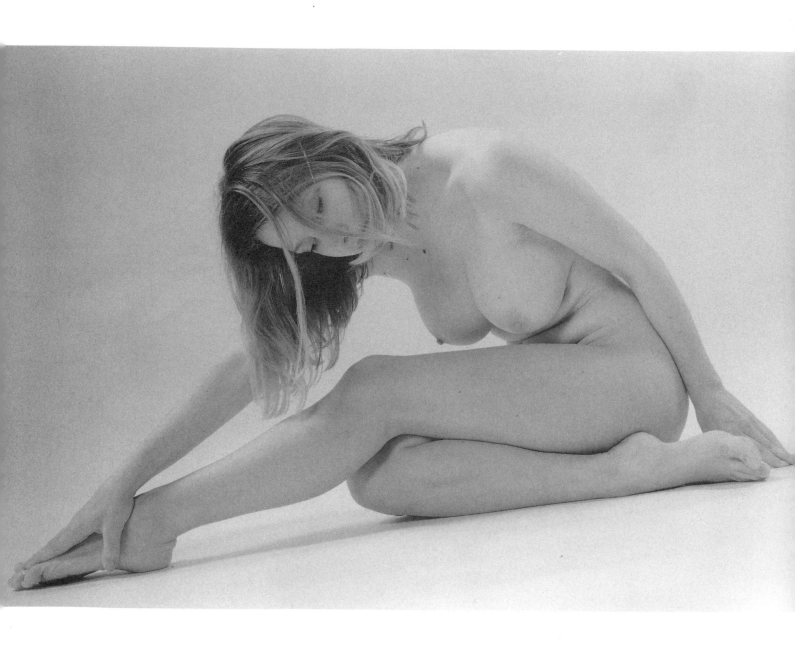

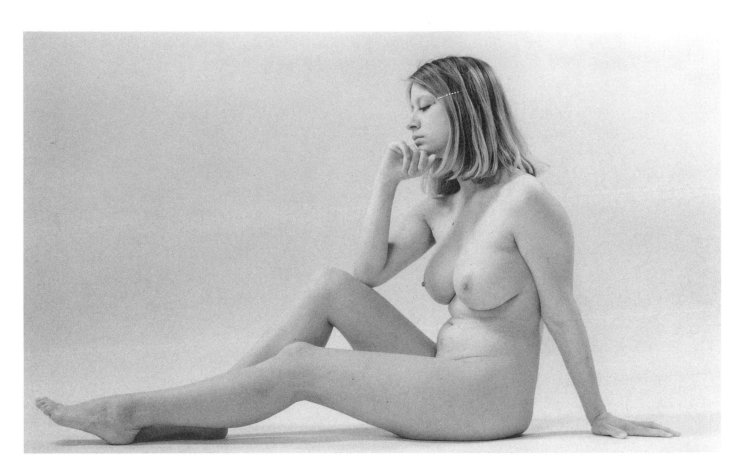

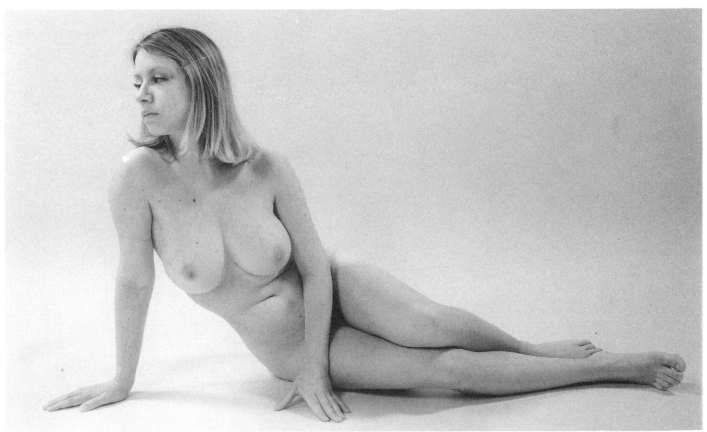

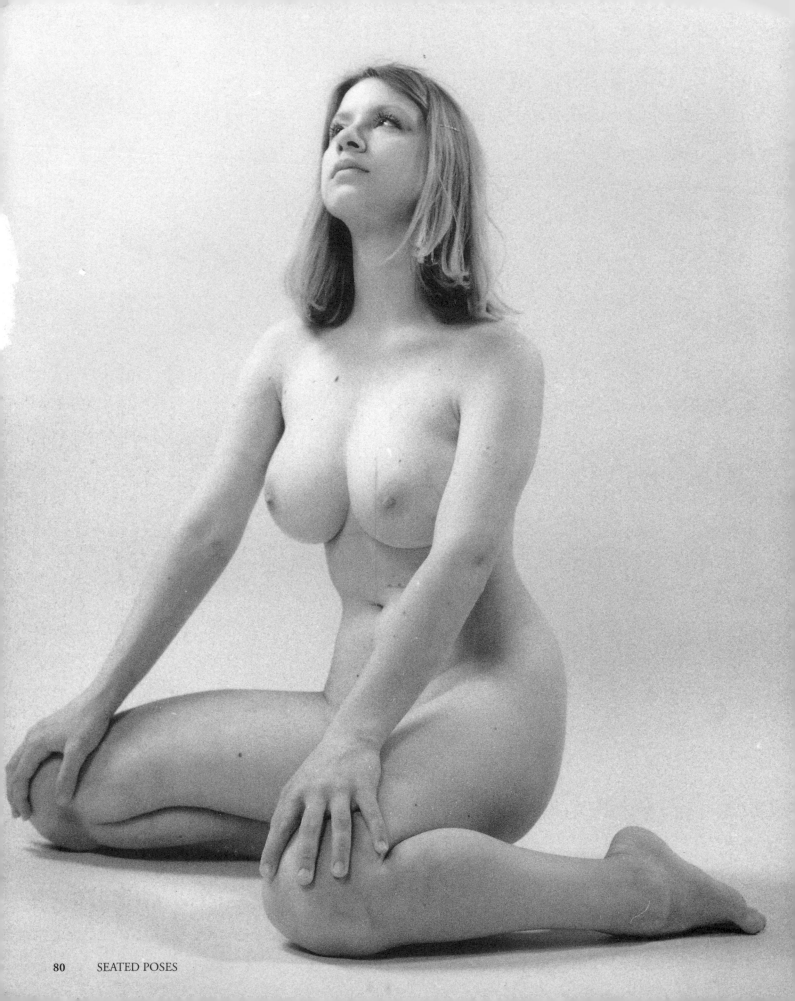

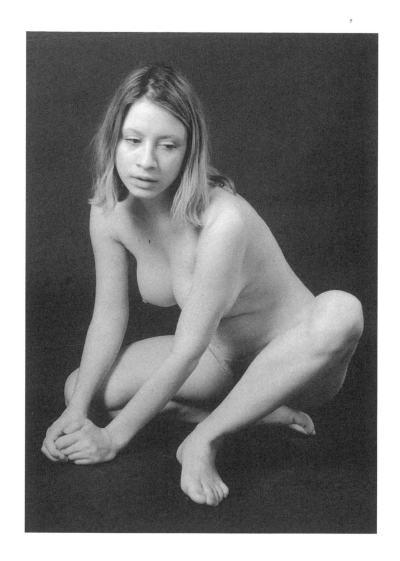

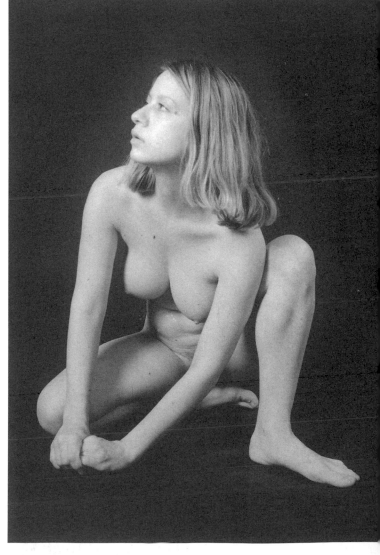

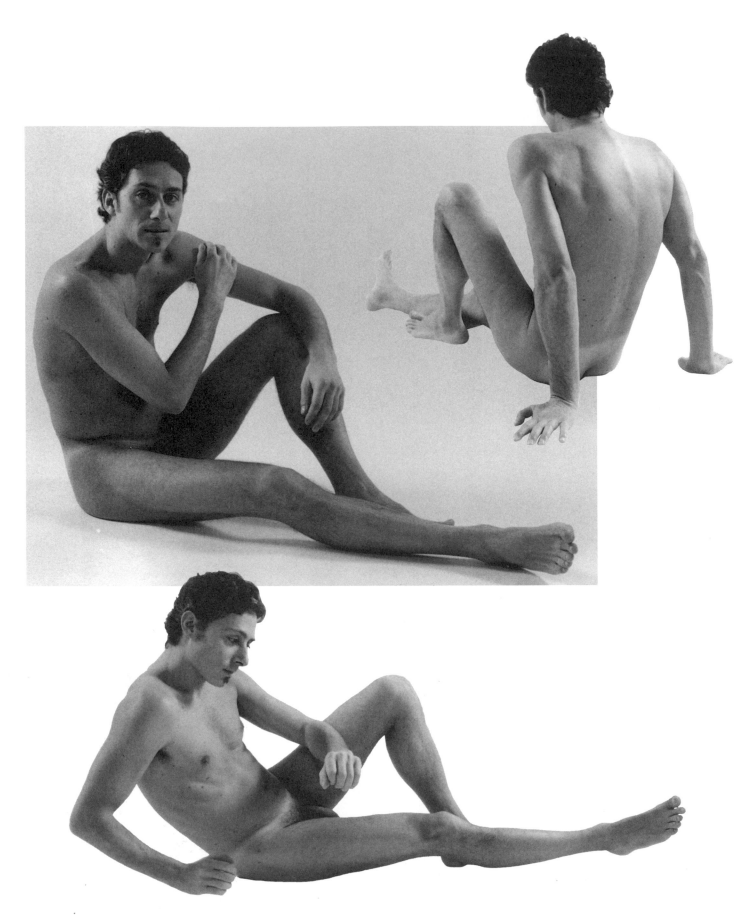

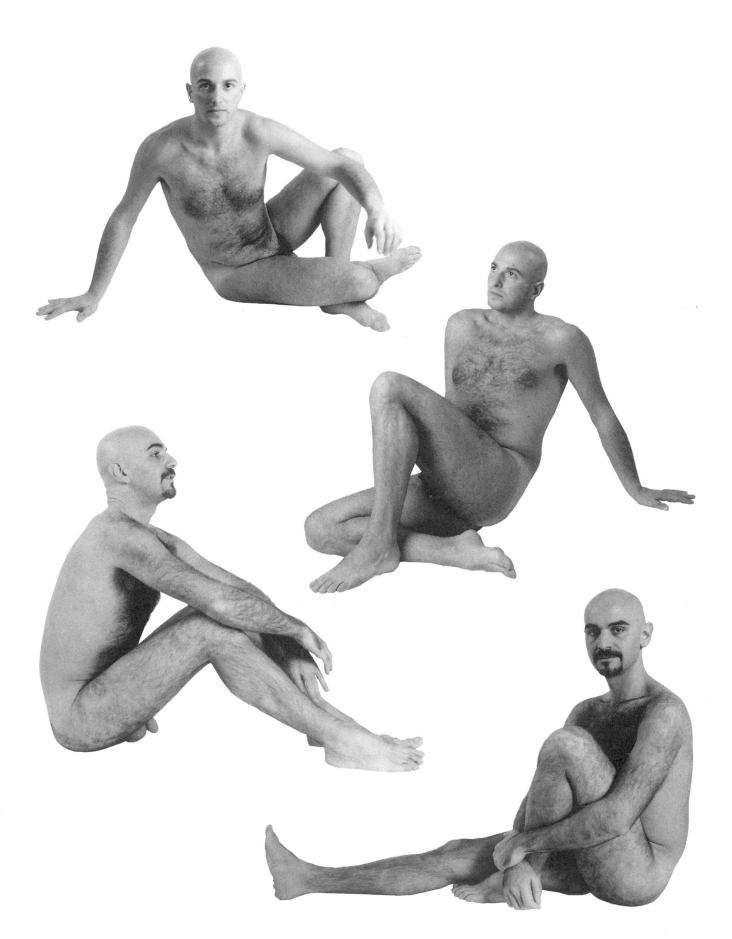

RECLINING
POSES

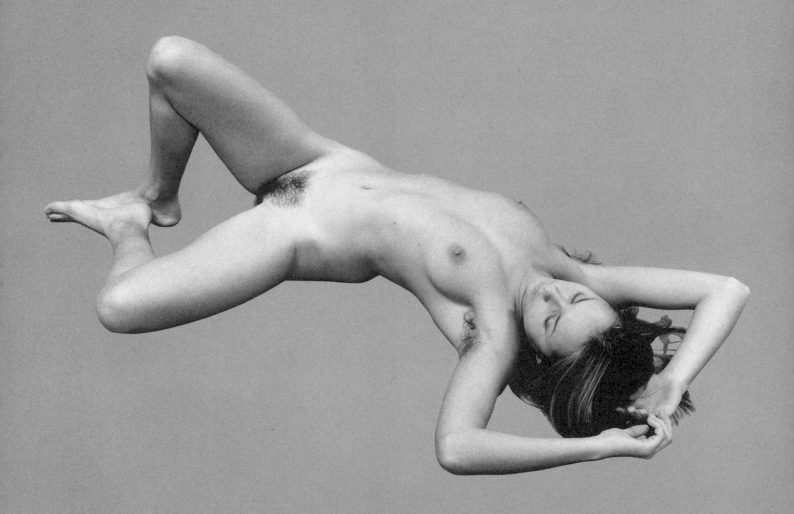

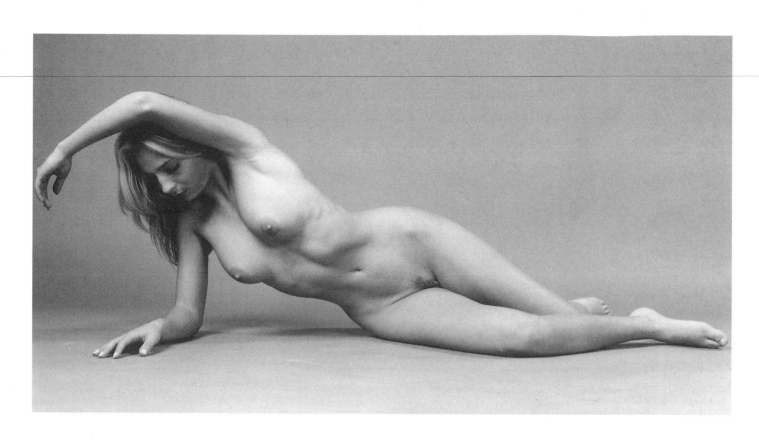

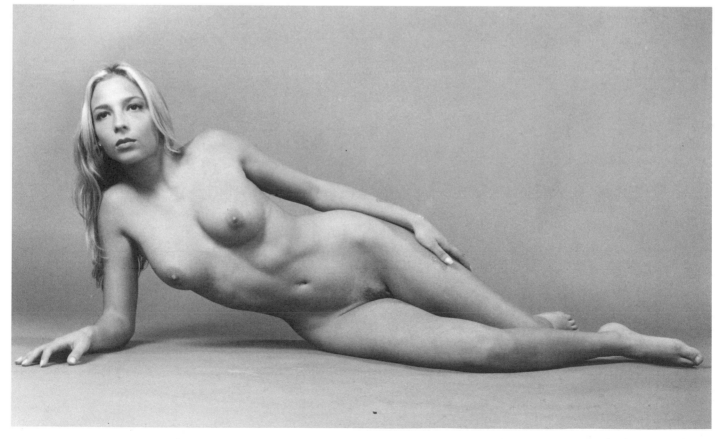

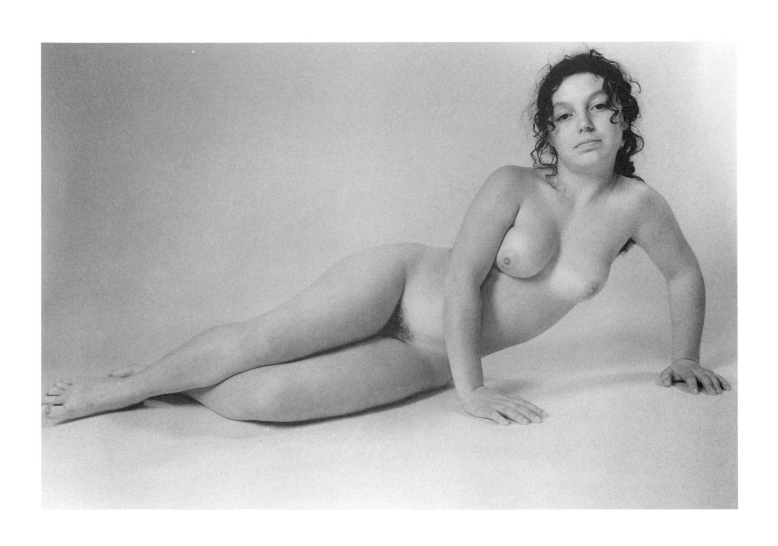

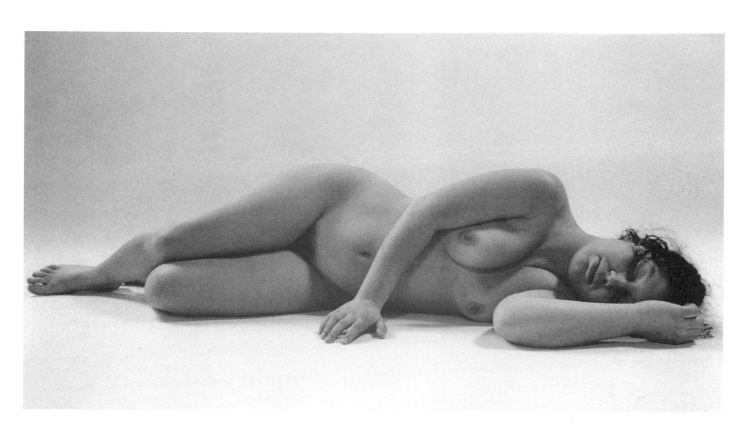

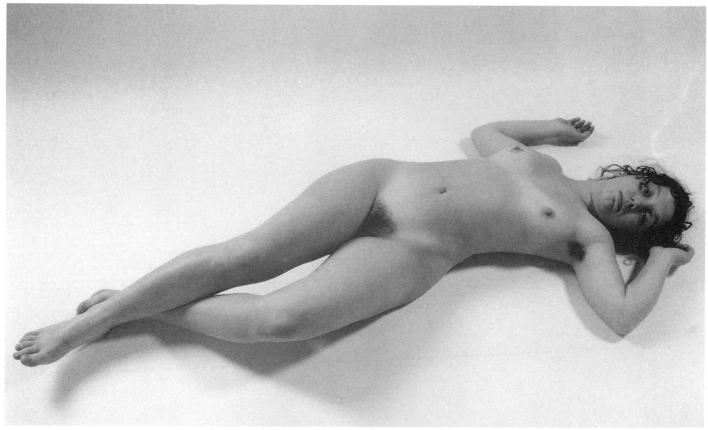

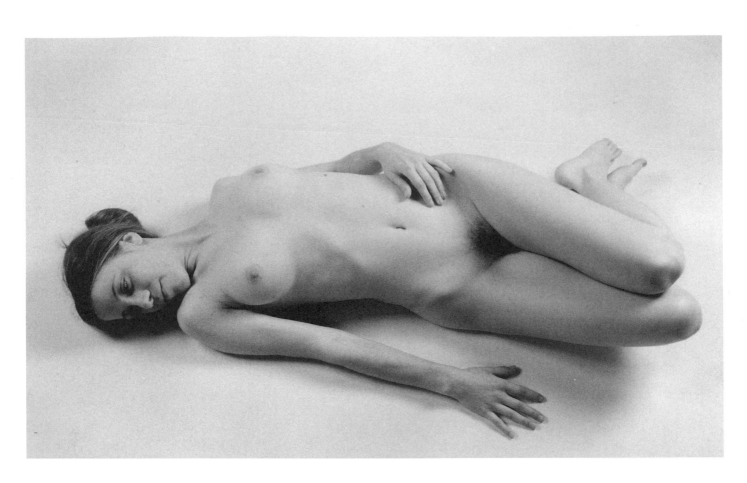

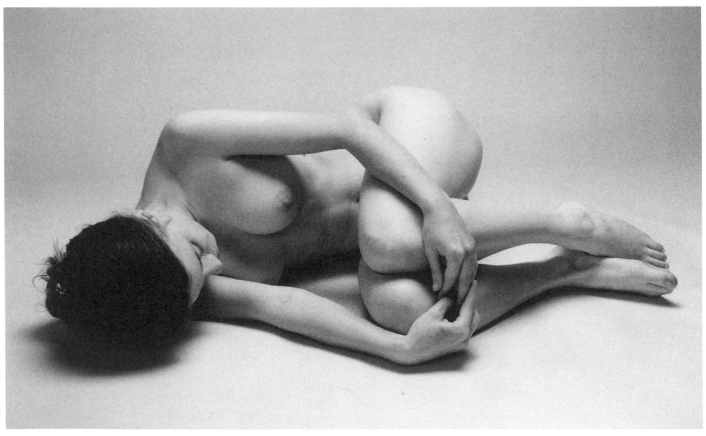

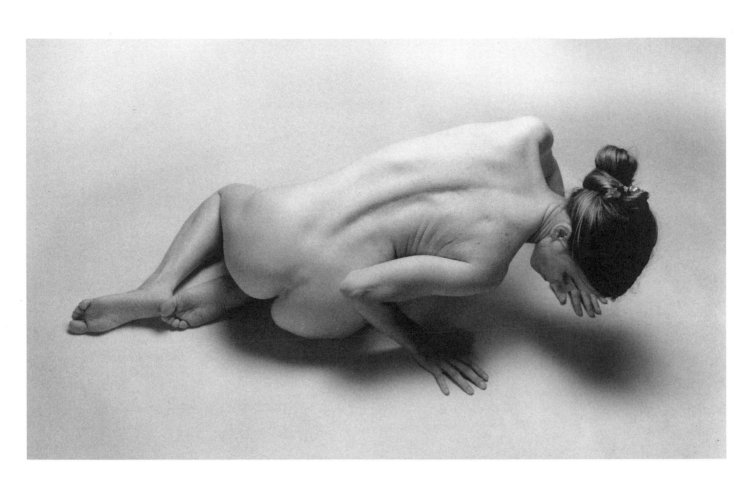

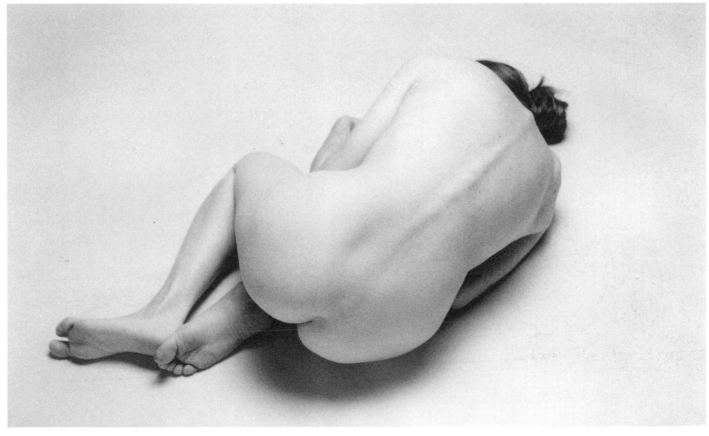

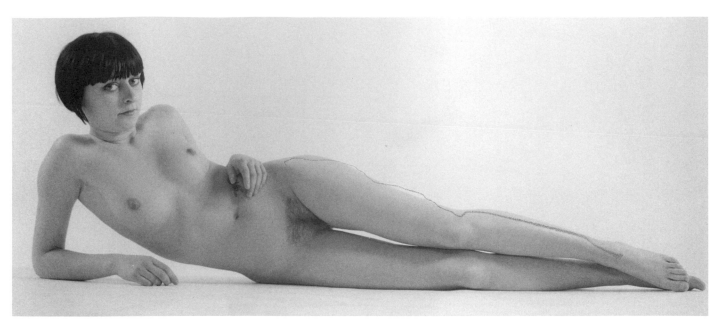

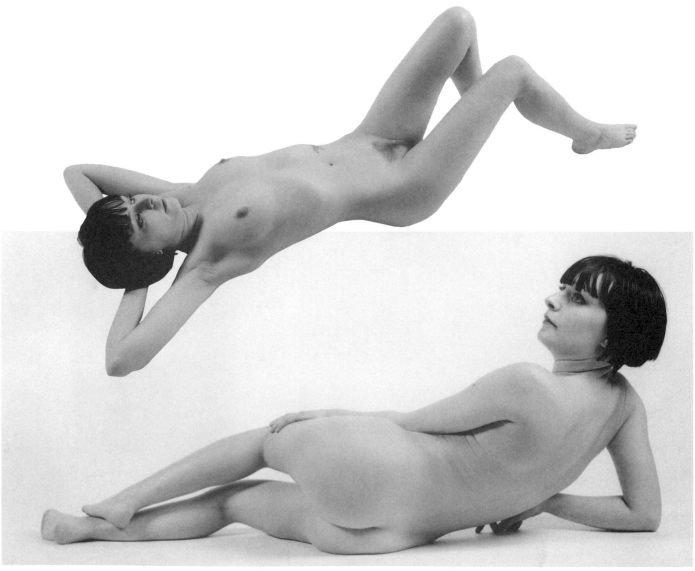

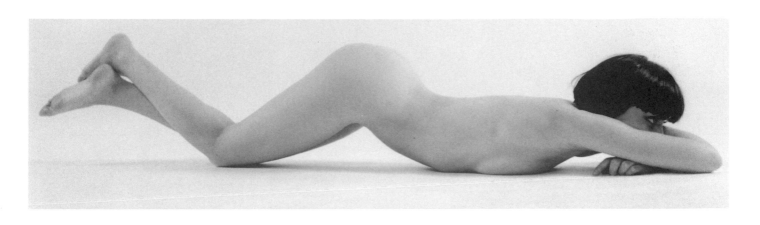

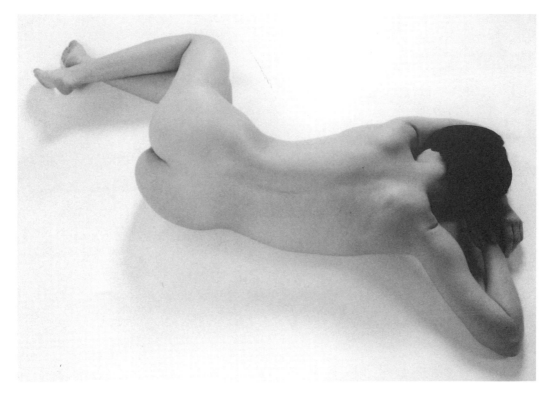

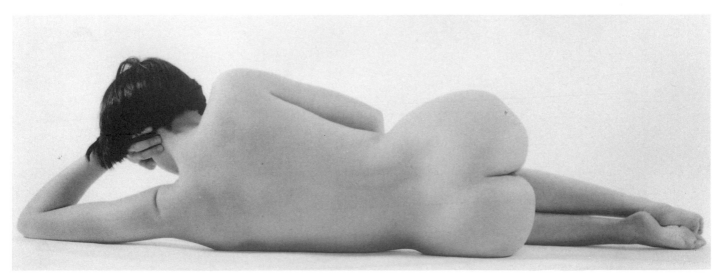

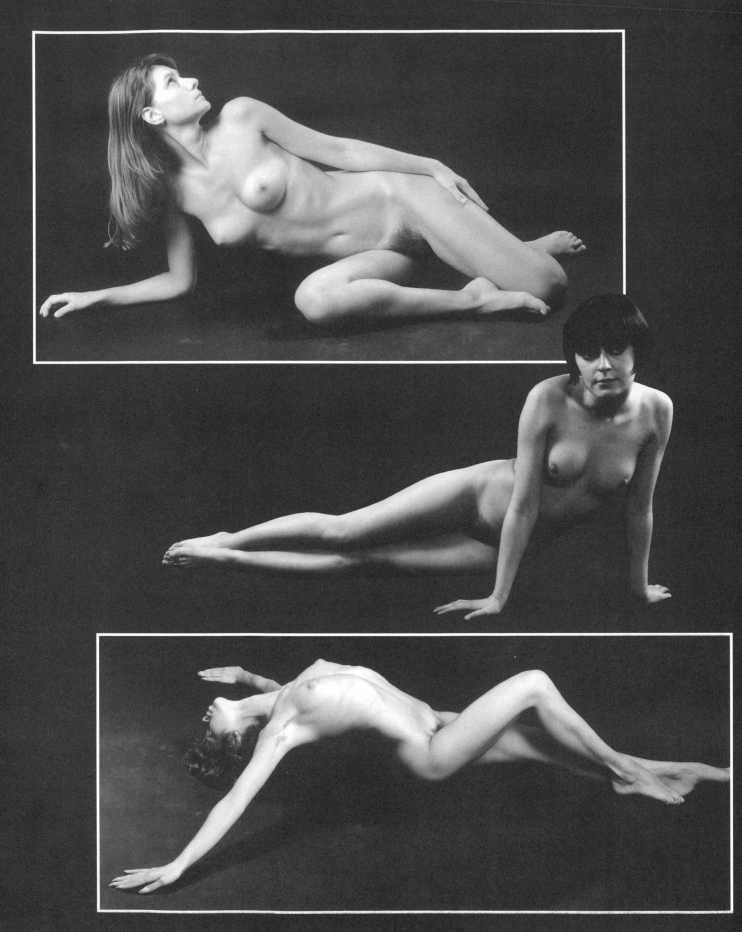

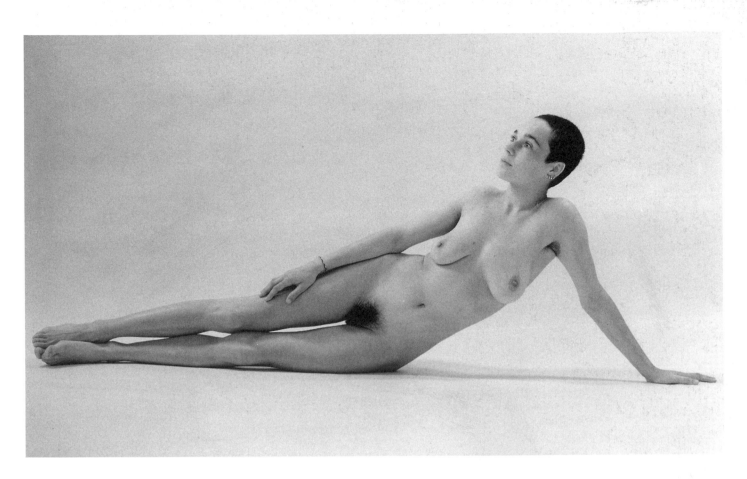

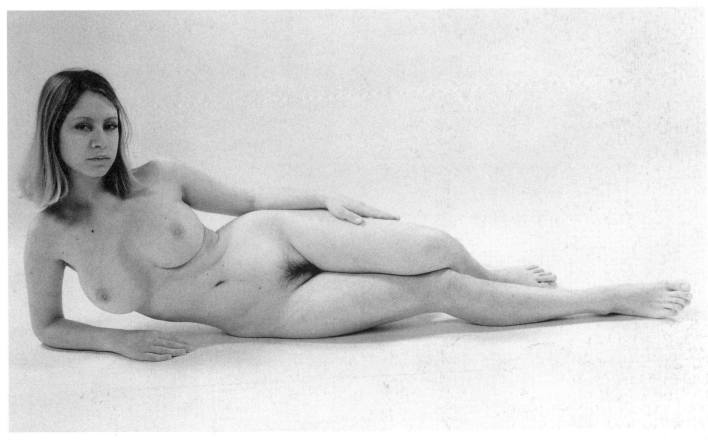

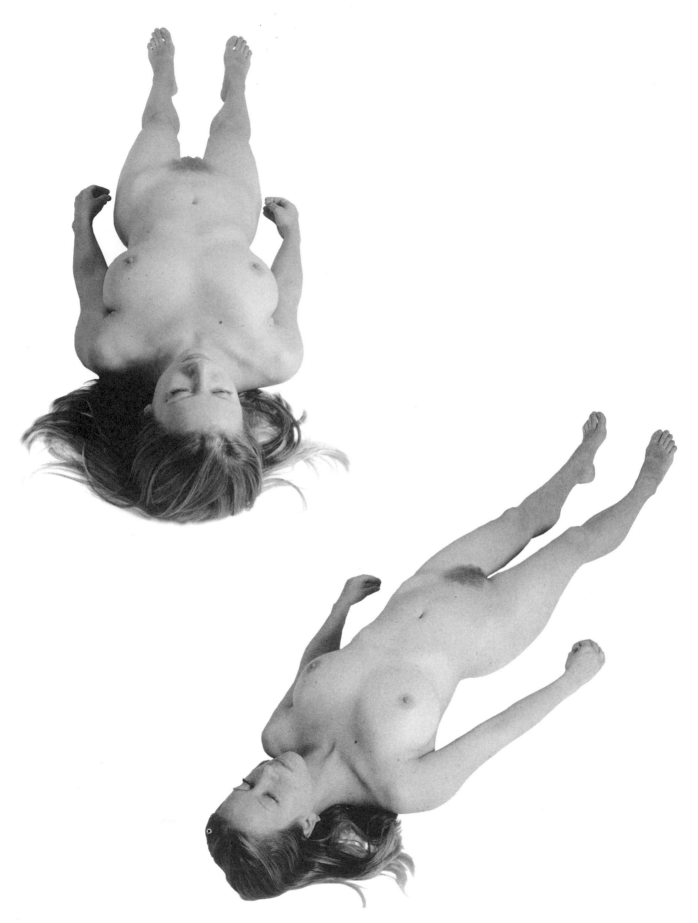

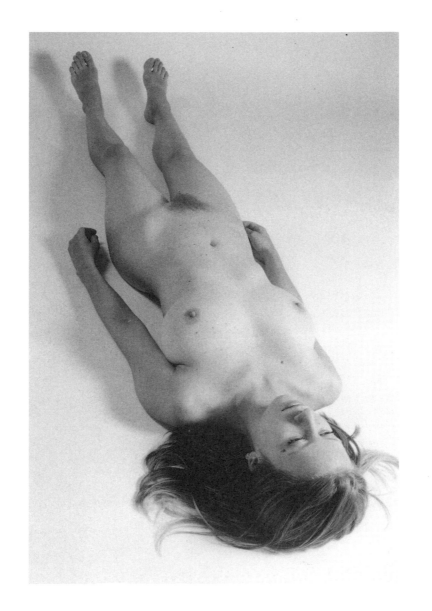

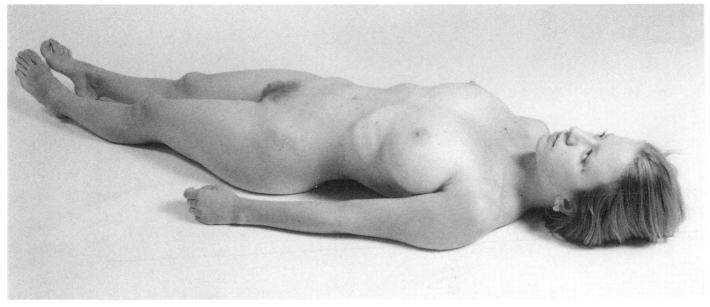

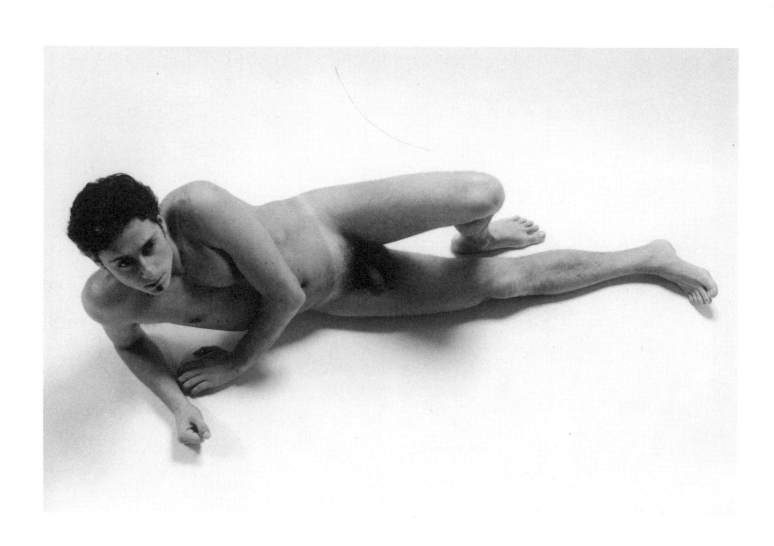

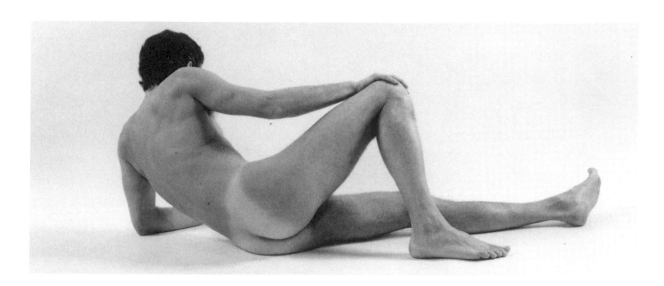

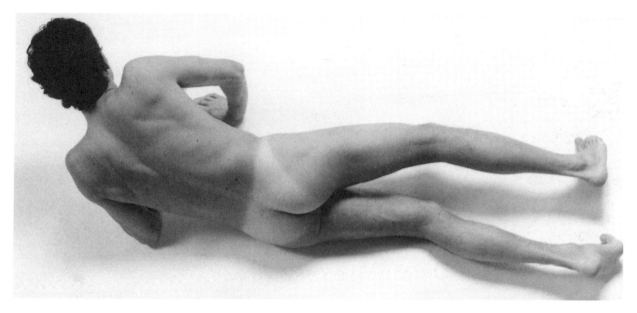

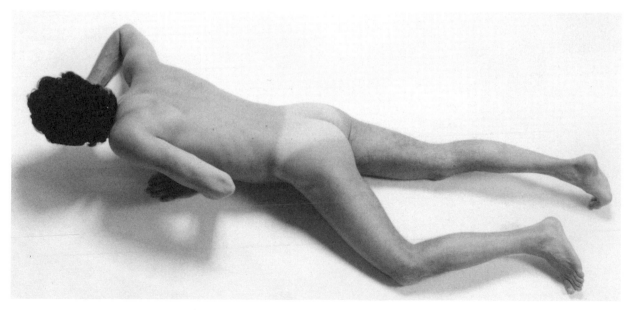

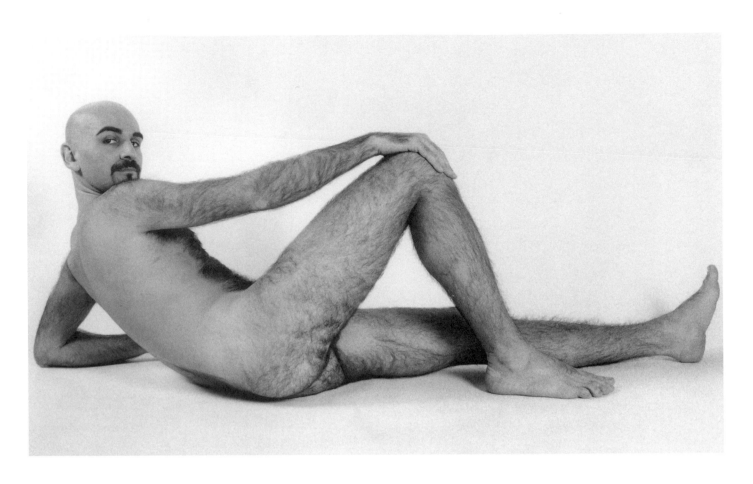

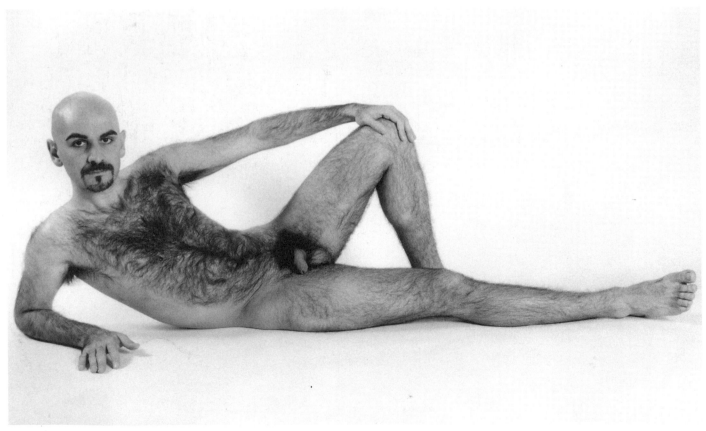

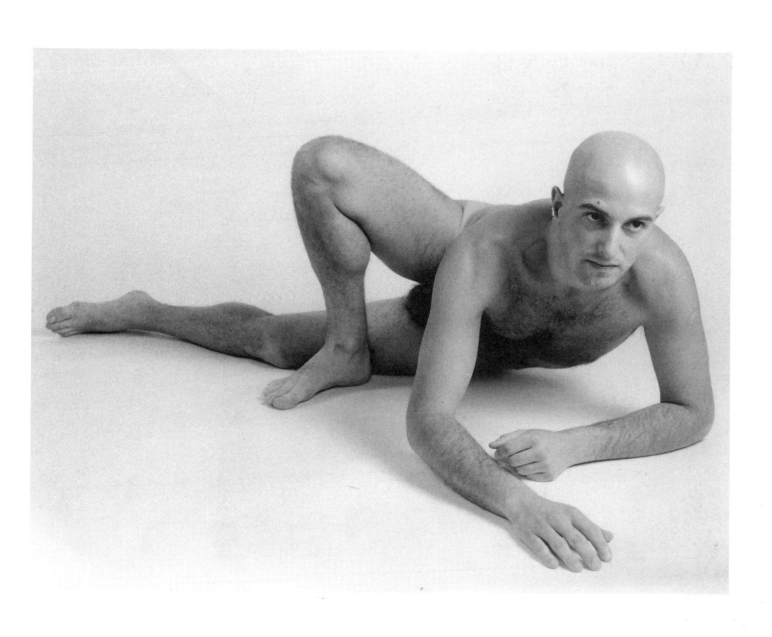

THE FIGURE ON A STOOL

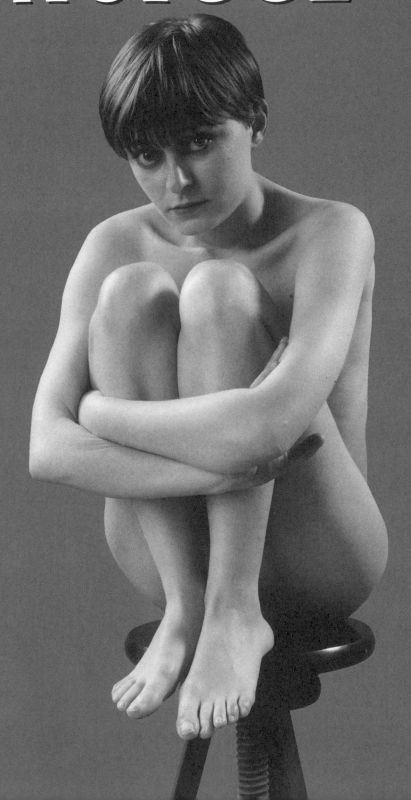

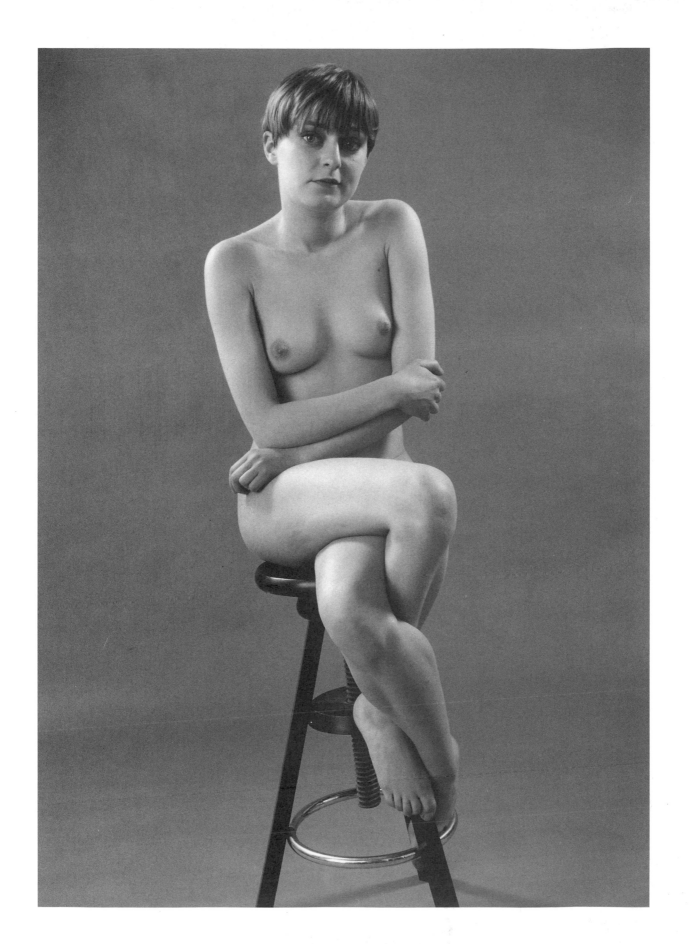

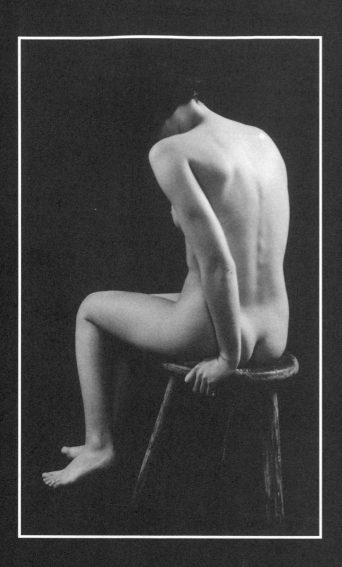

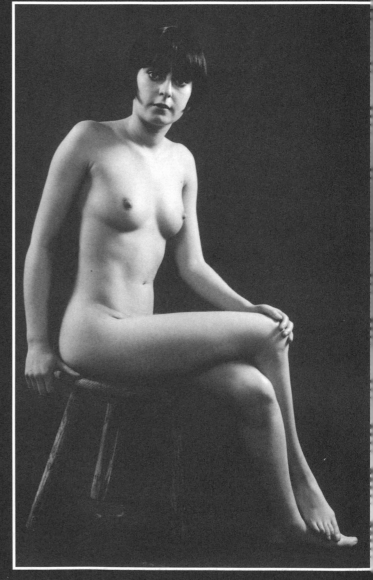

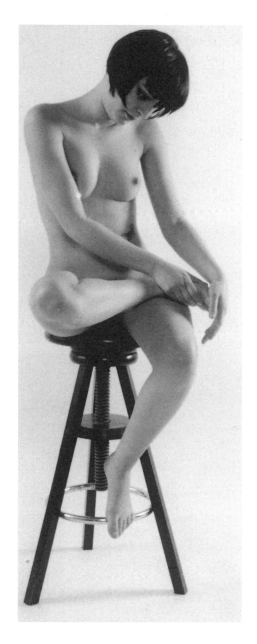
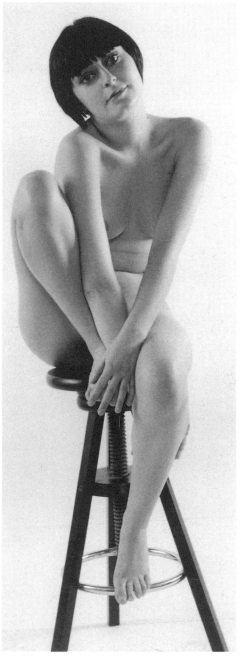
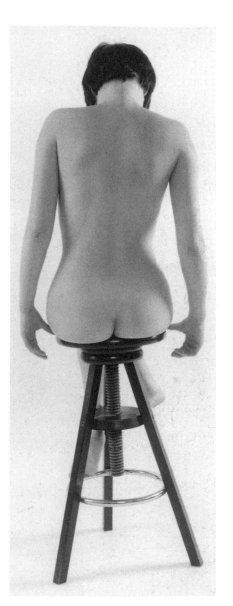

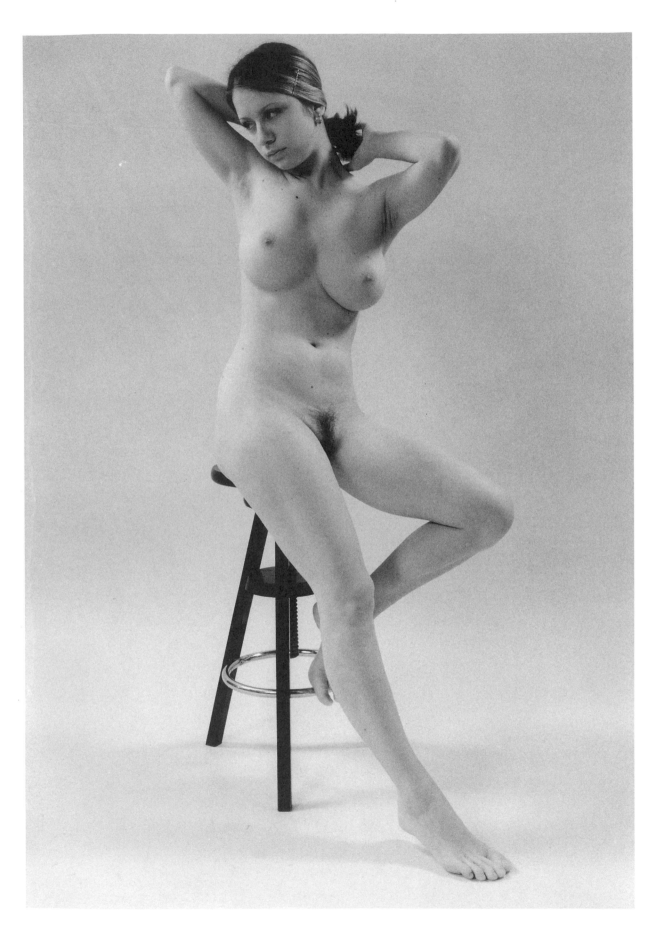

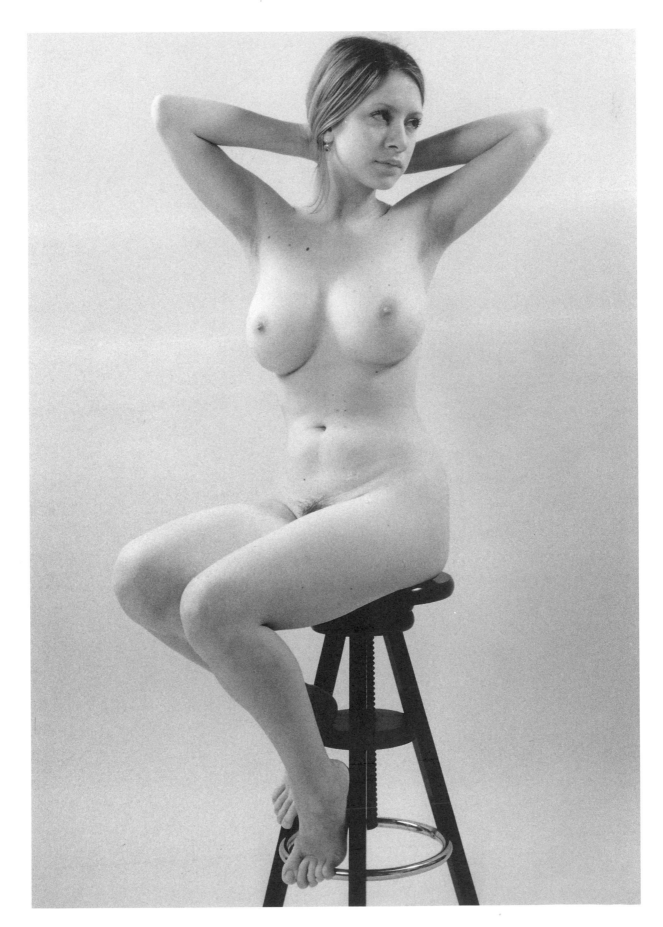

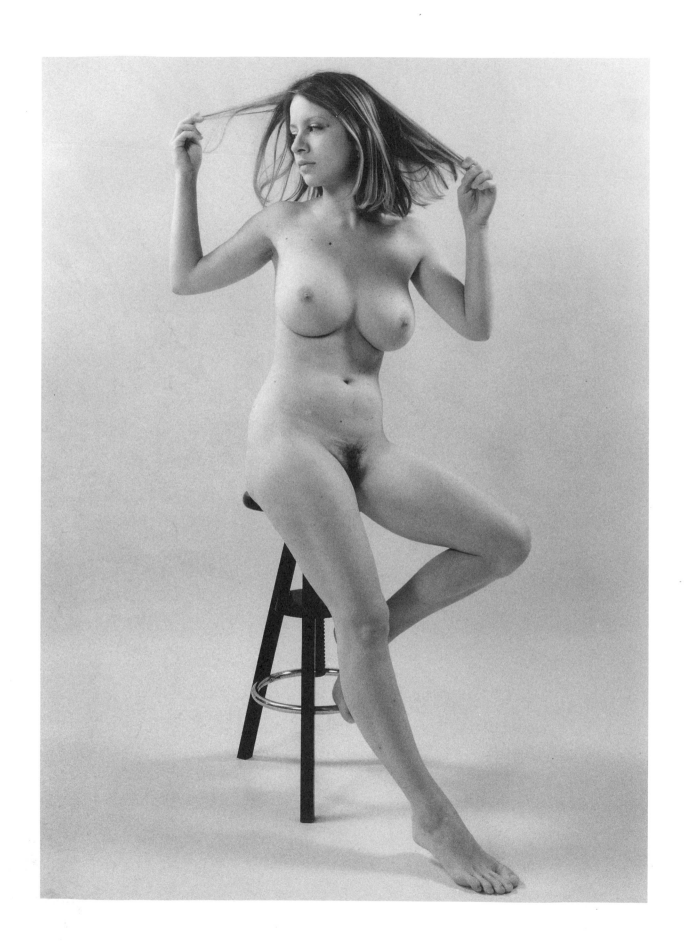

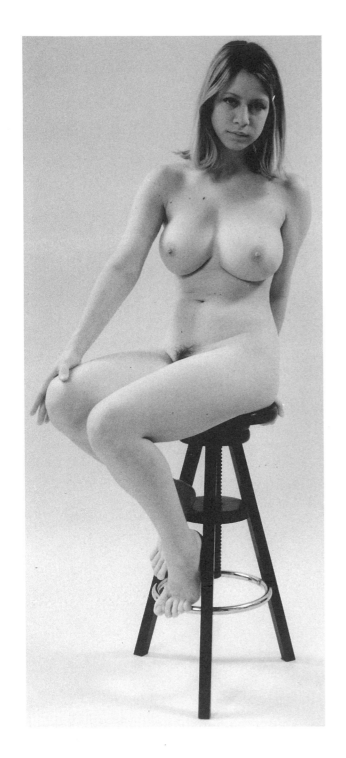
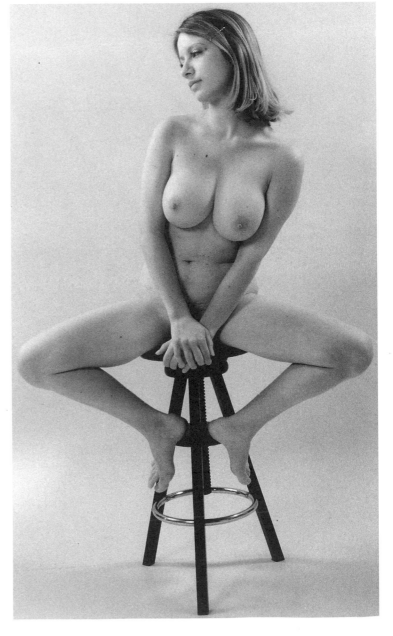

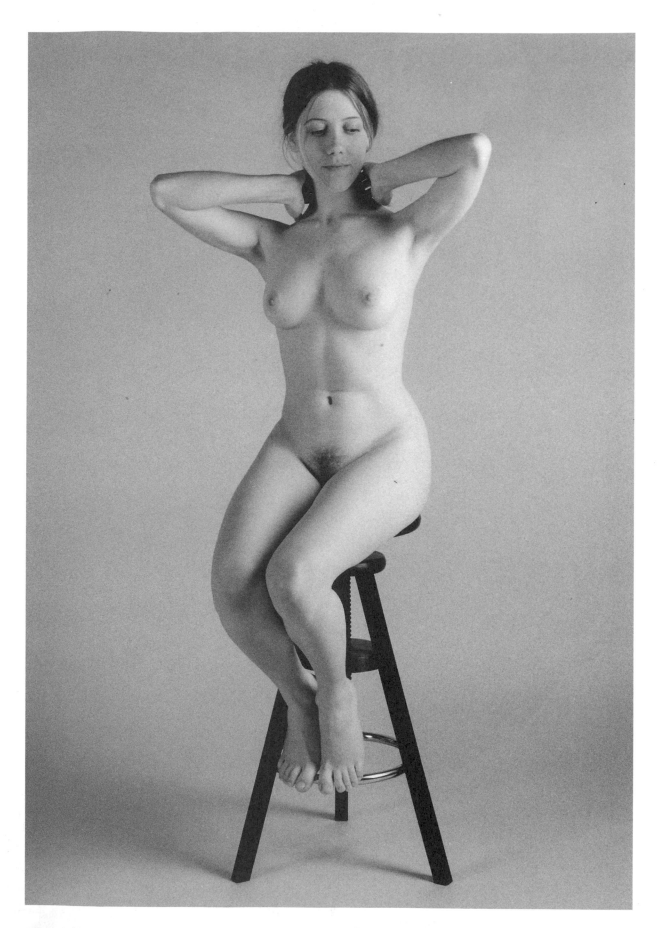

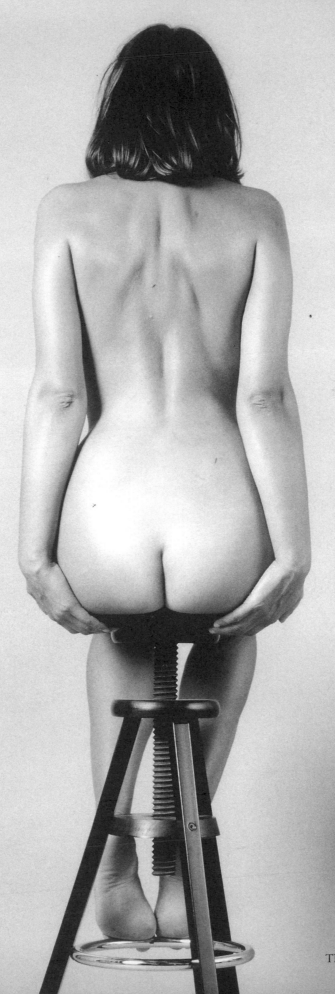

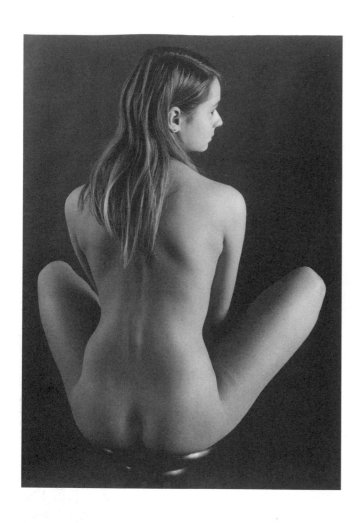

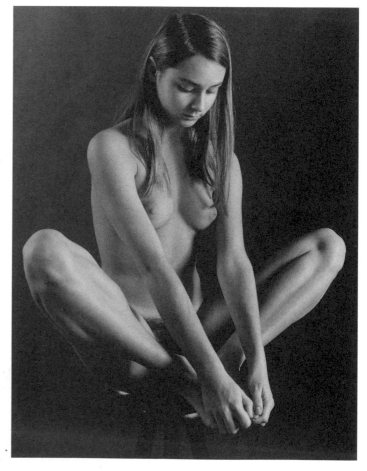

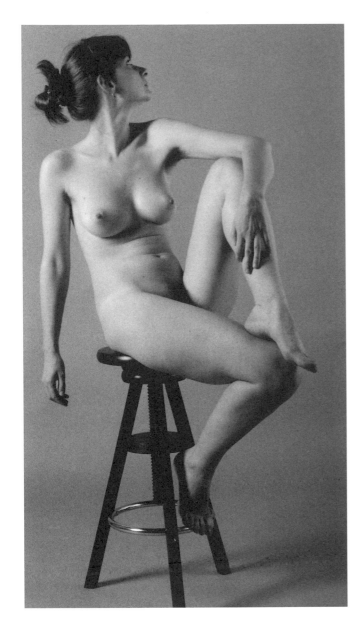

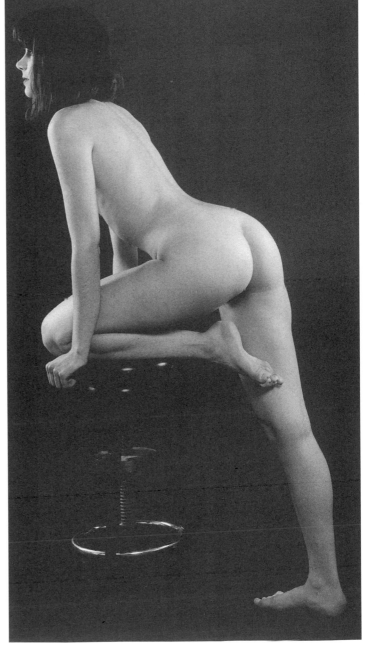

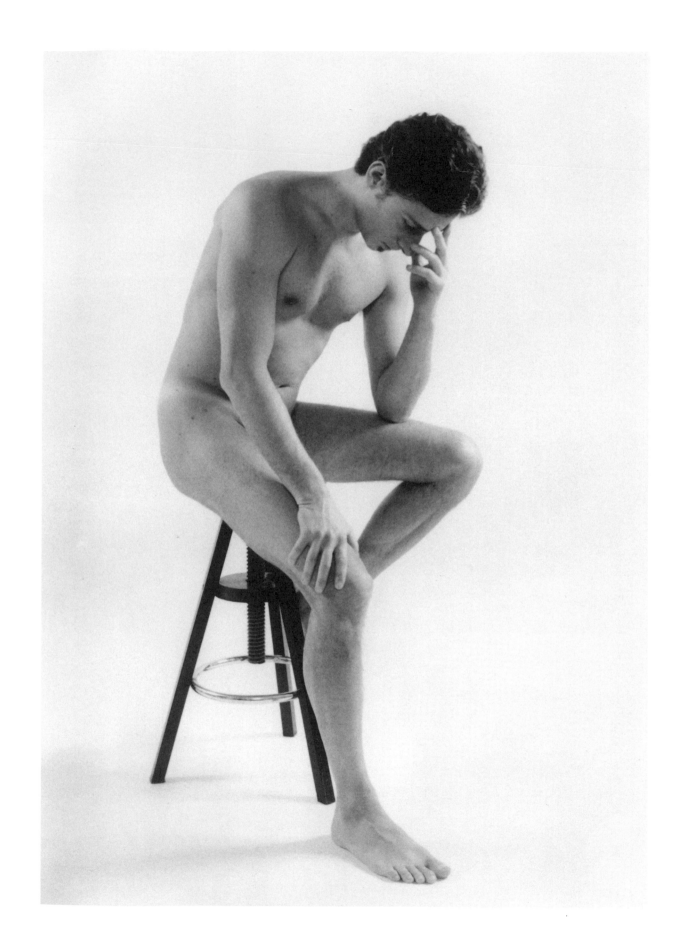

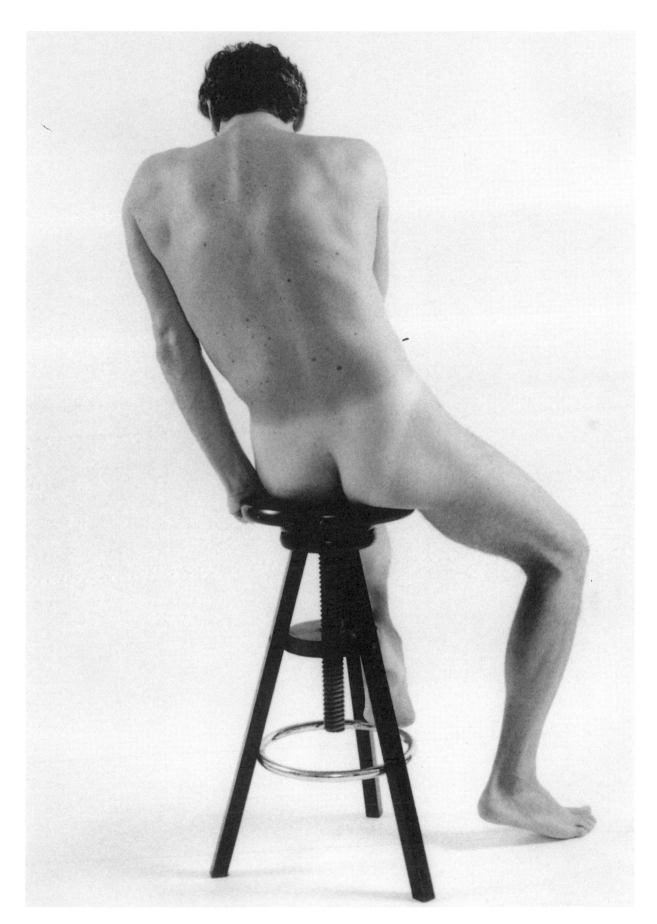

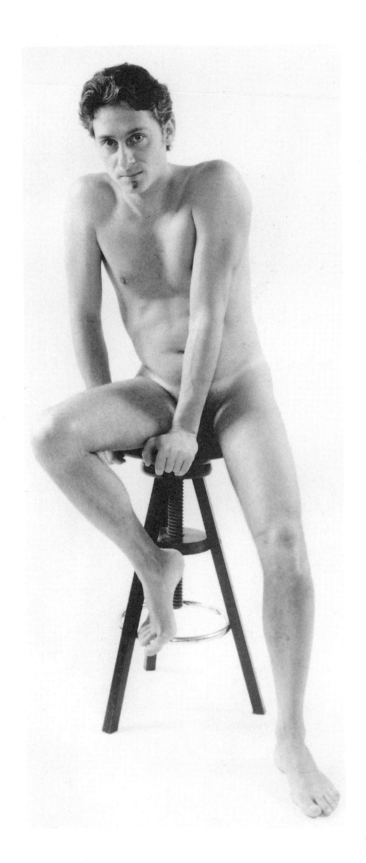
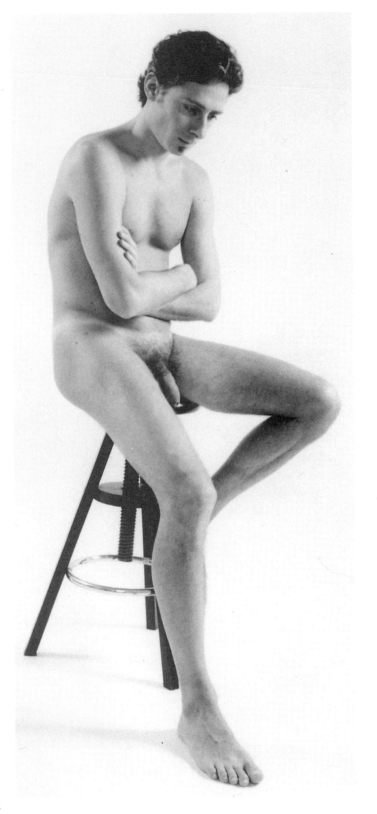

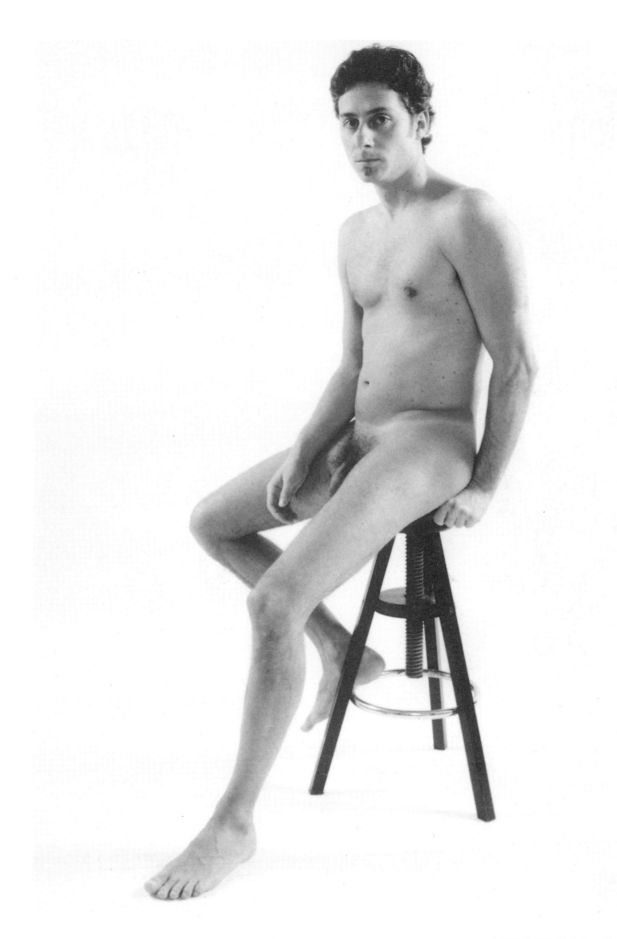

KNEELING POSES

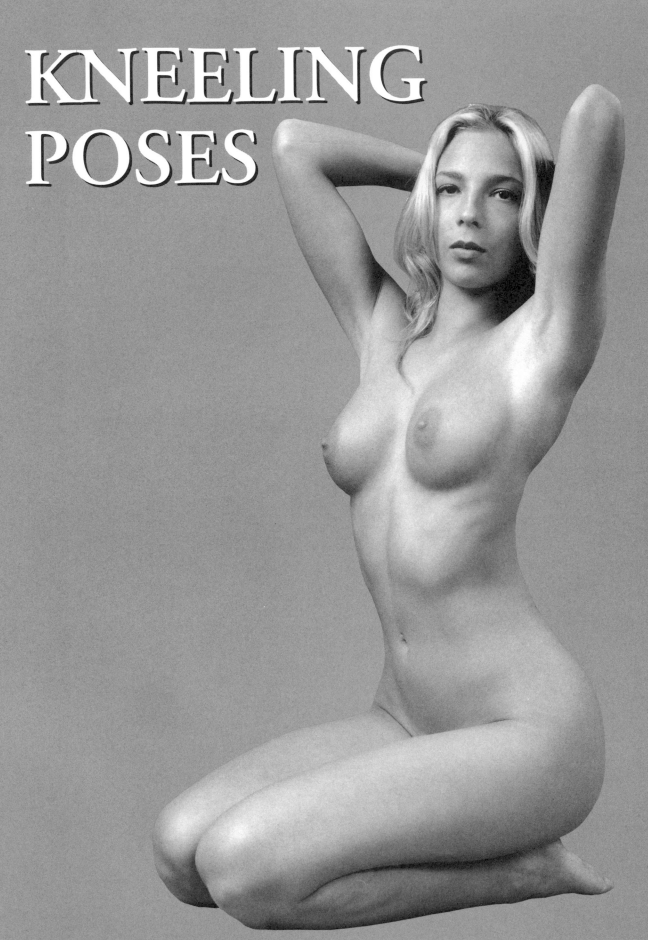

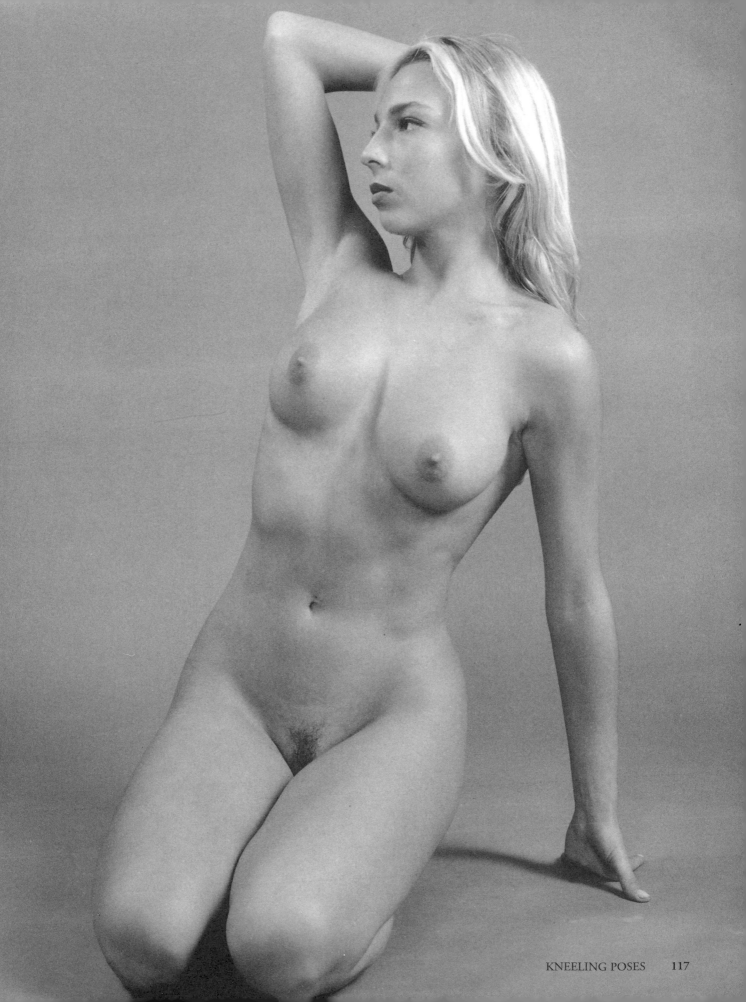

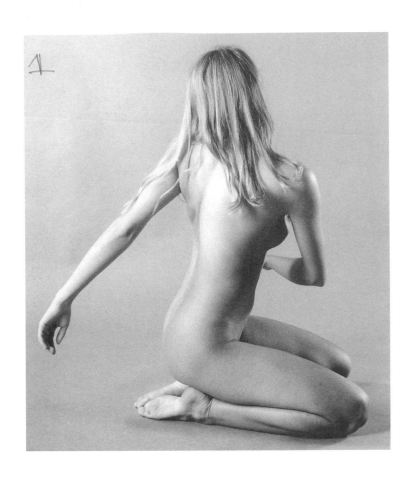

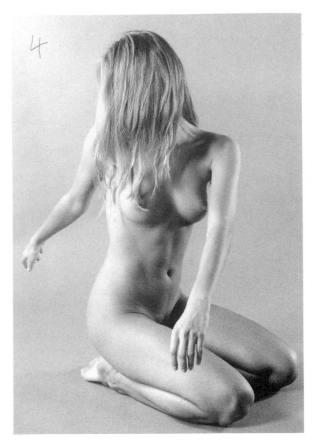

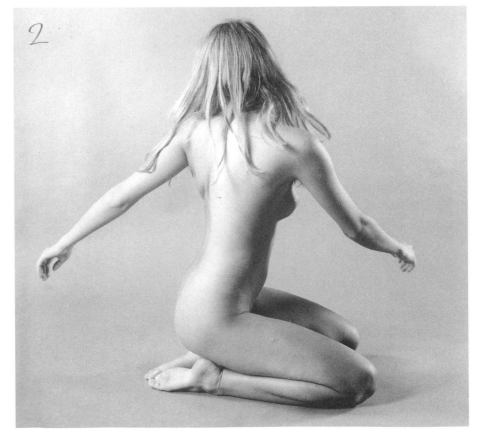

3

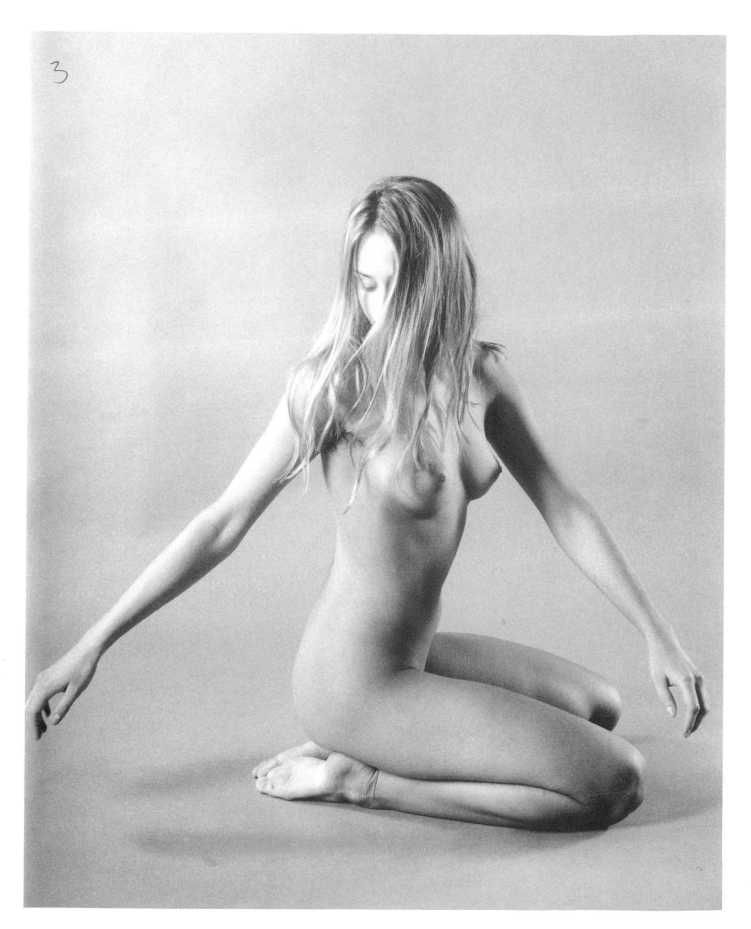

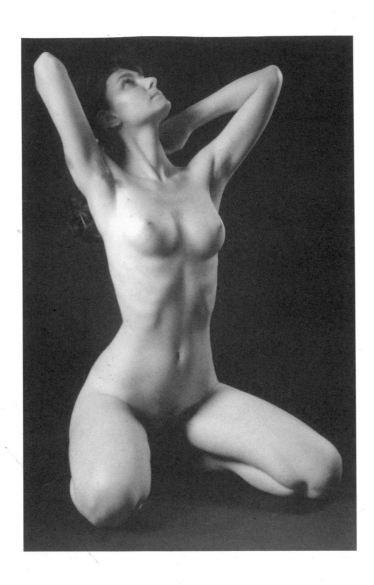

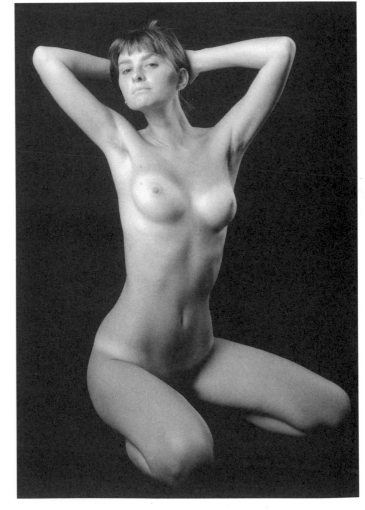

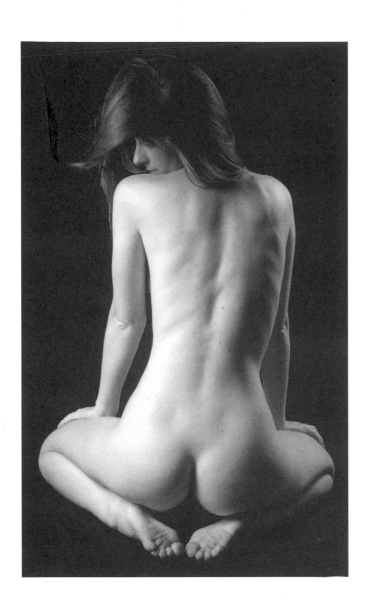

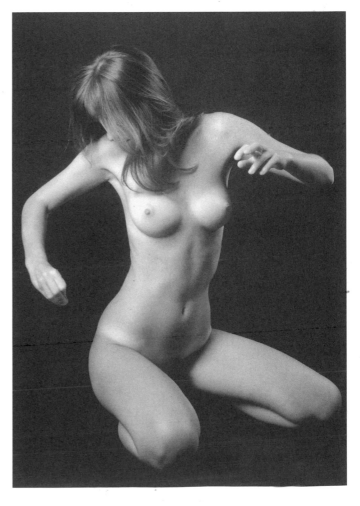

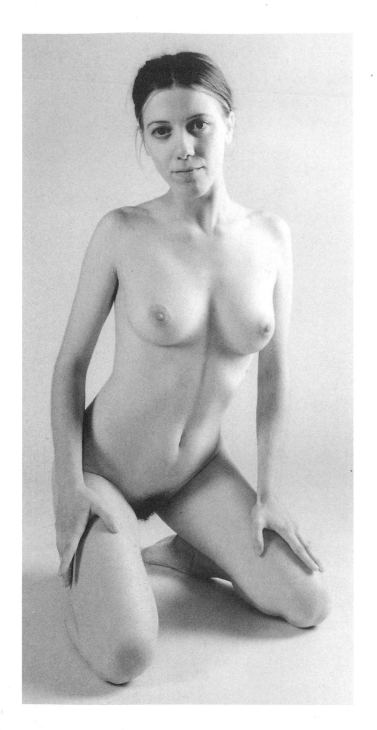

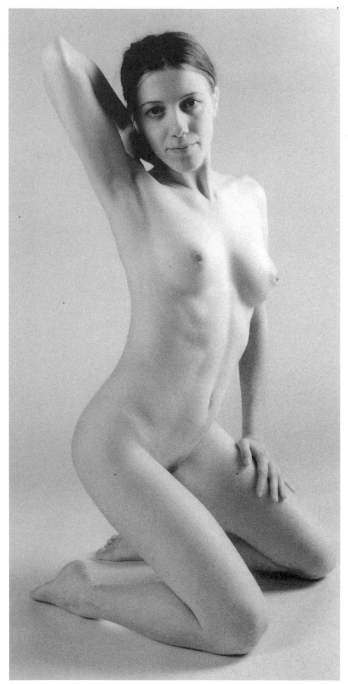

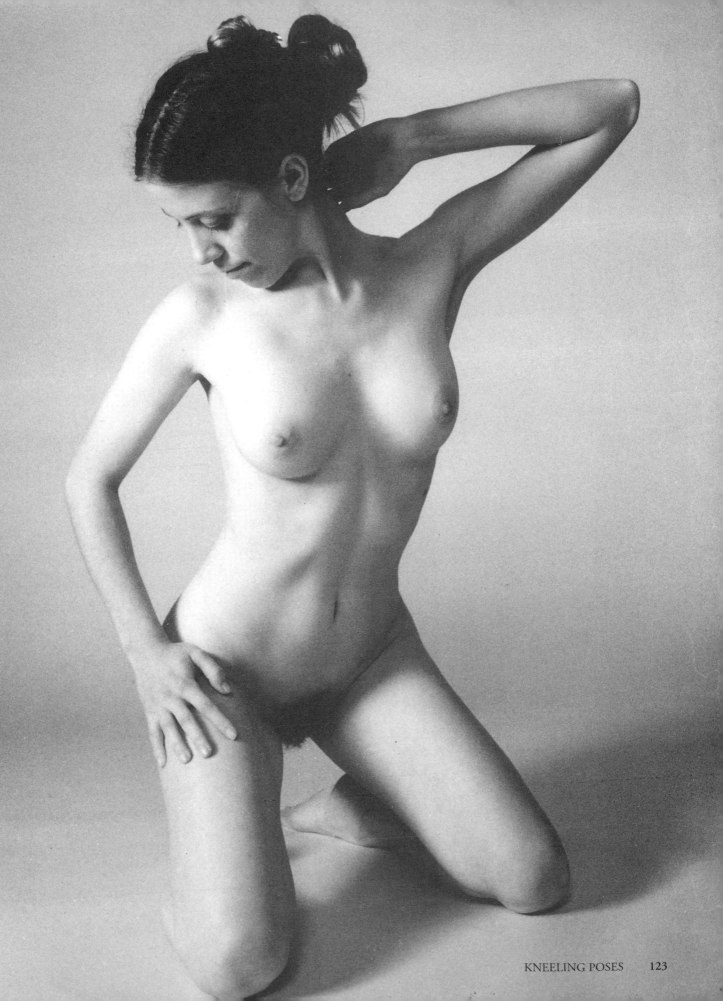

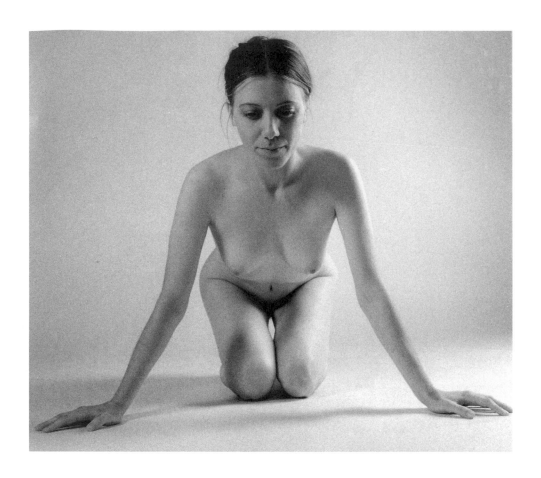

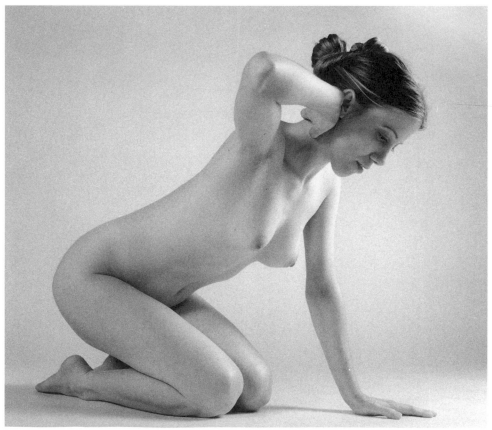

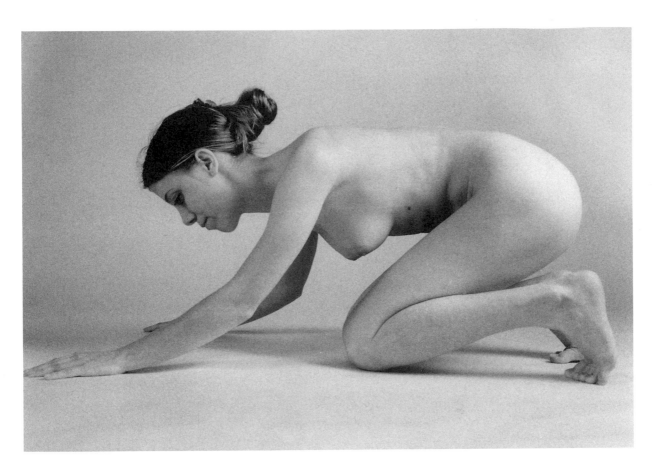

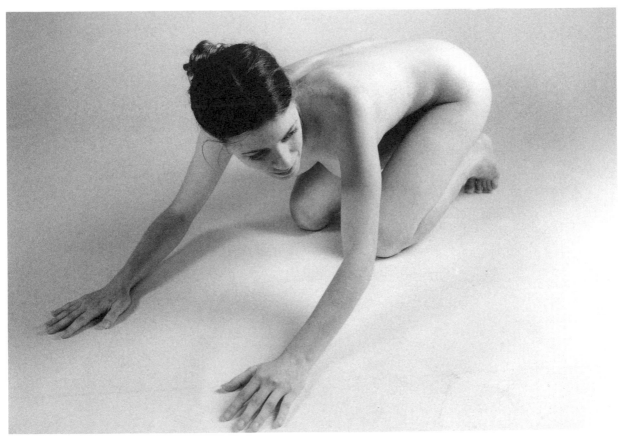

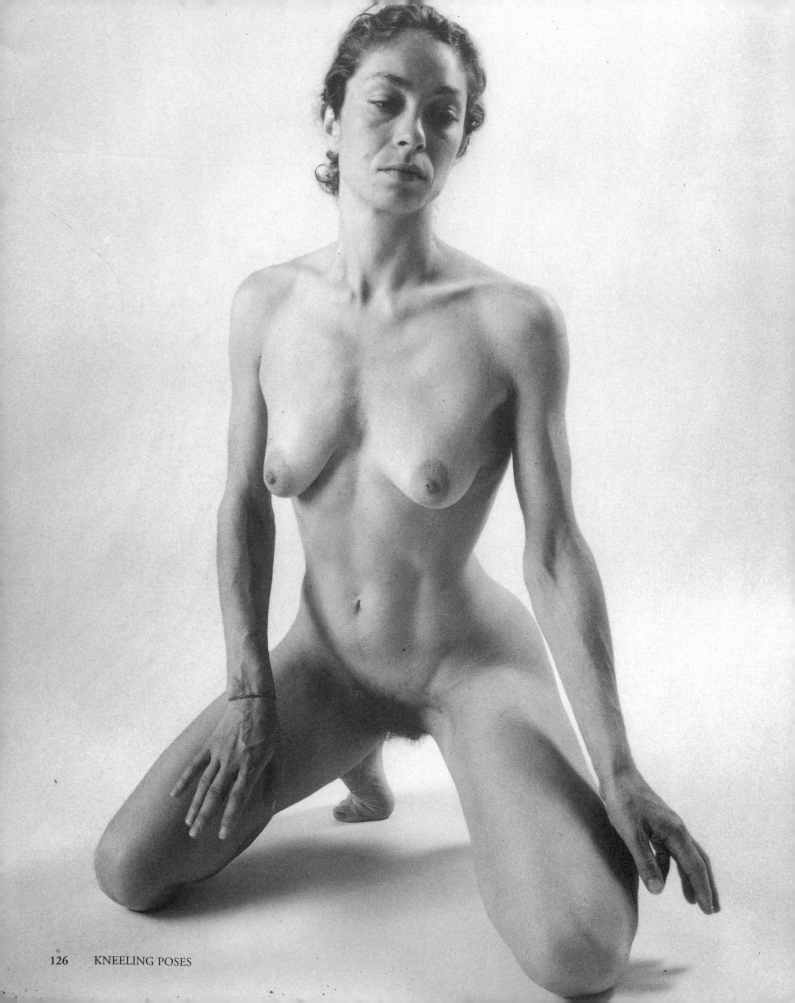

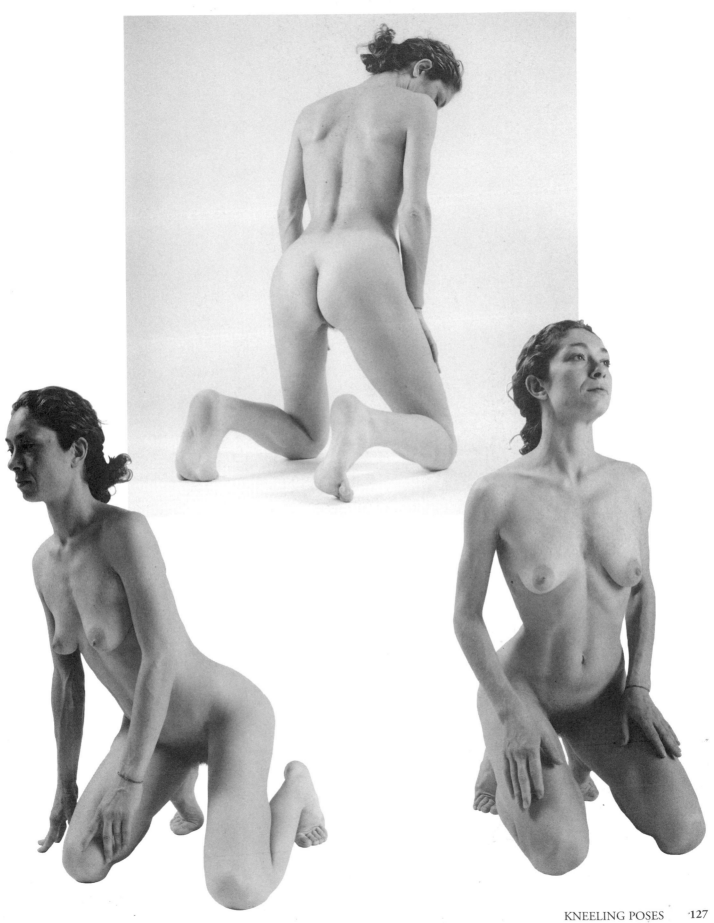

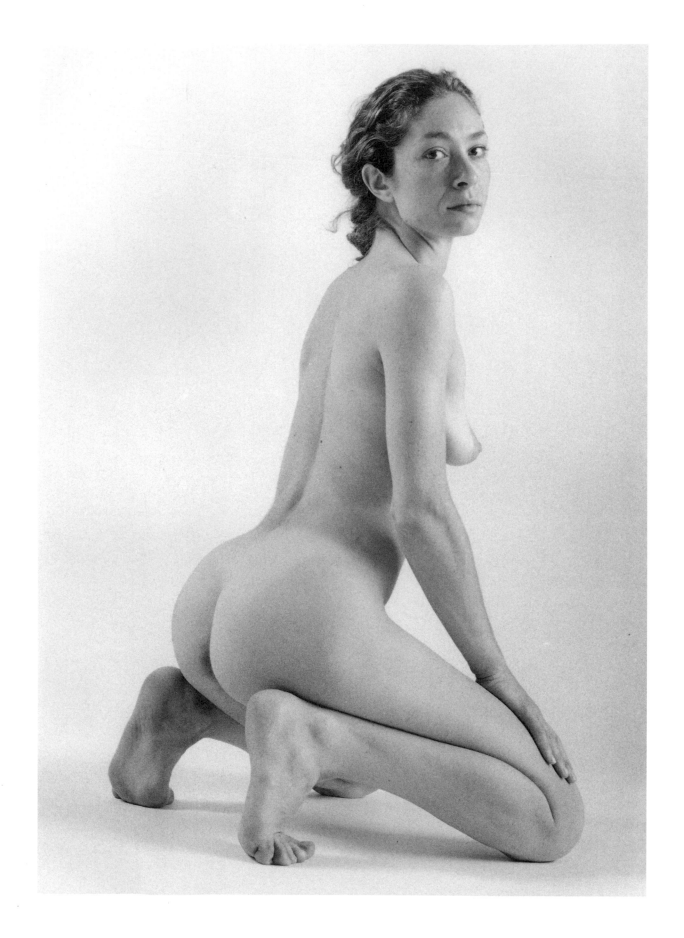

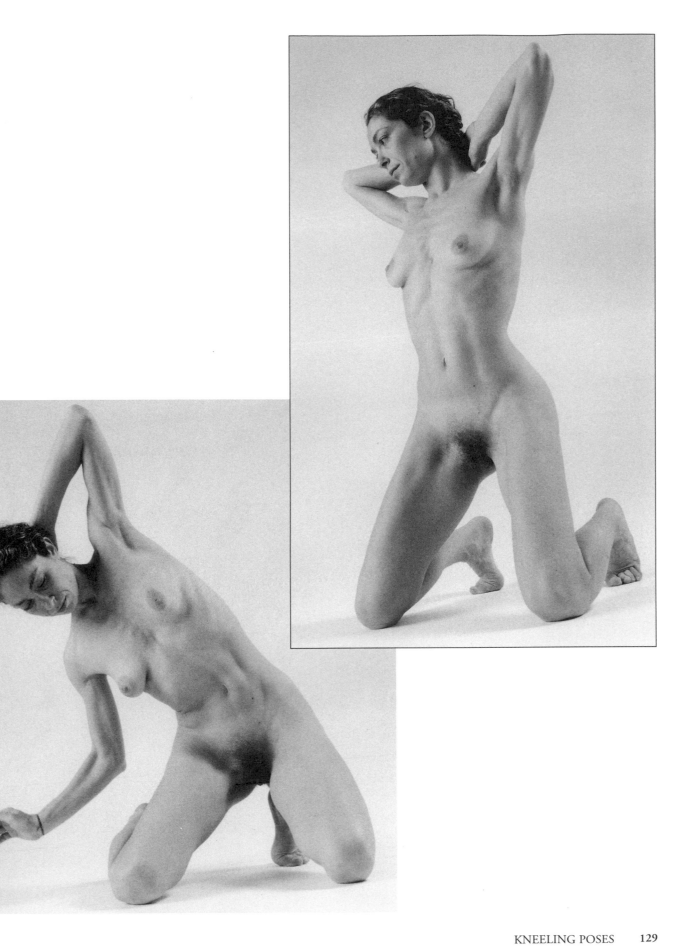

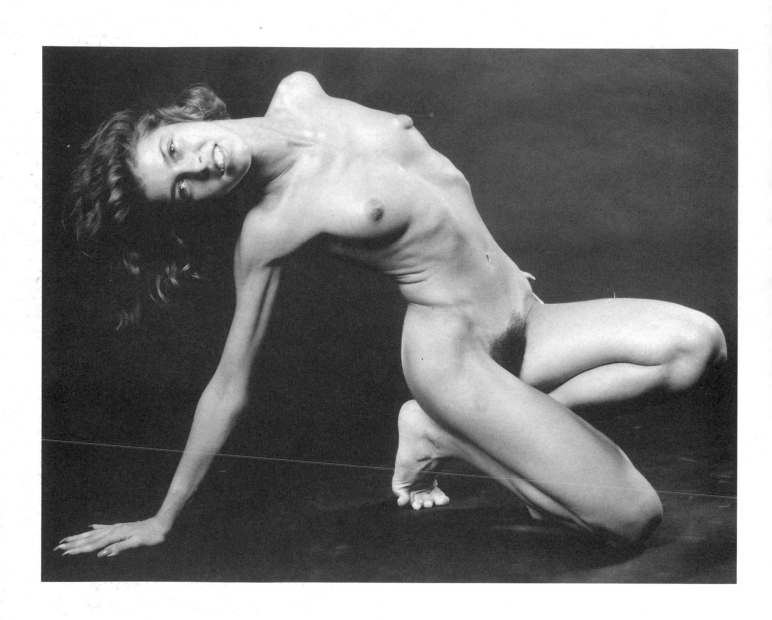

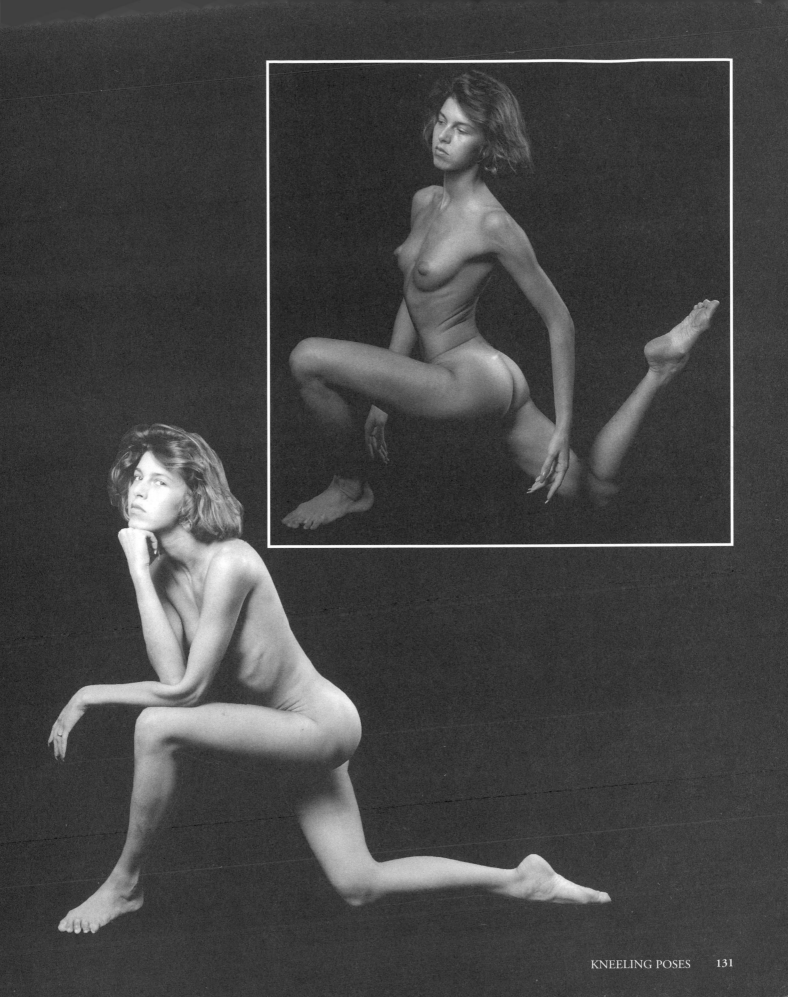

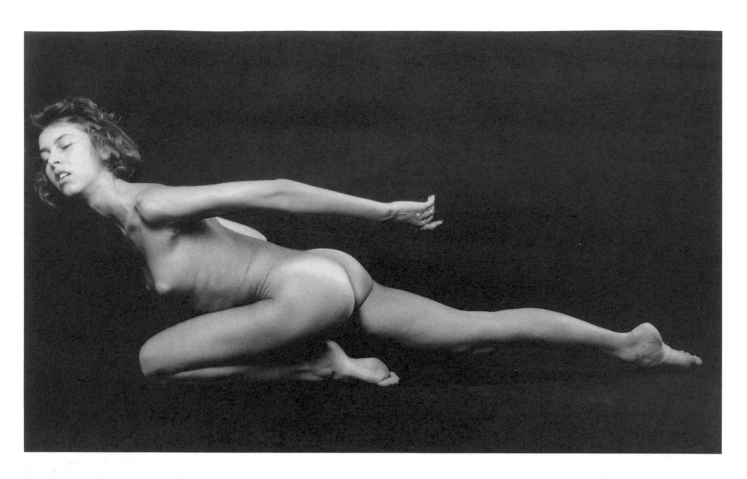

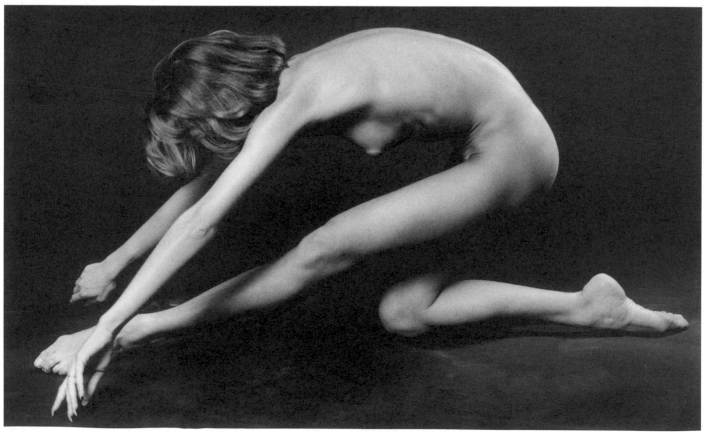

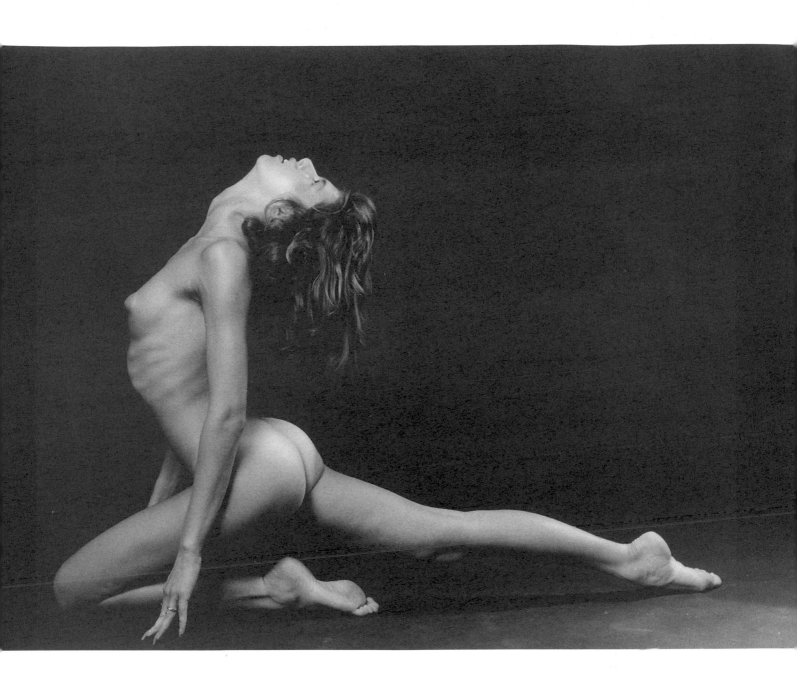

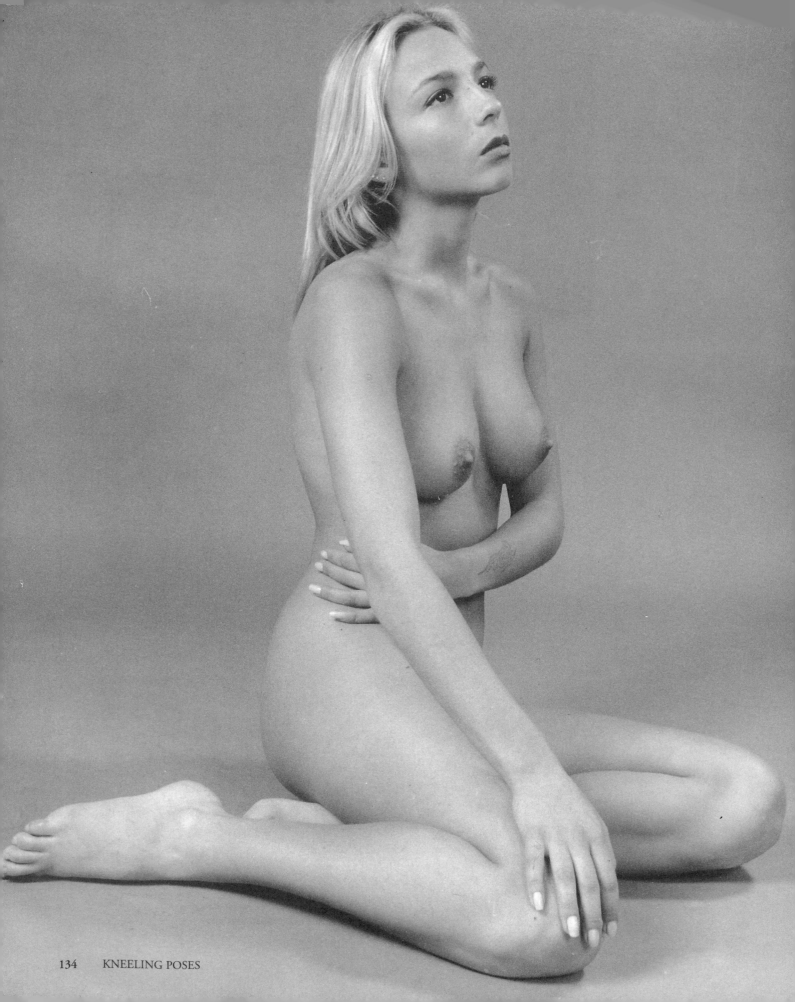

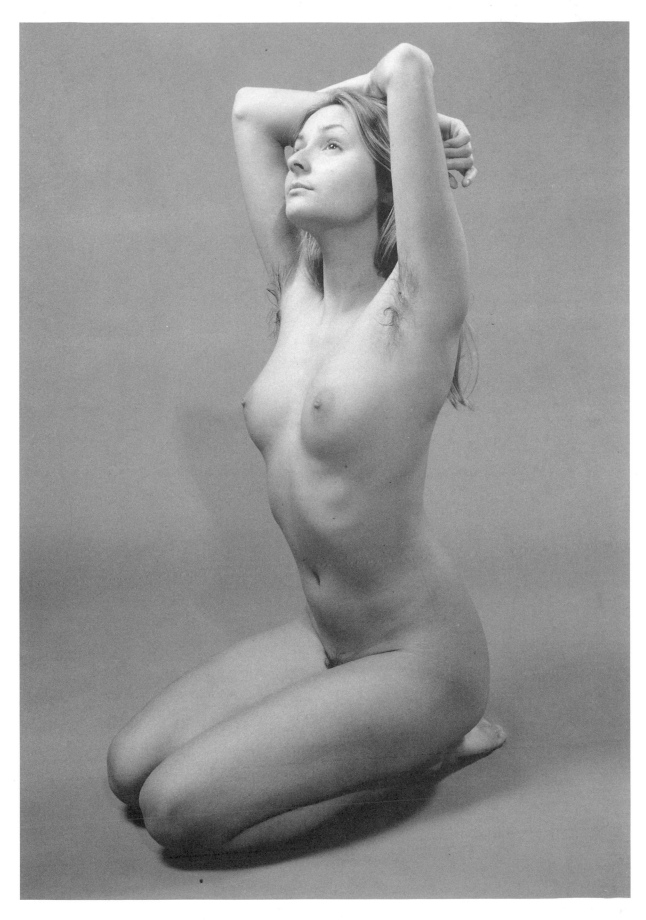

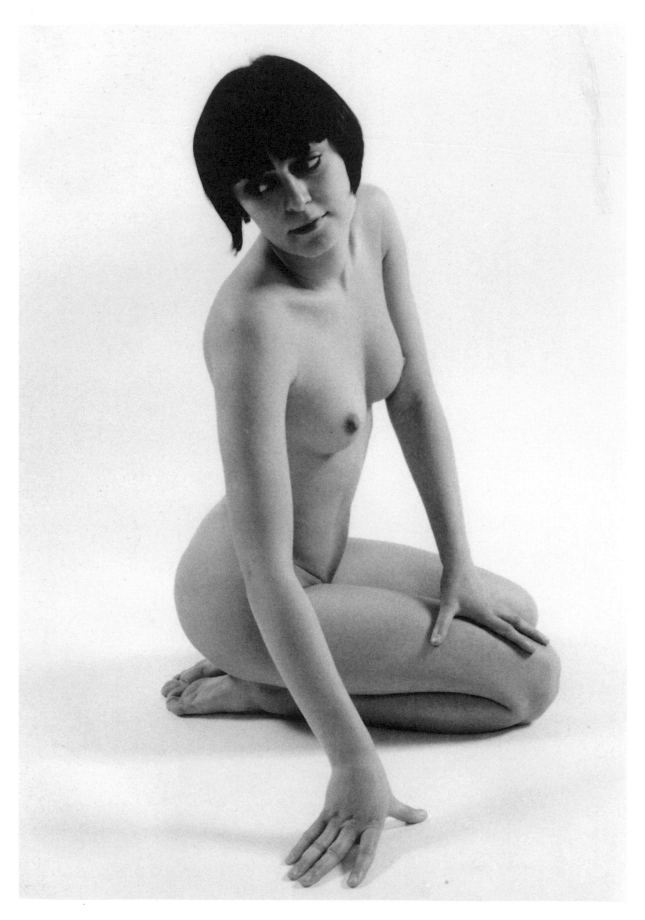

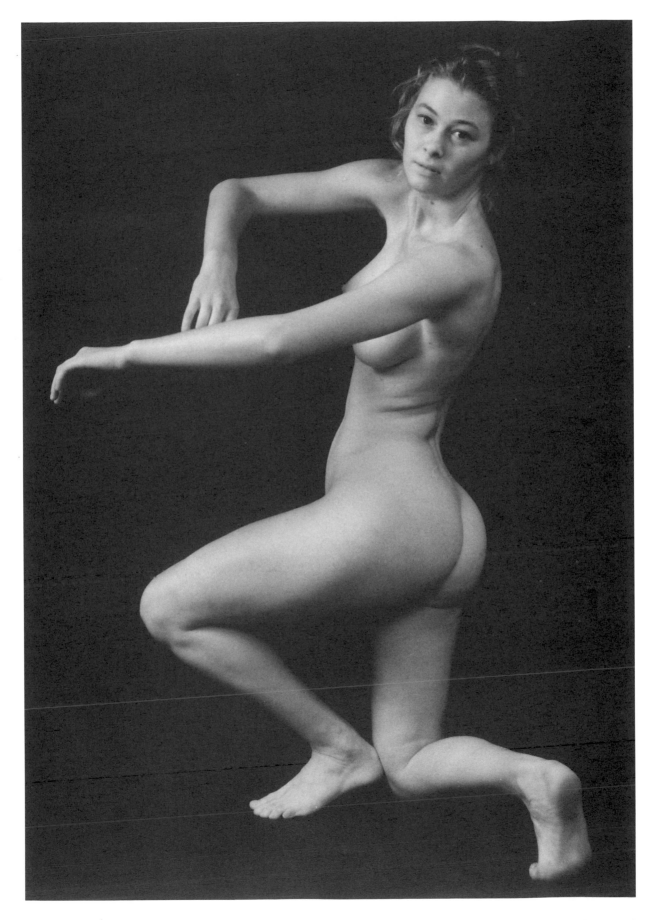

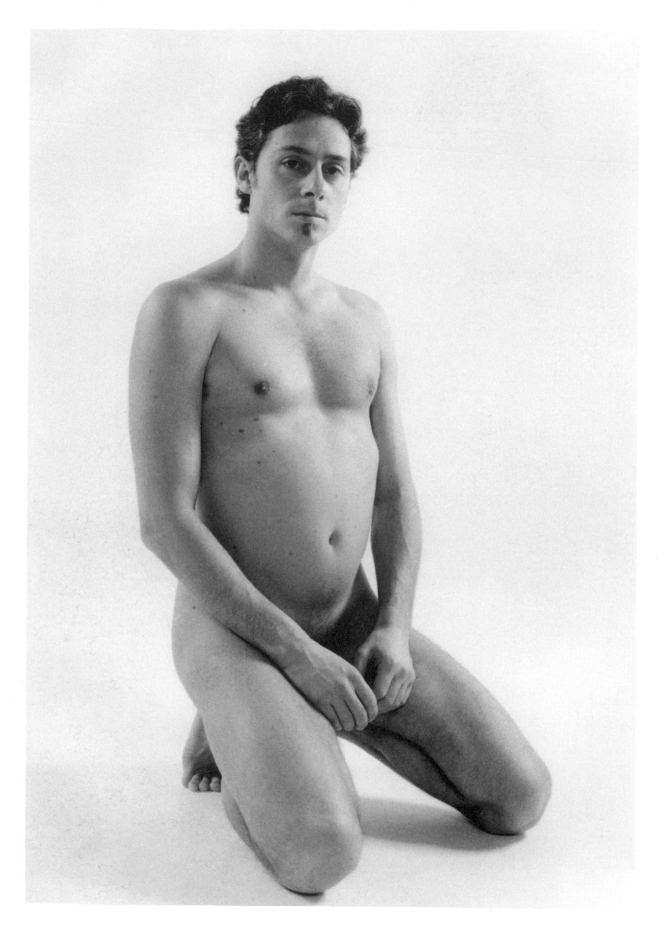

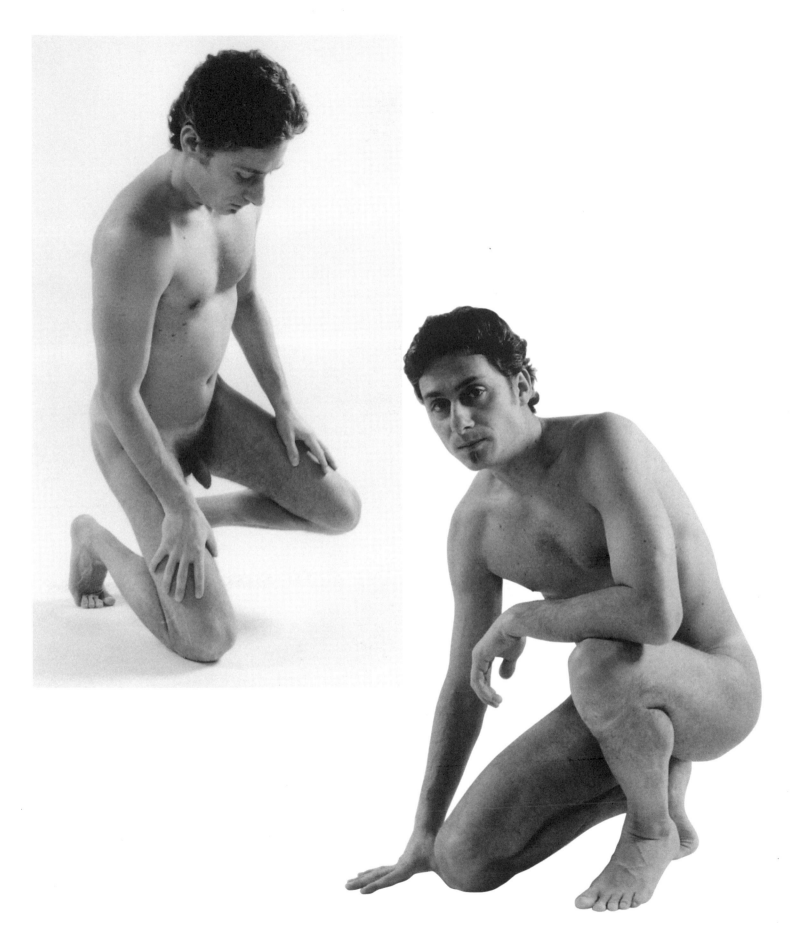

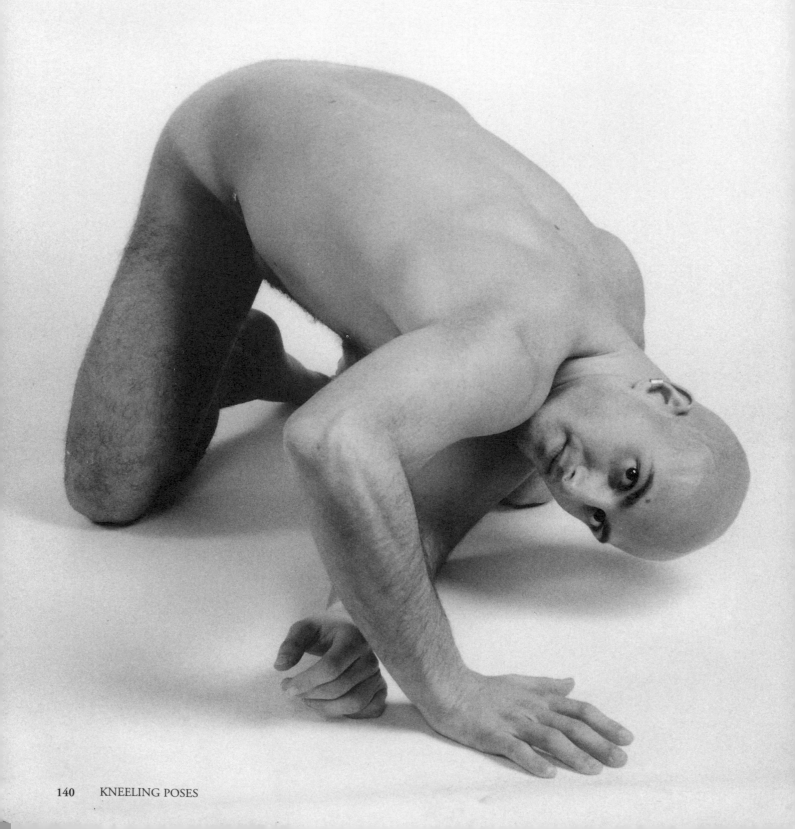

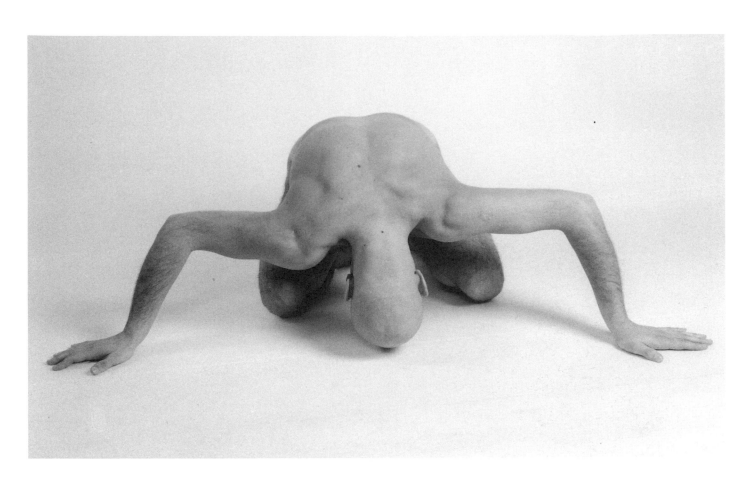

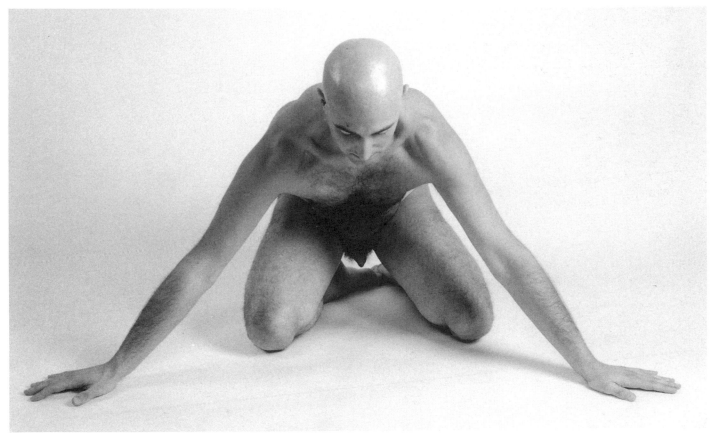

BENDING POSES

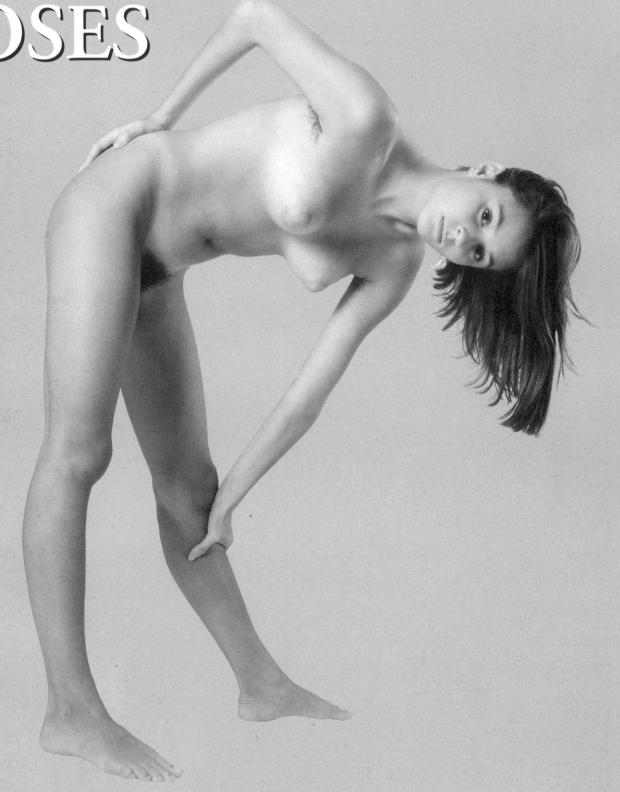

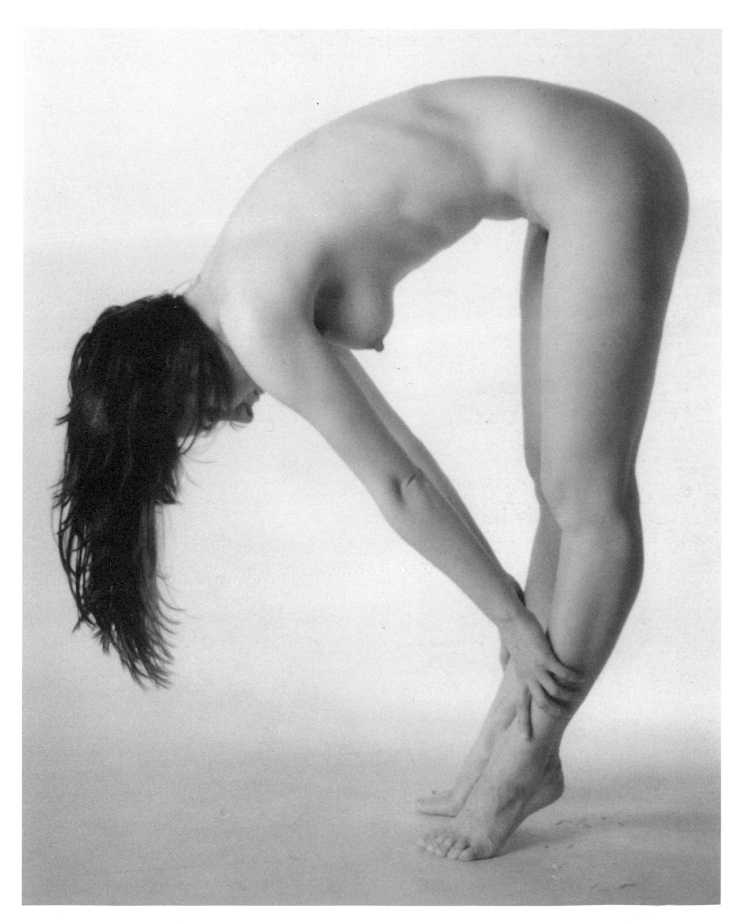

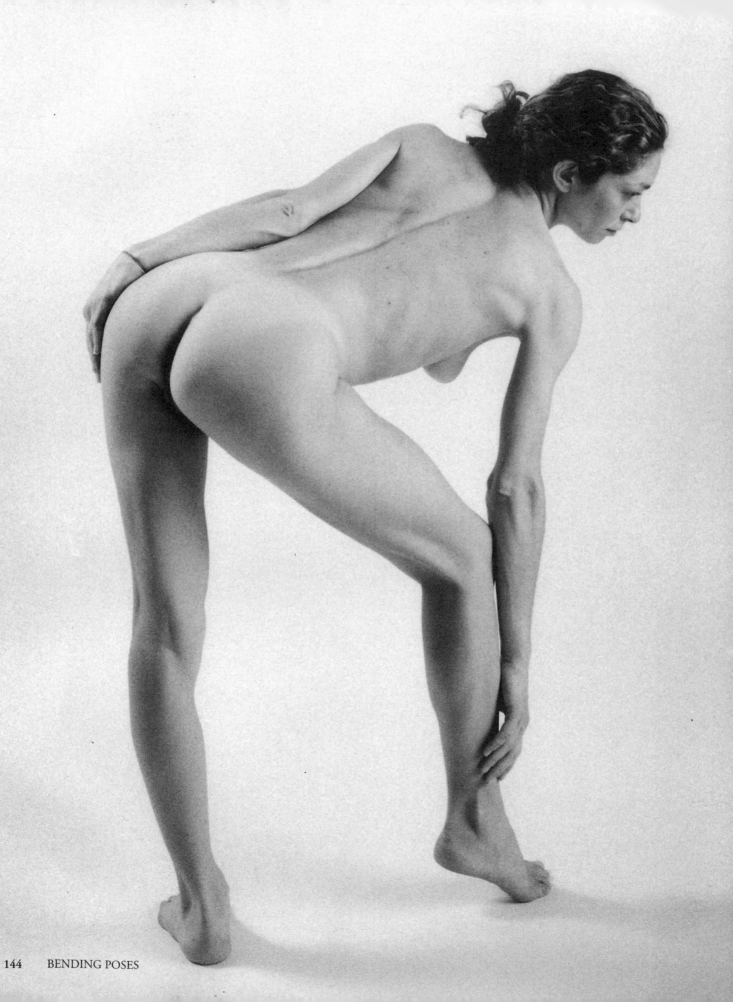

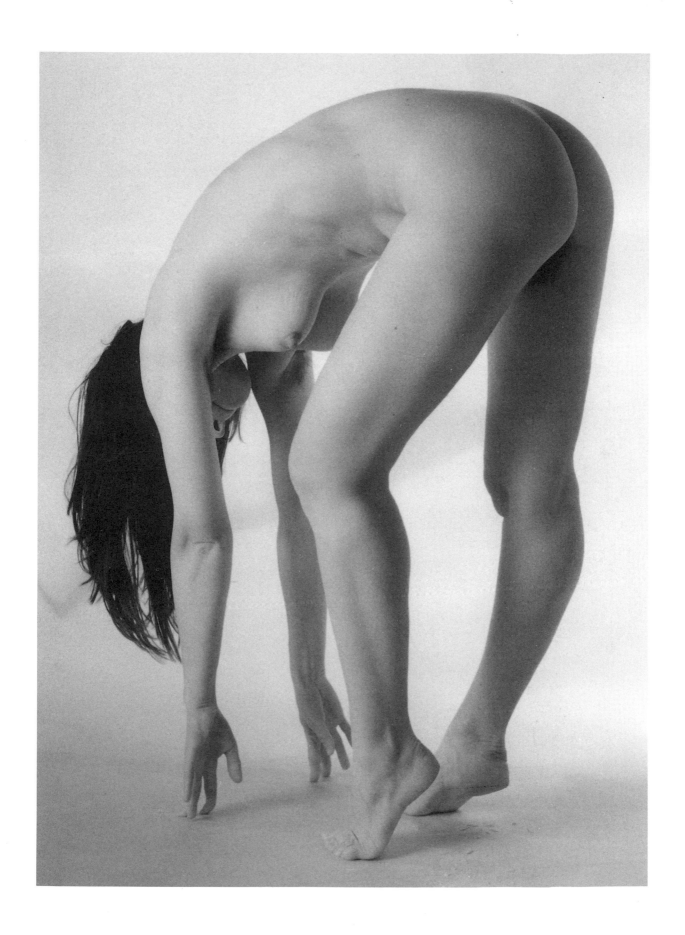

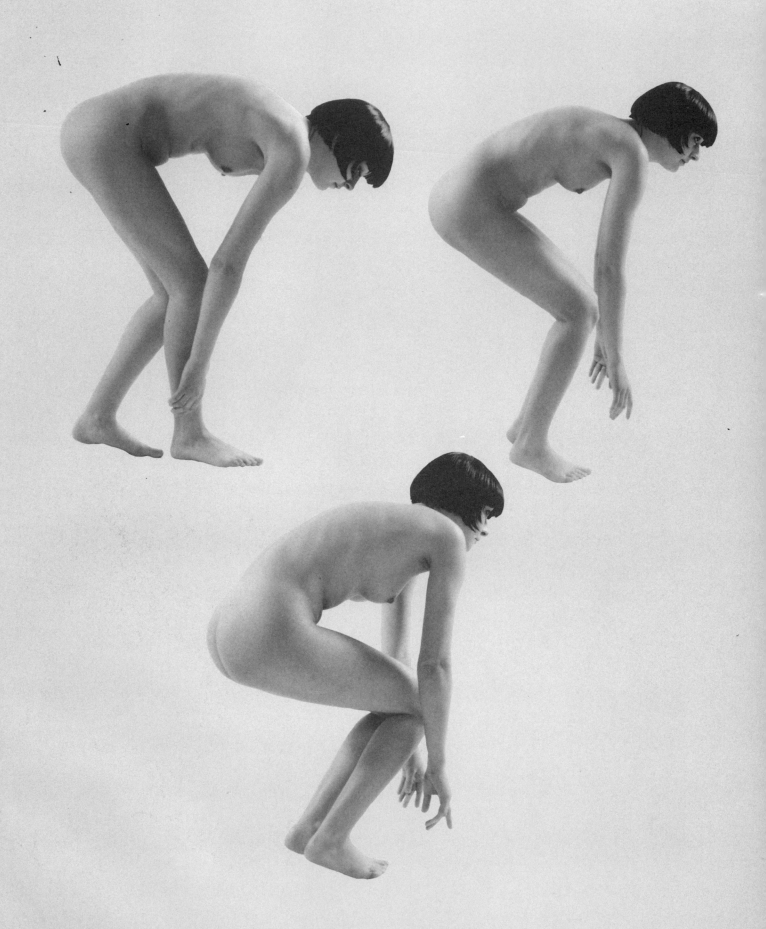

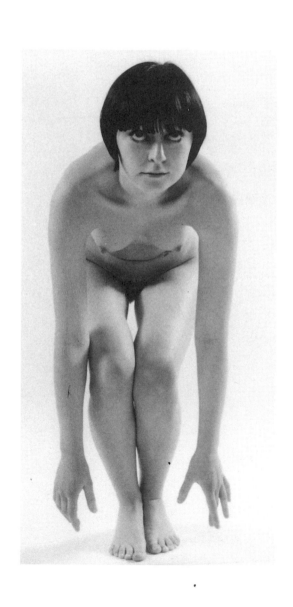

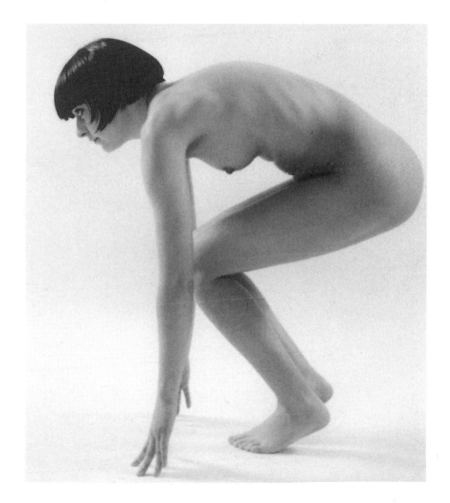

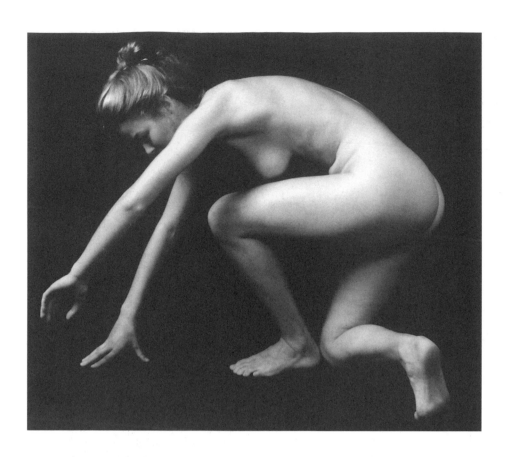

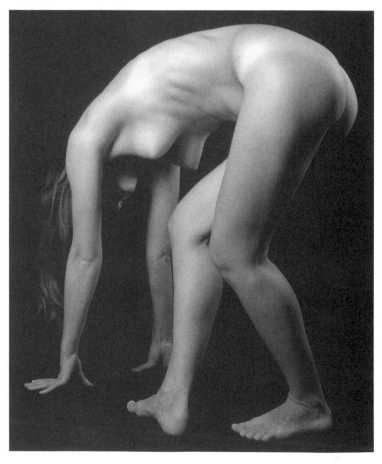

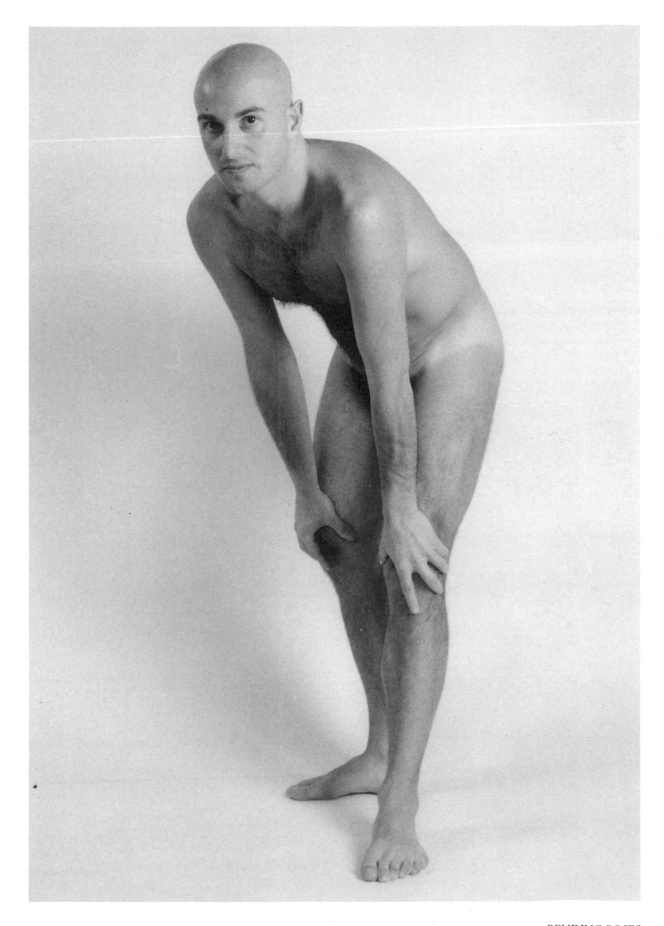

CROUCHING POSES

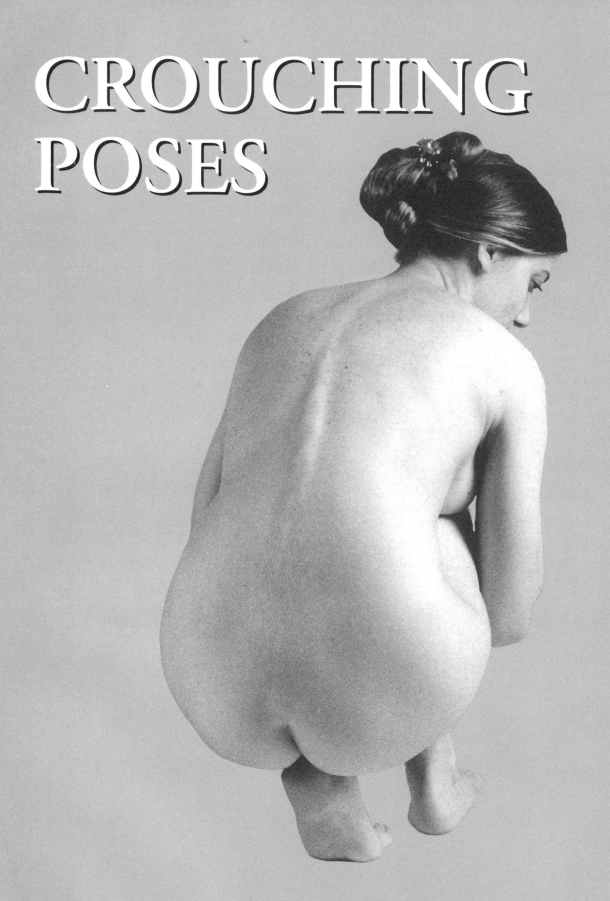

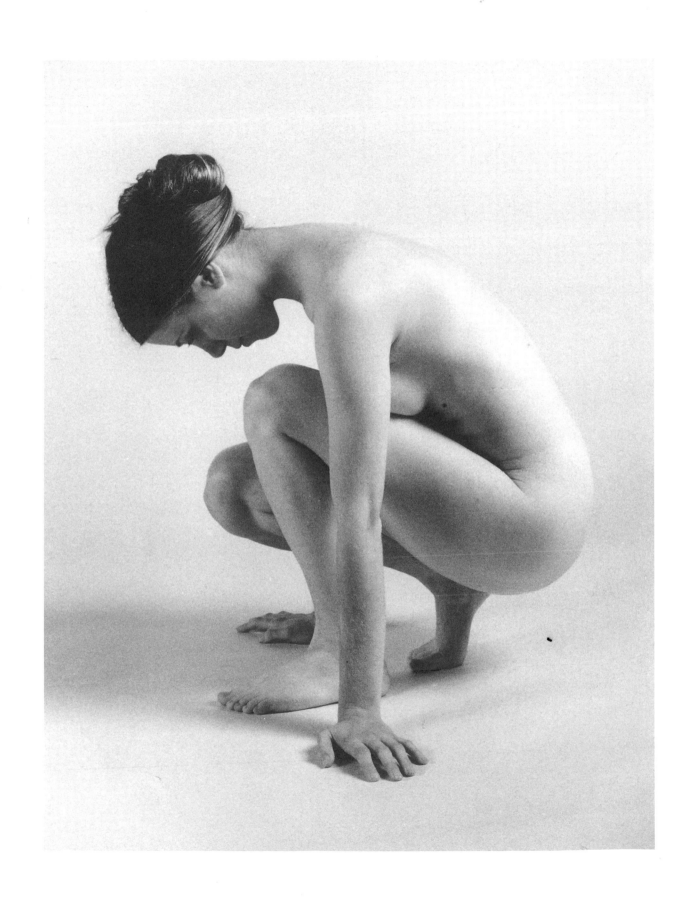

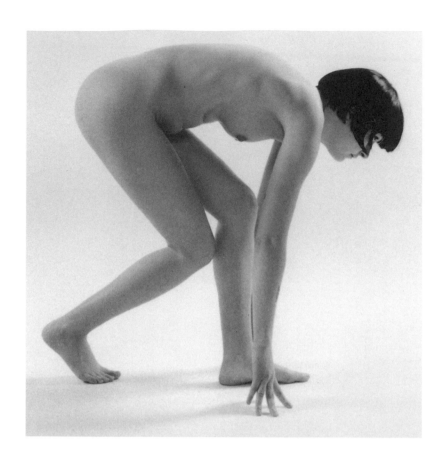

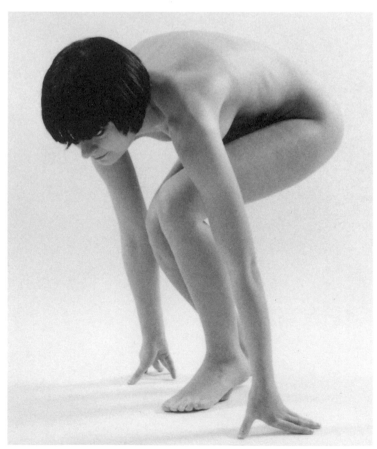

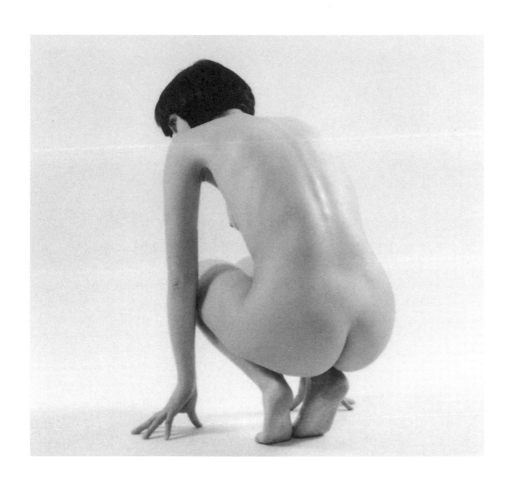

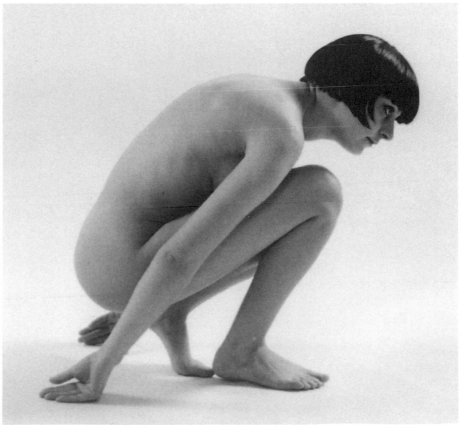

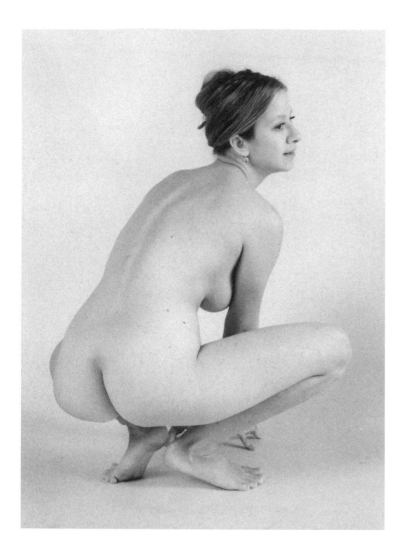

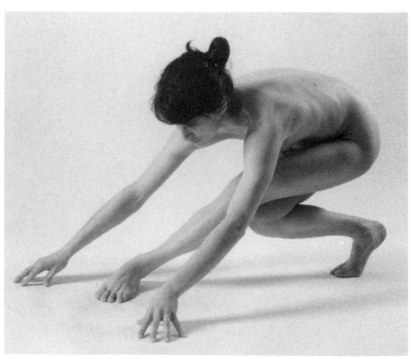

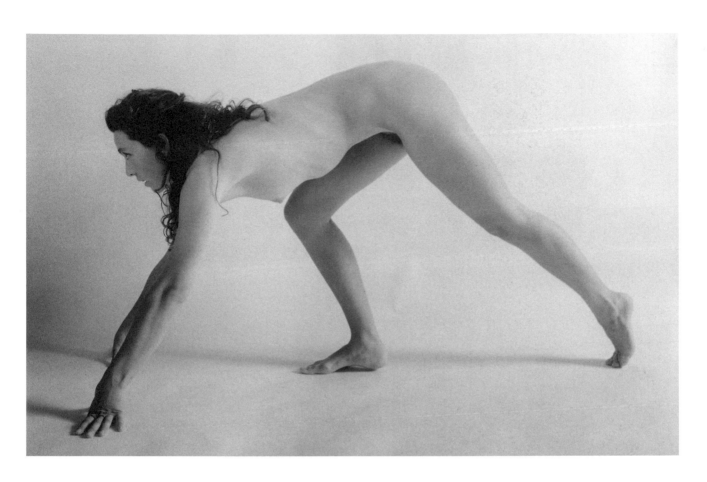

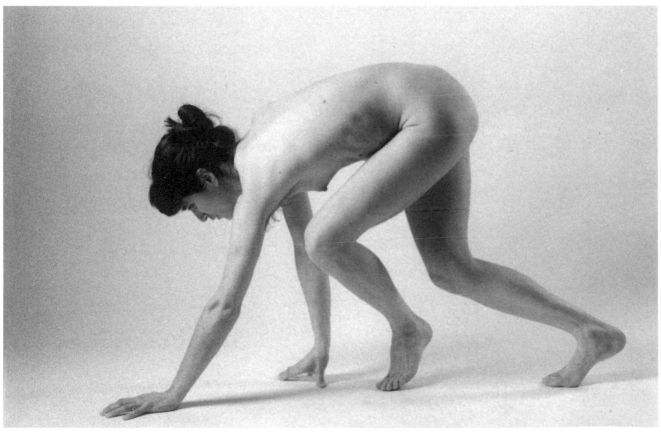

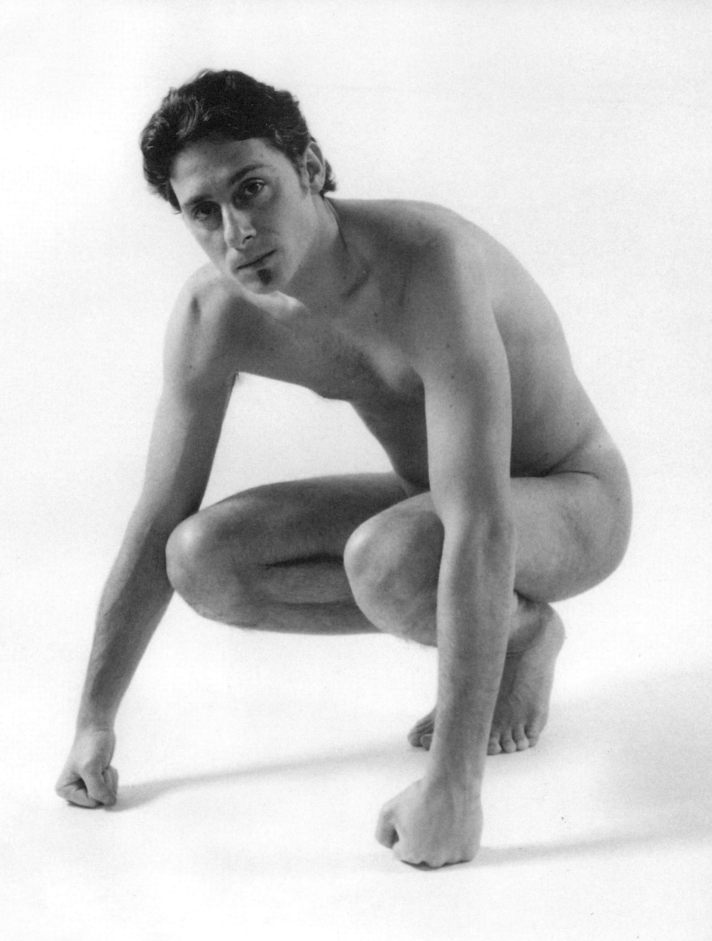

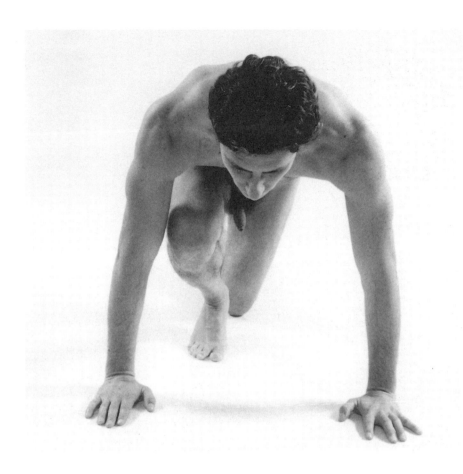

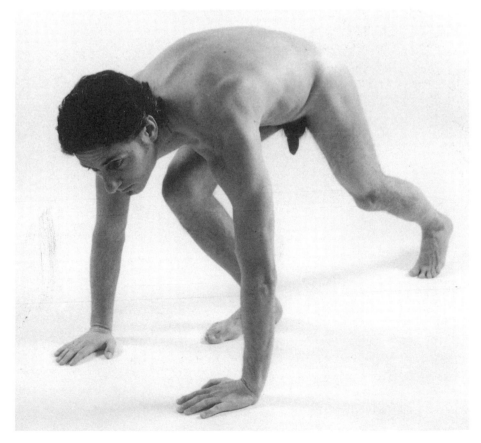

THE FIGURE
IN MOTION

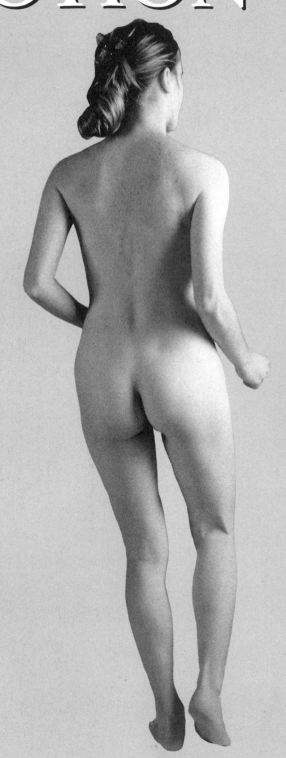

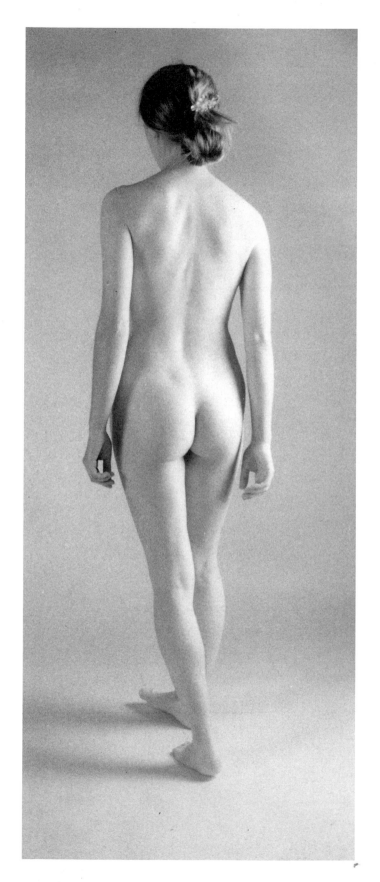
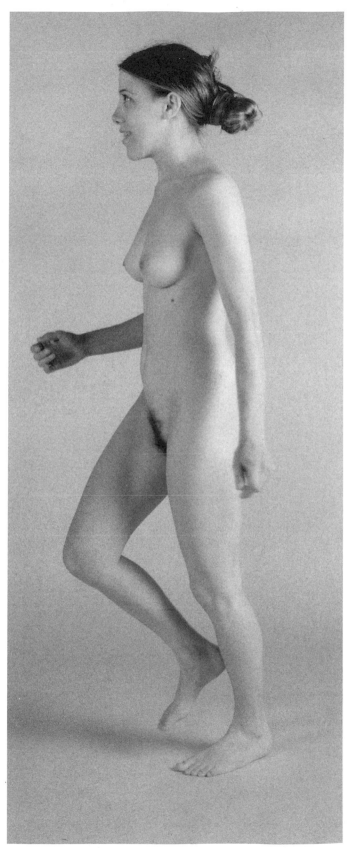

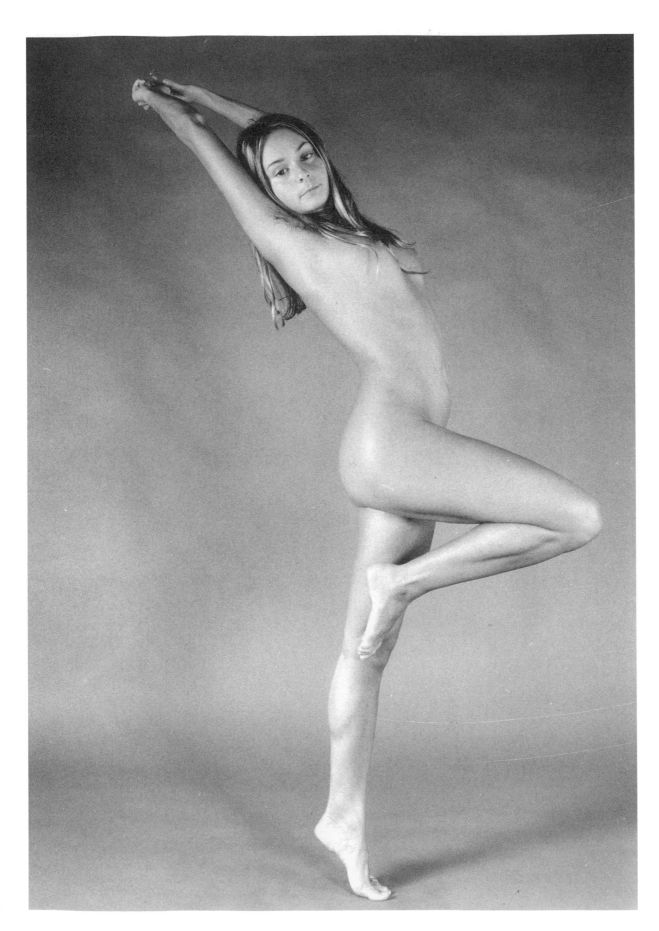

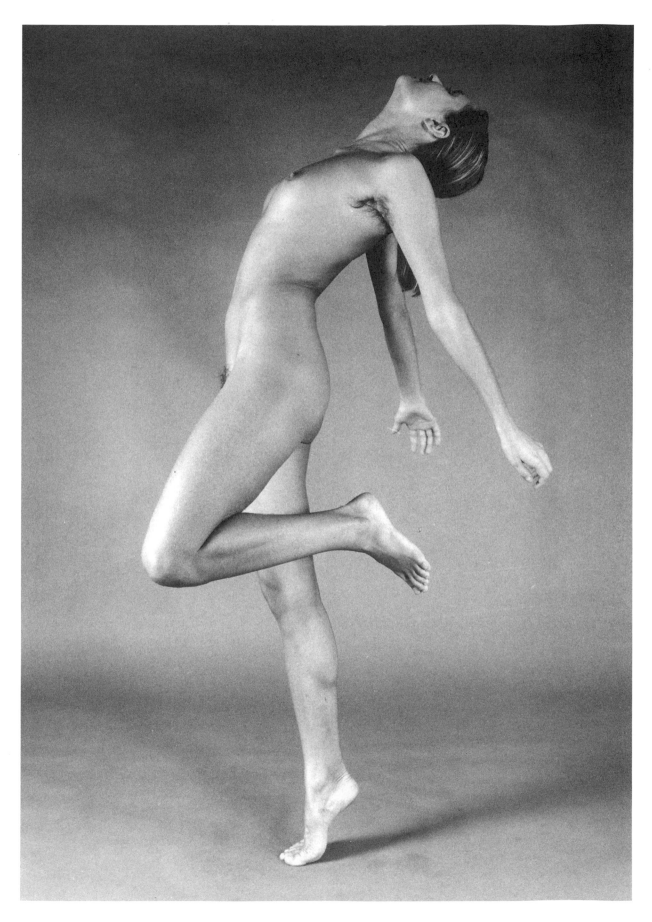

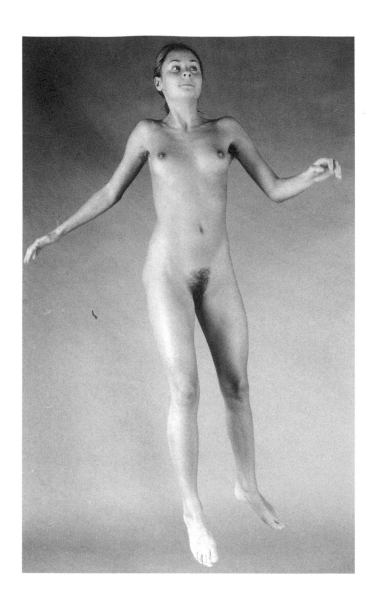

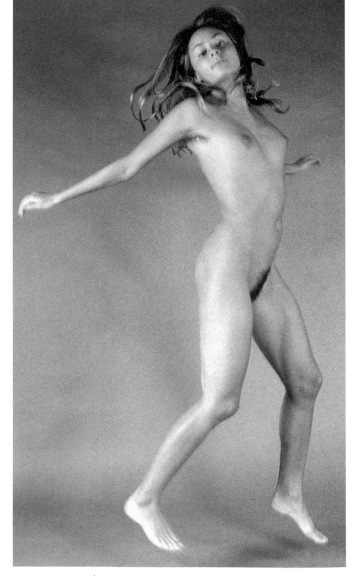

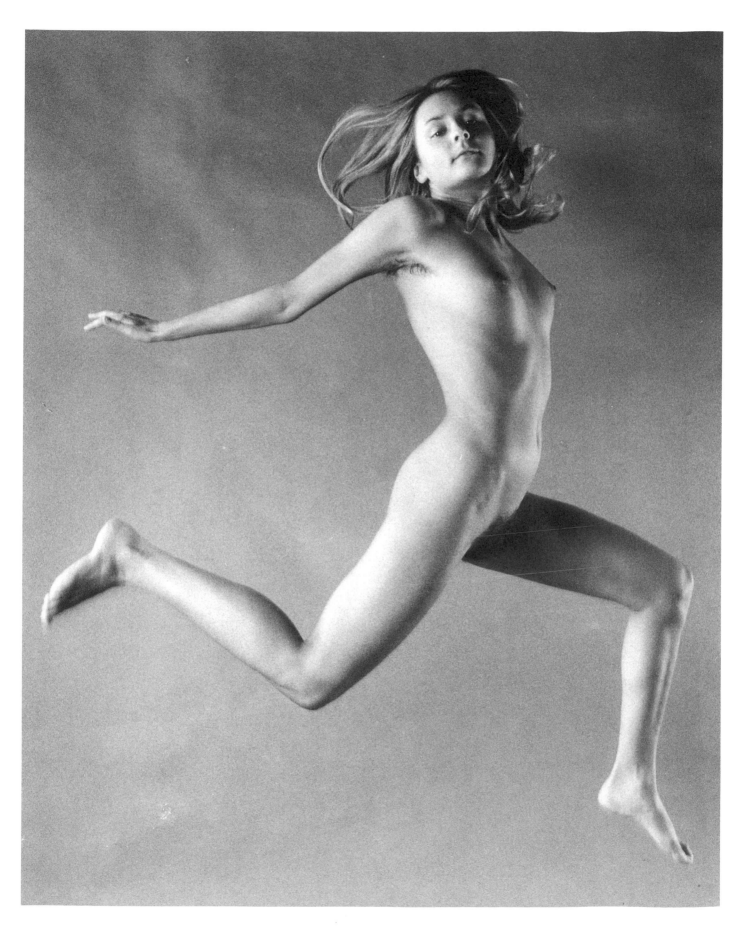

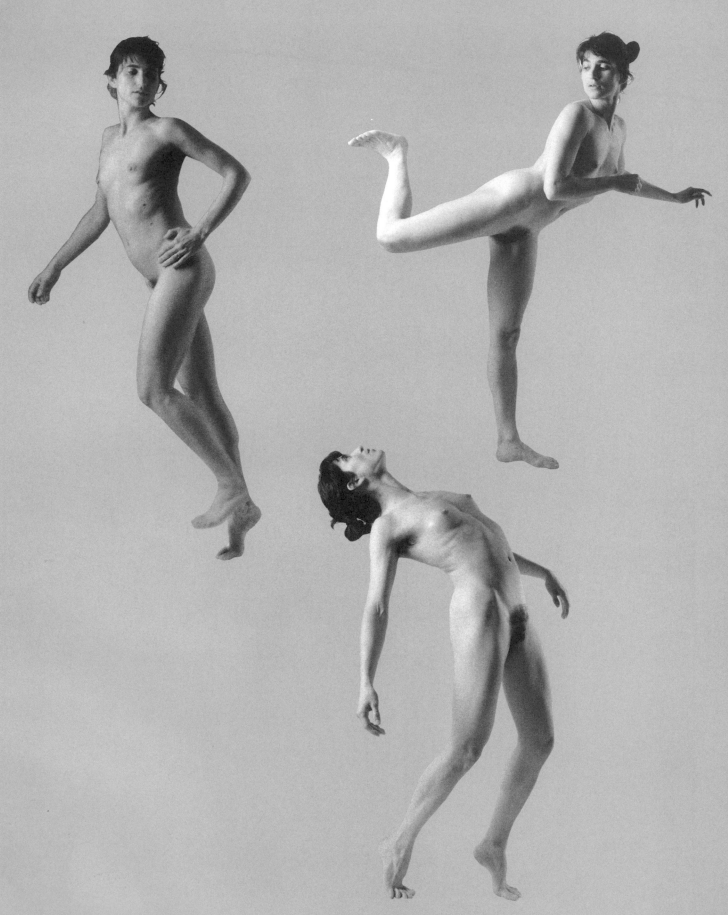

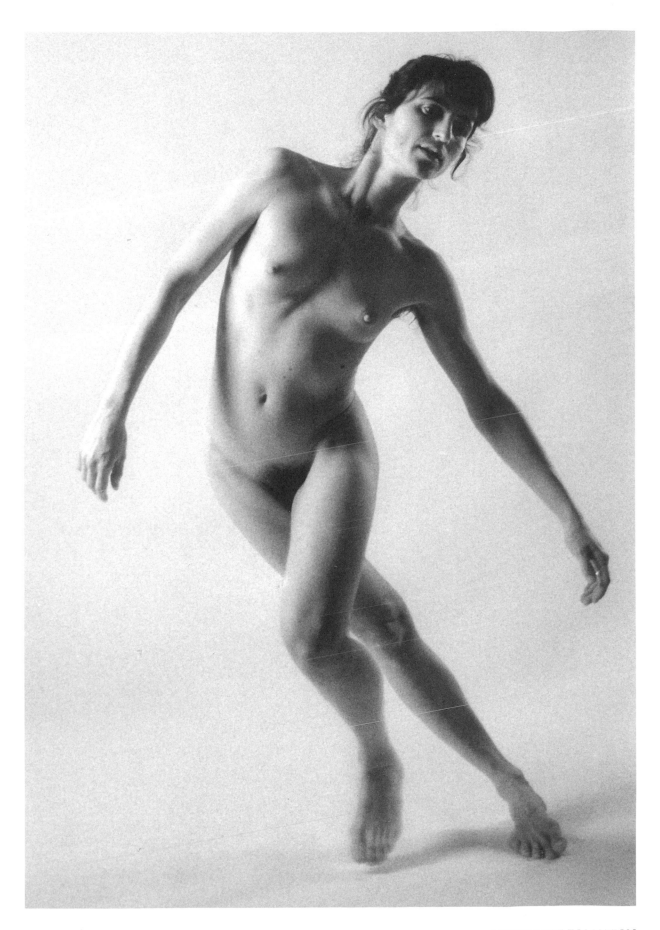

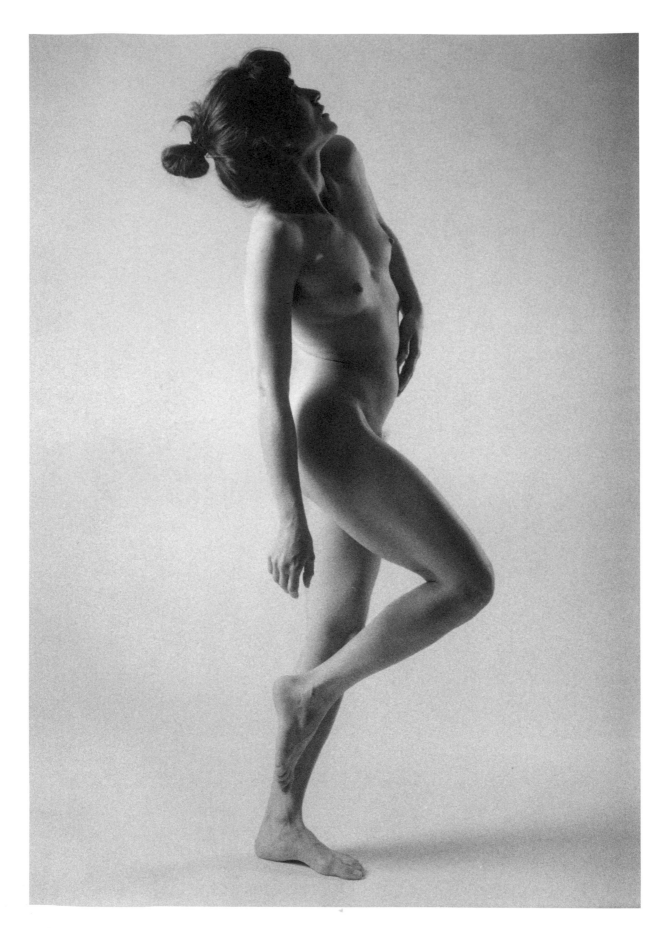

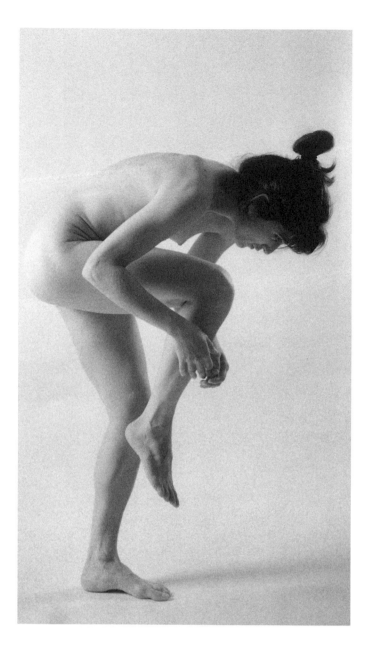

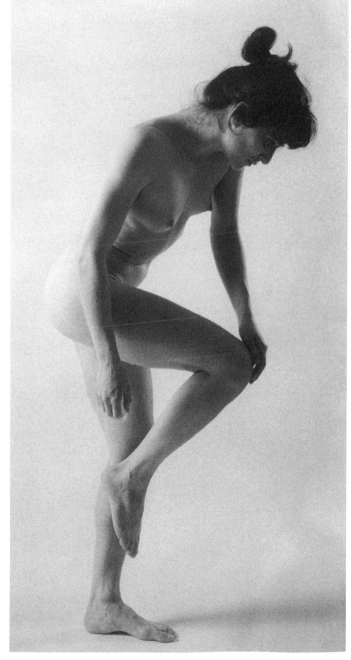

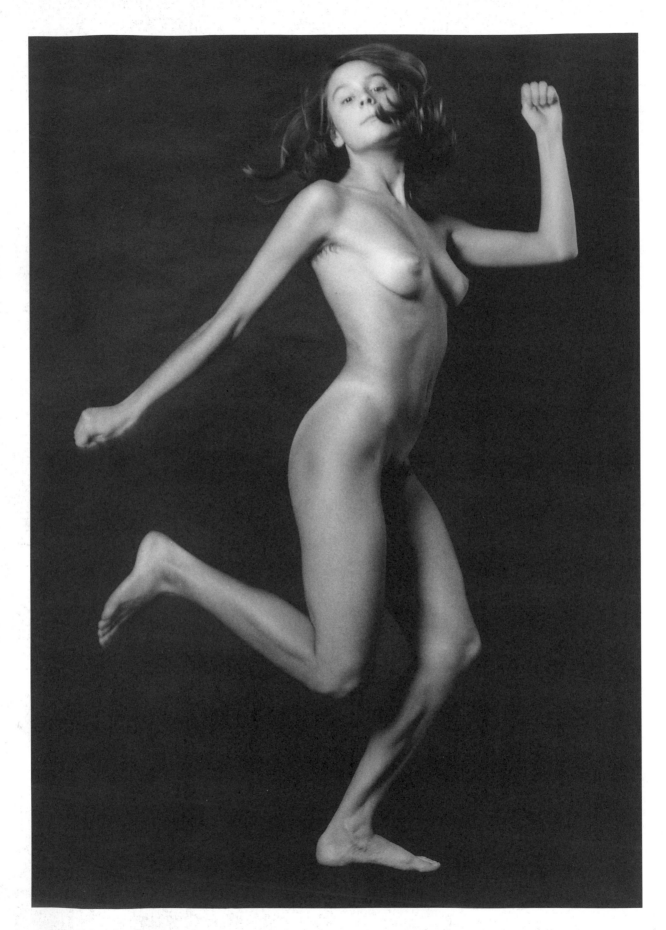

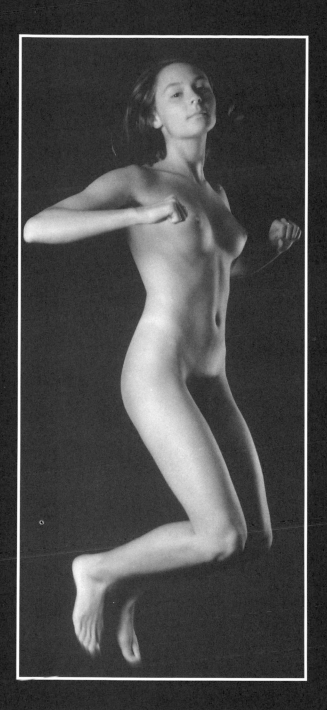
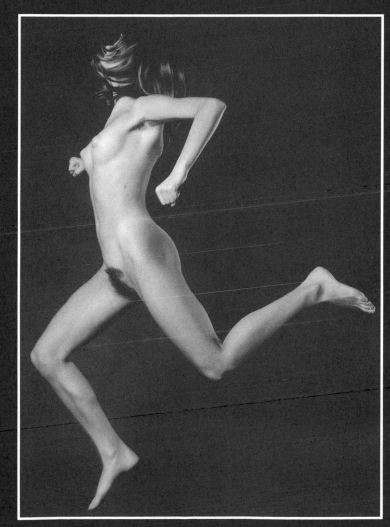

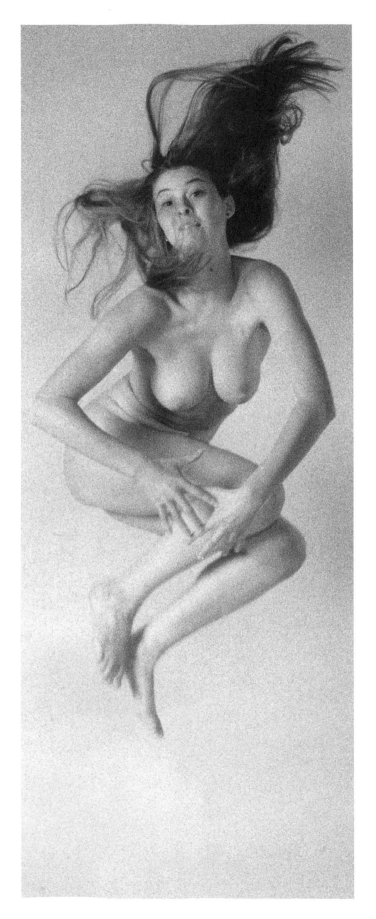
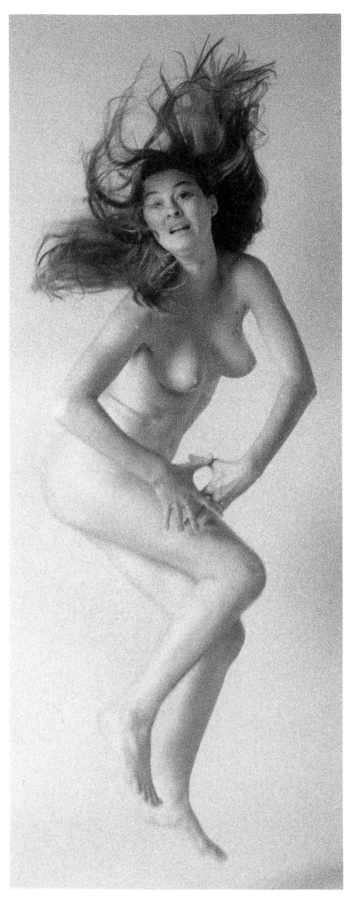

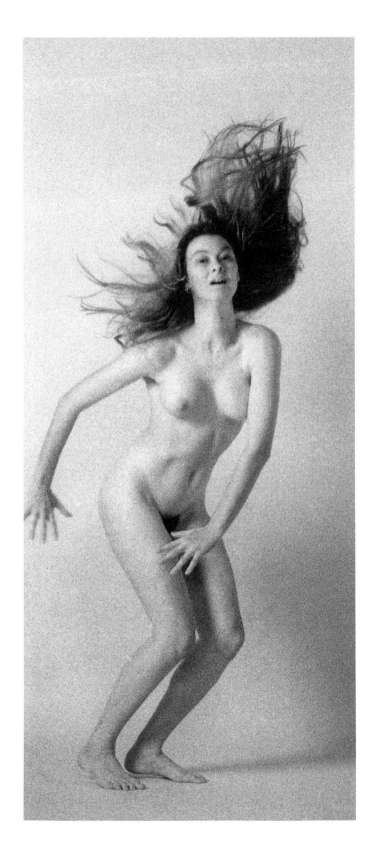

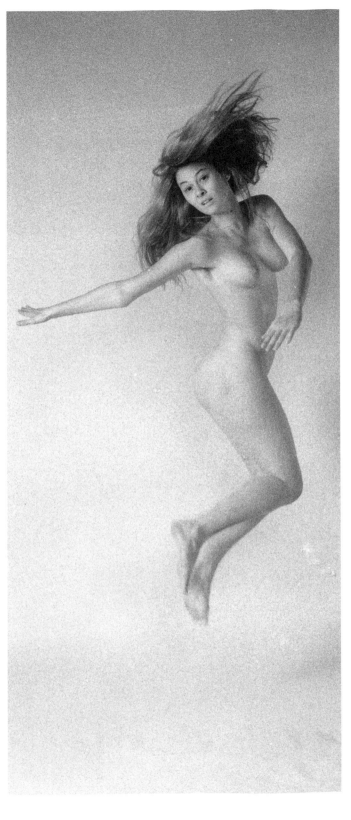

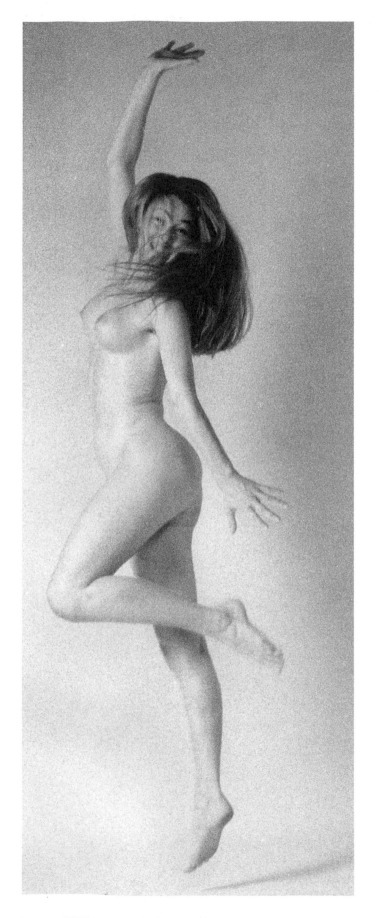
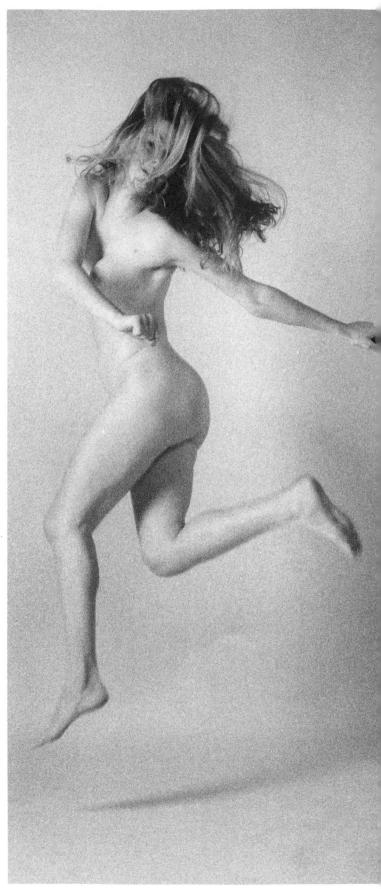

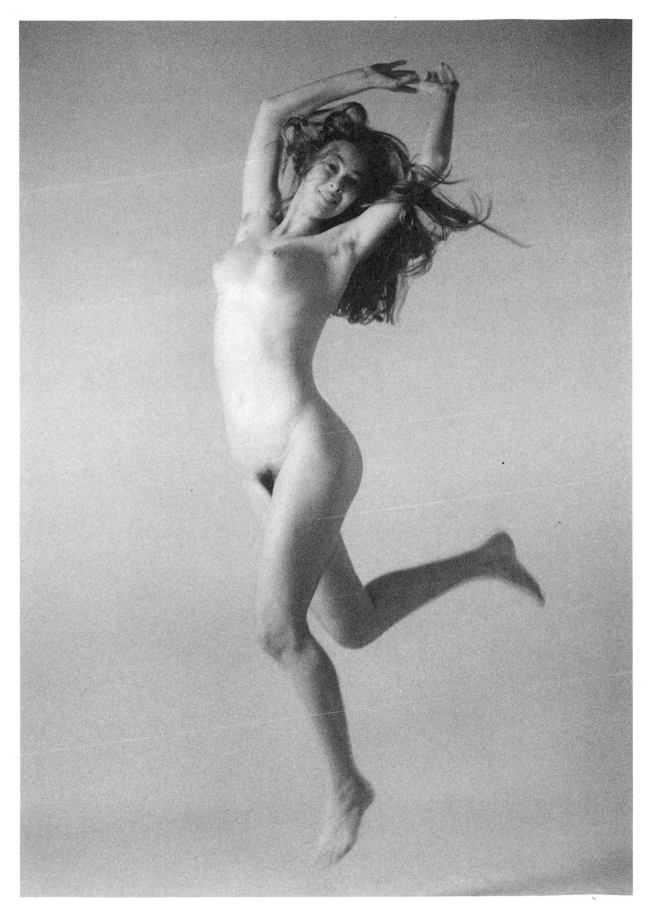

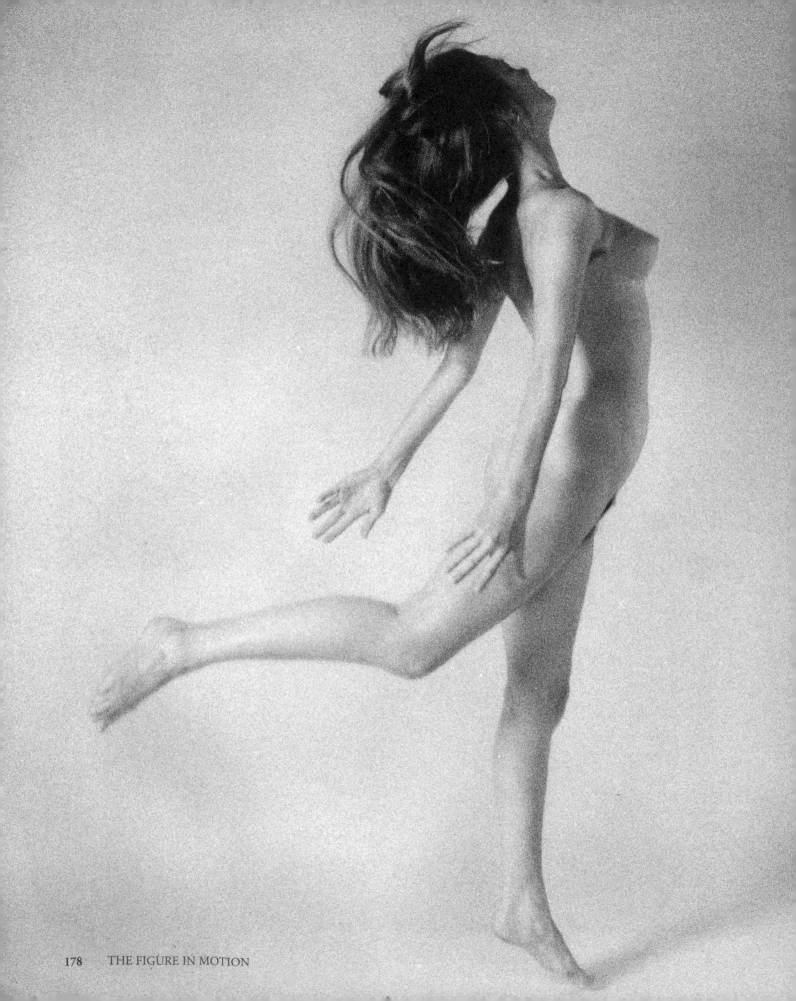

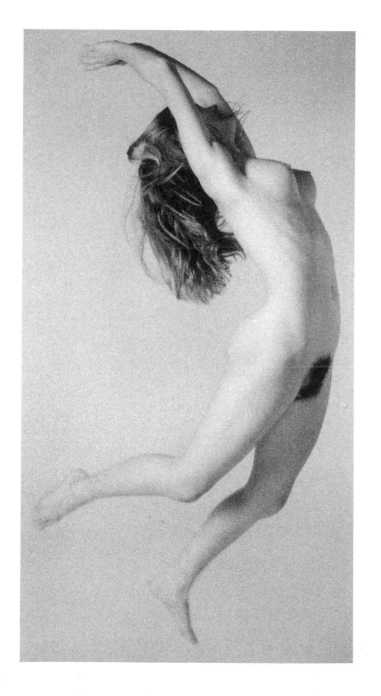

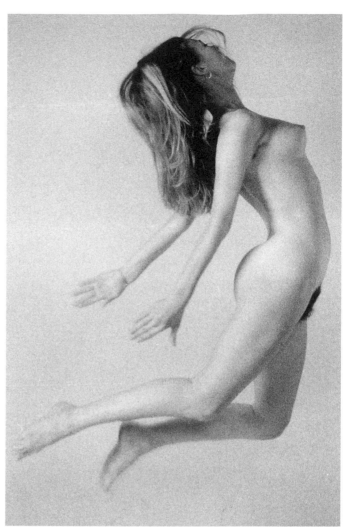

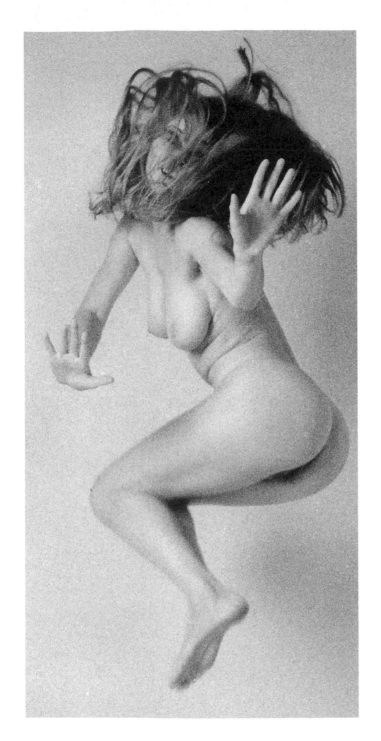

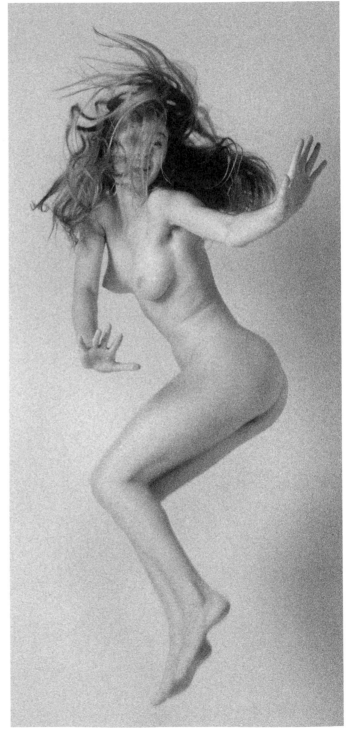

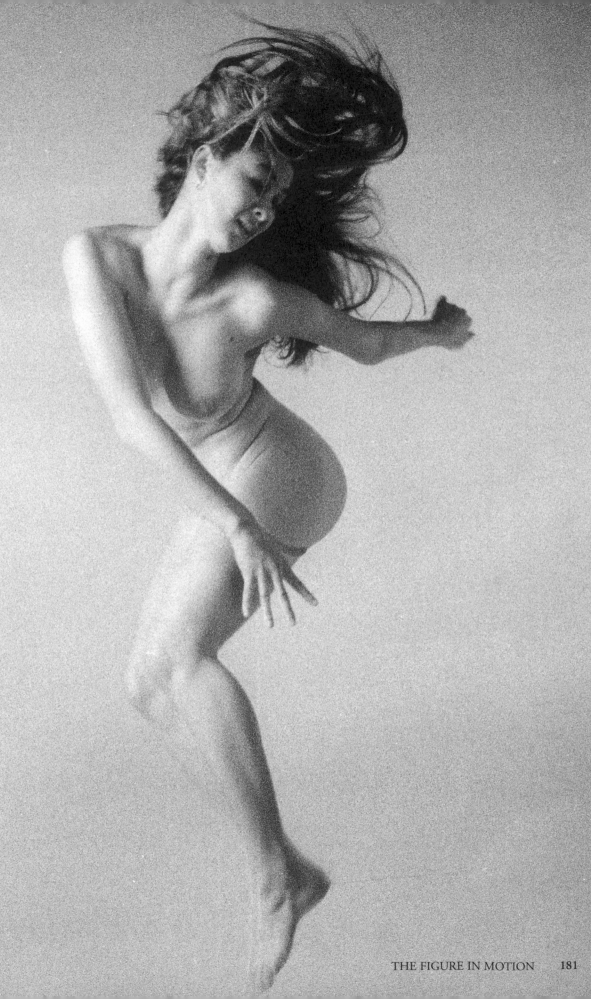

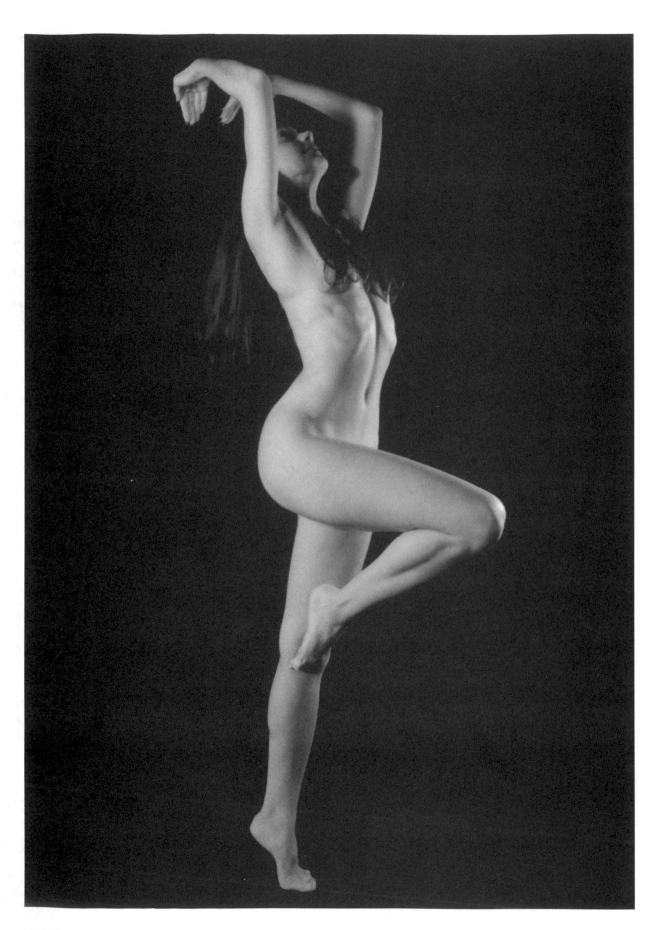

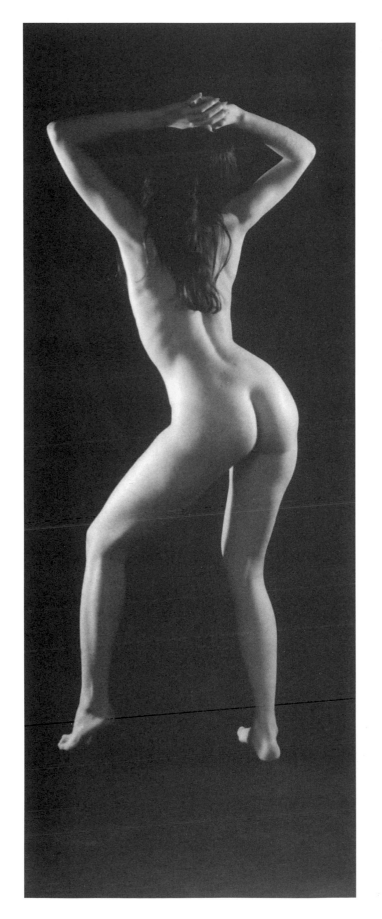
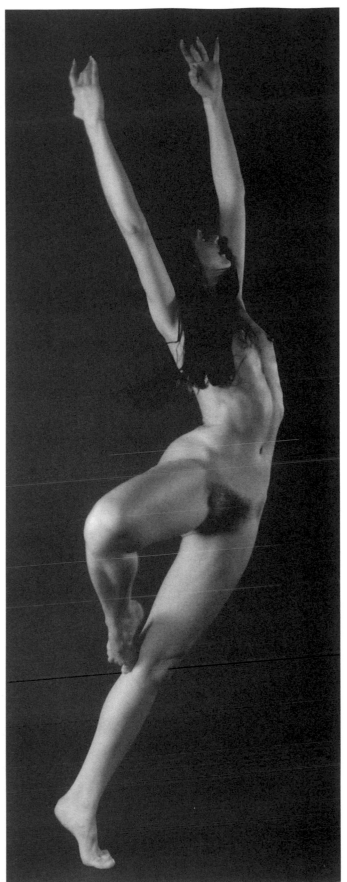

THE FIGURE IN MOTION 183

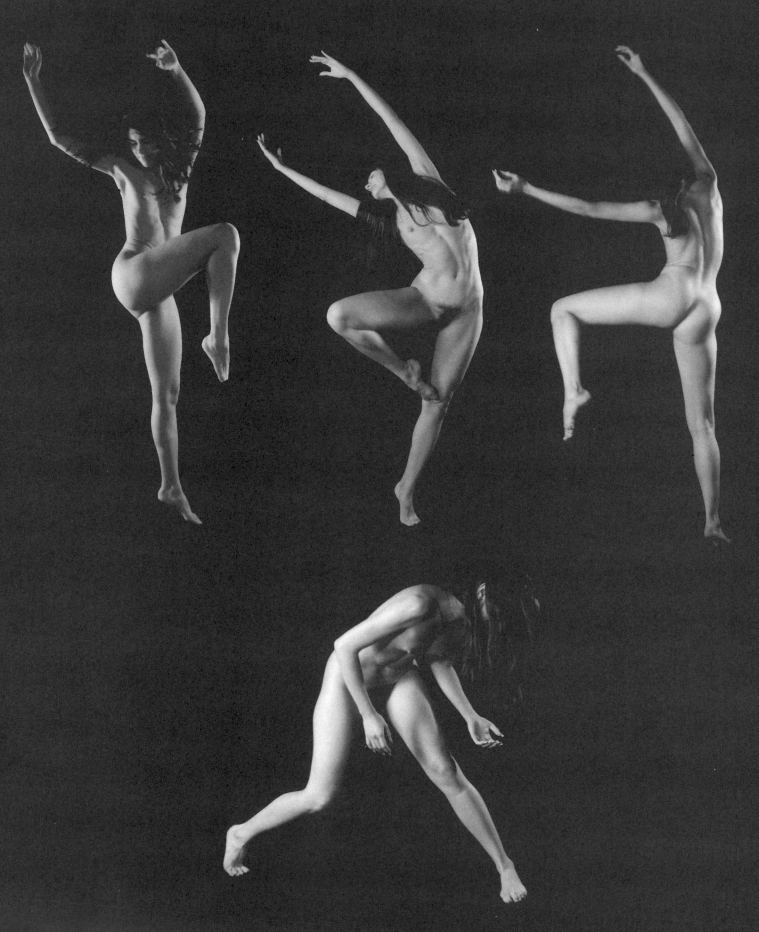

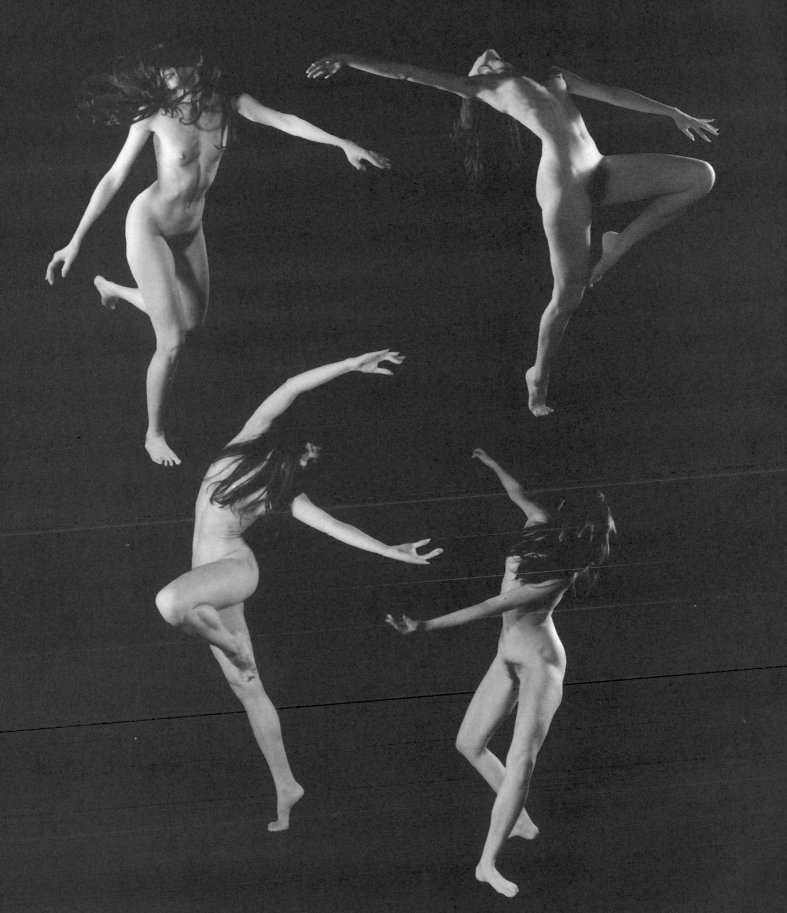

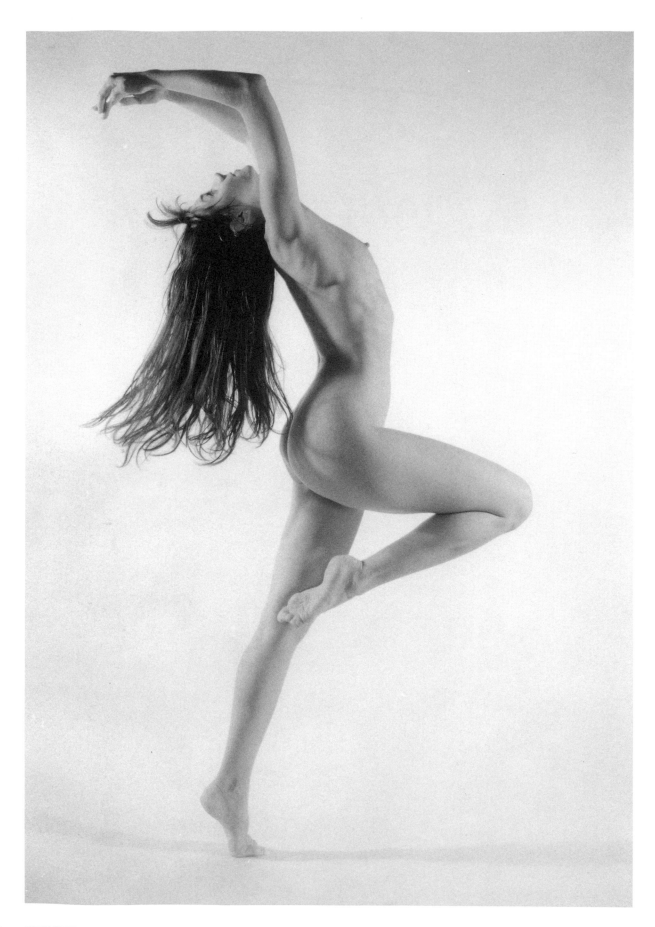

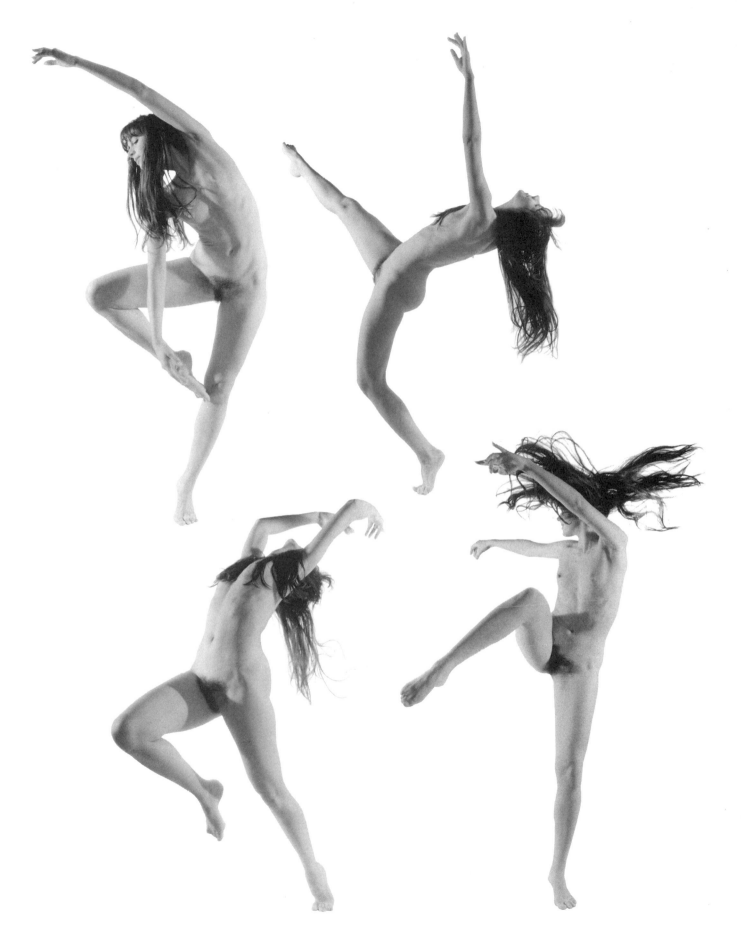

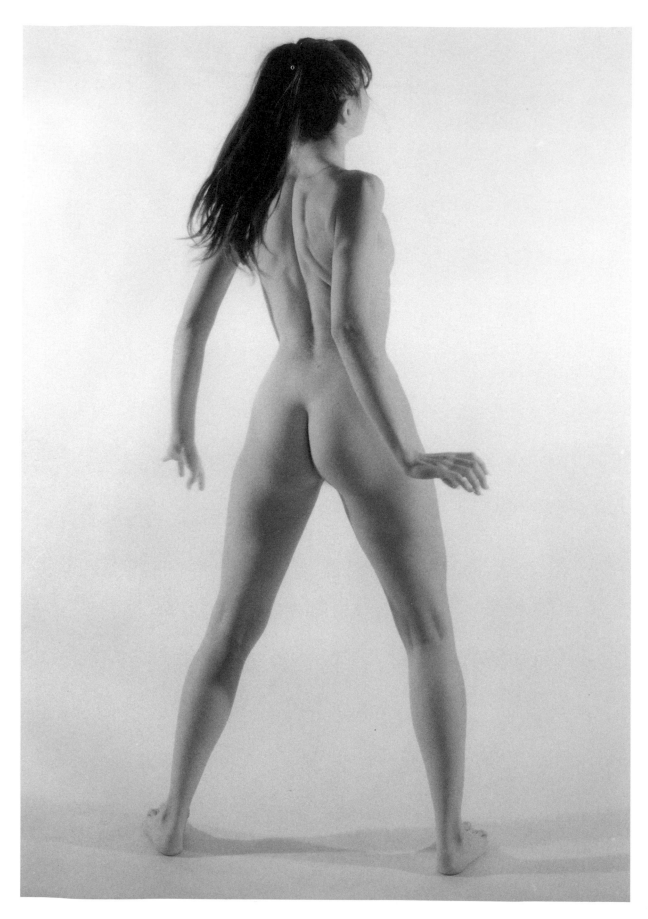

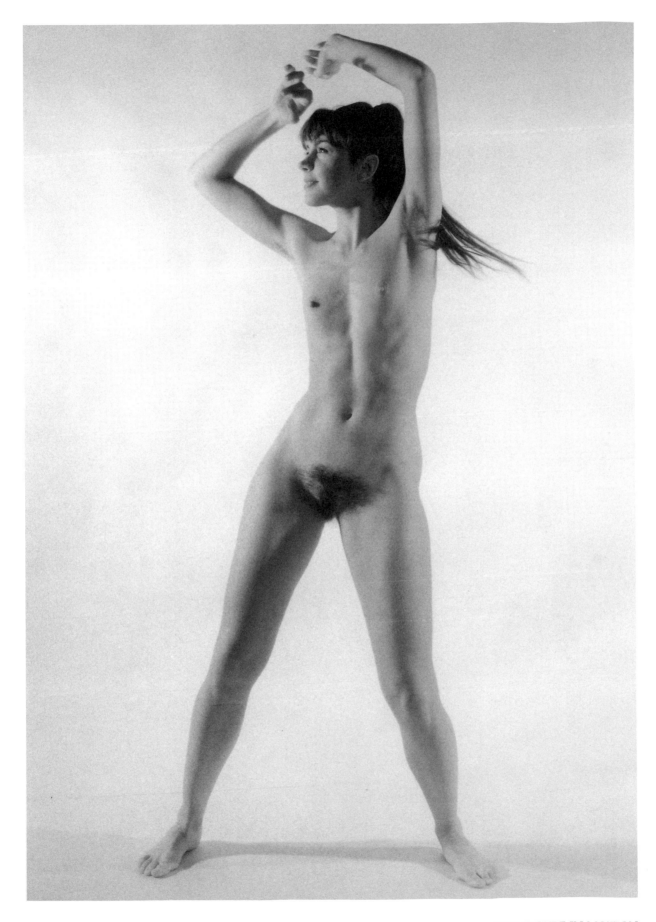

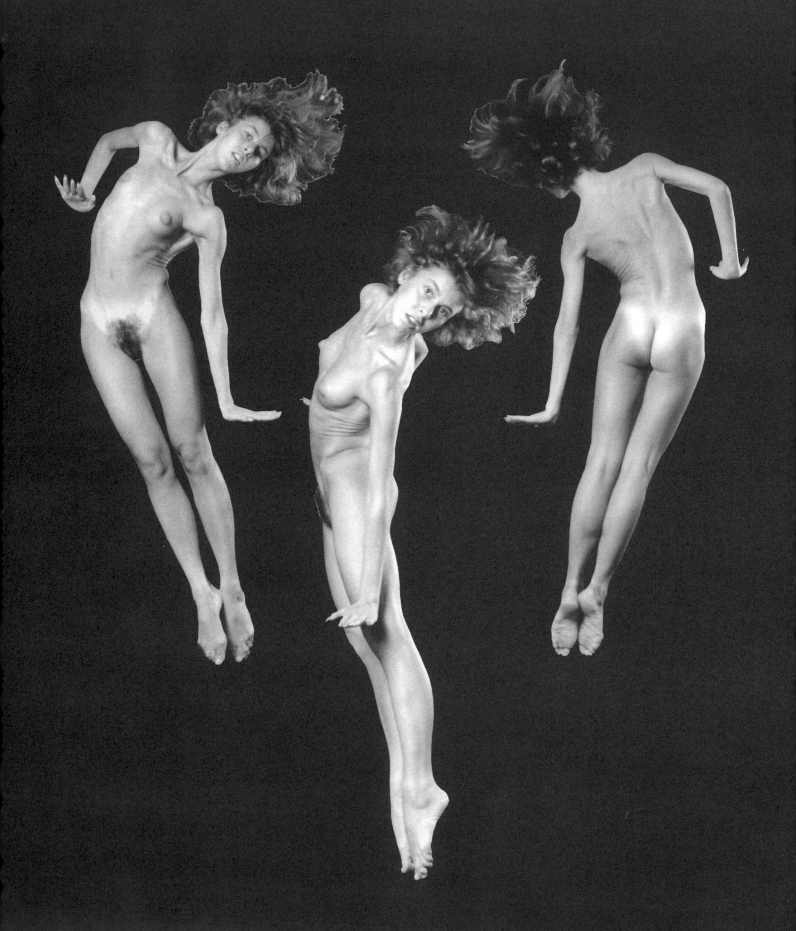

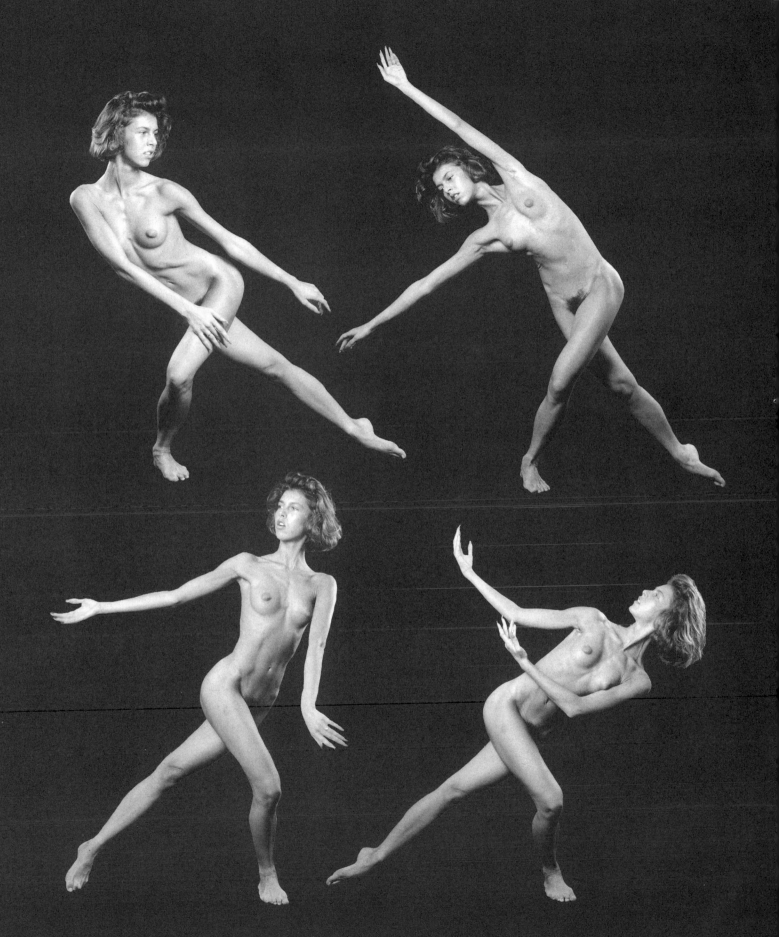

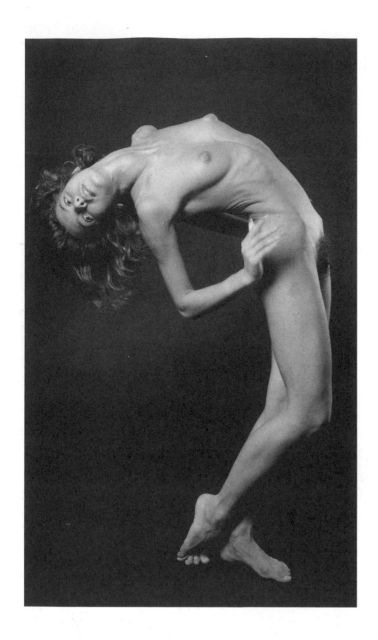

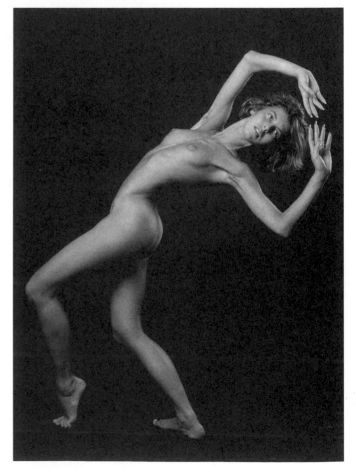

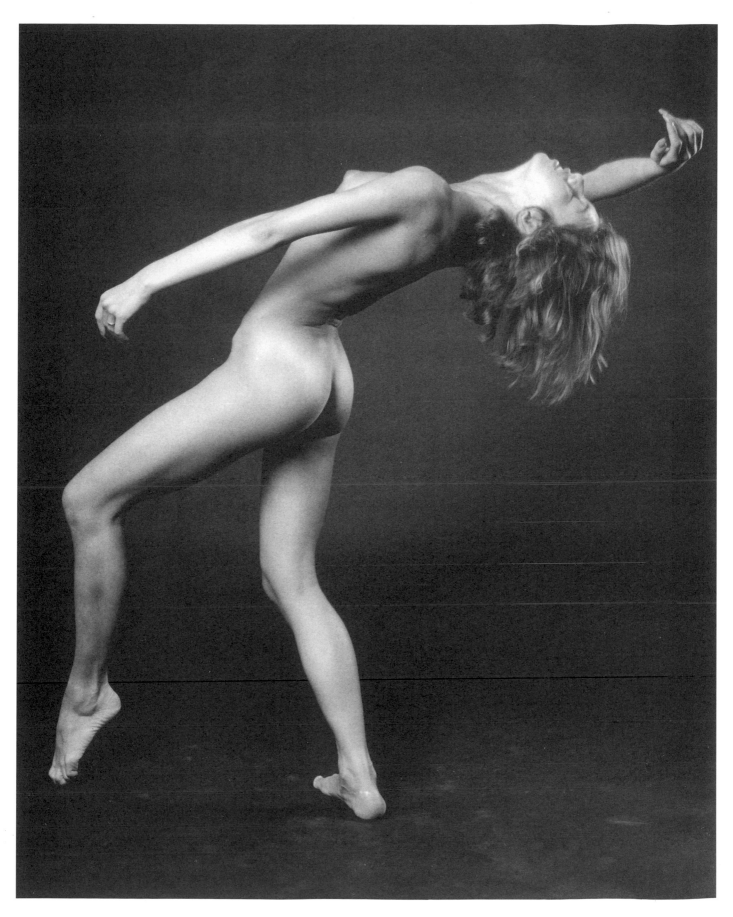

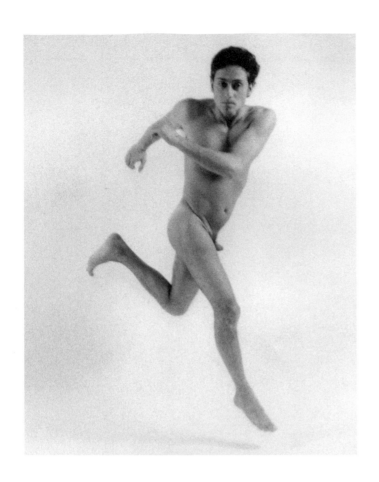
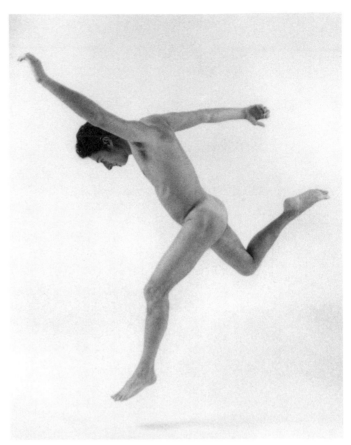
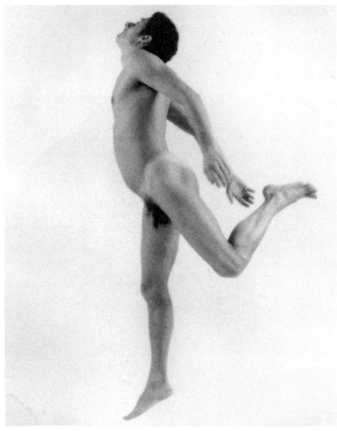
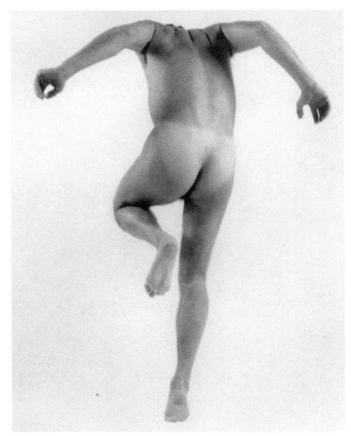

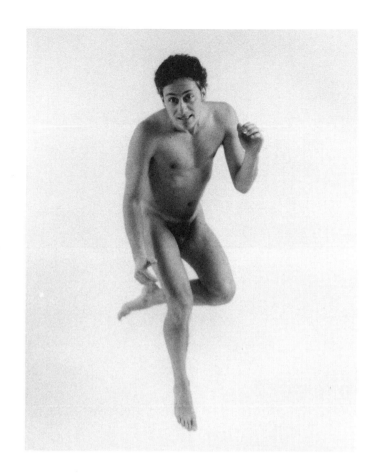
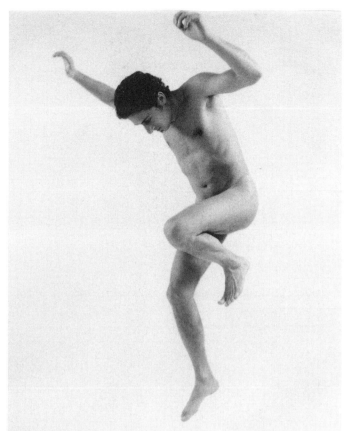
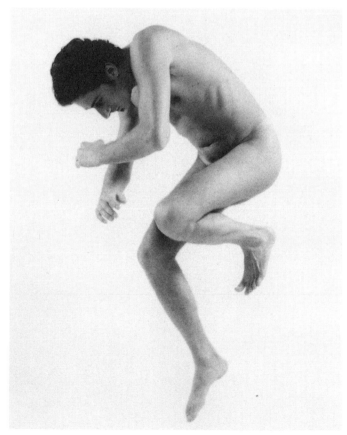
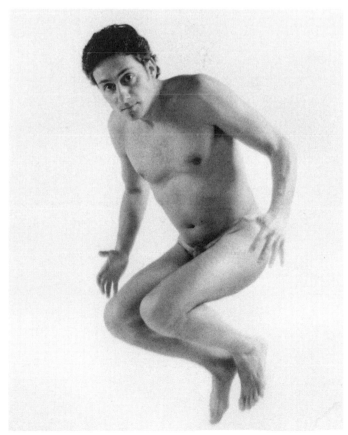

THE PREGNANT FIGURE

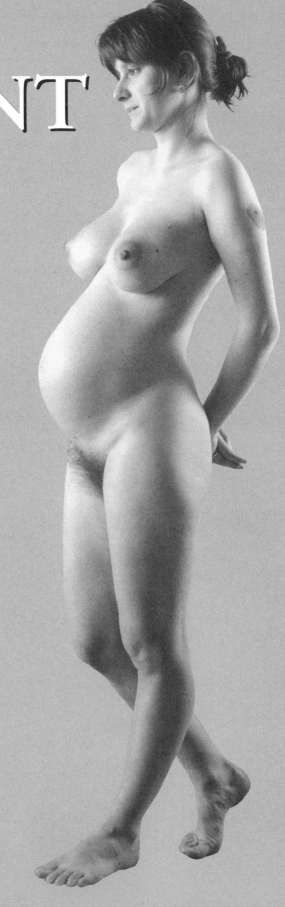

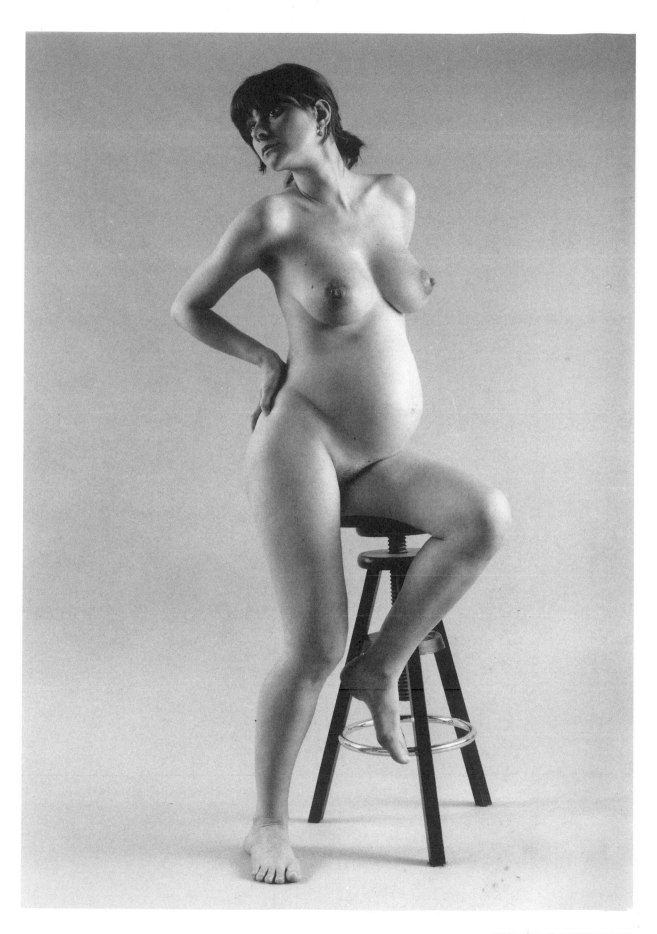

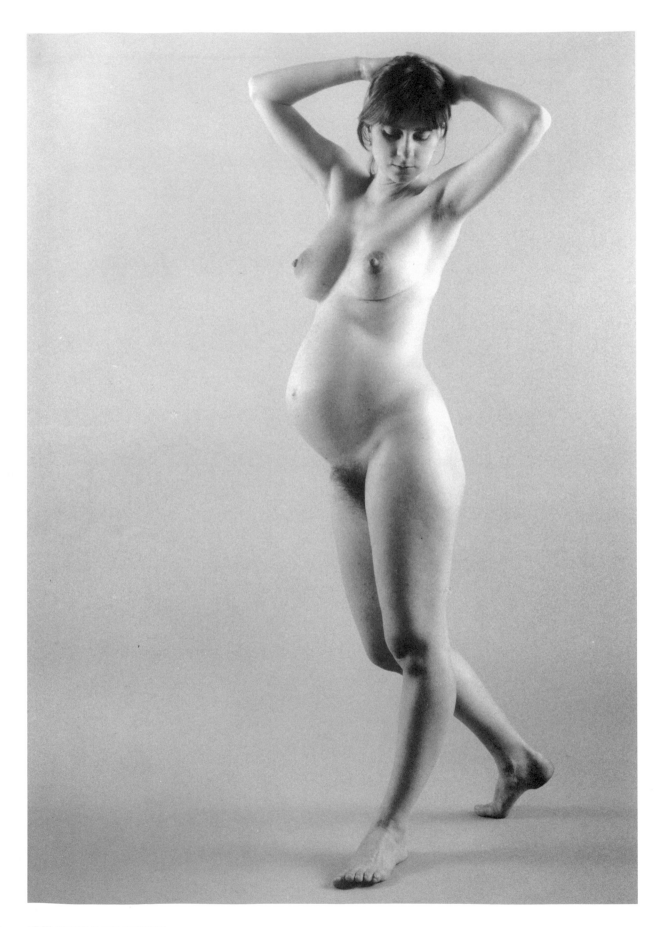

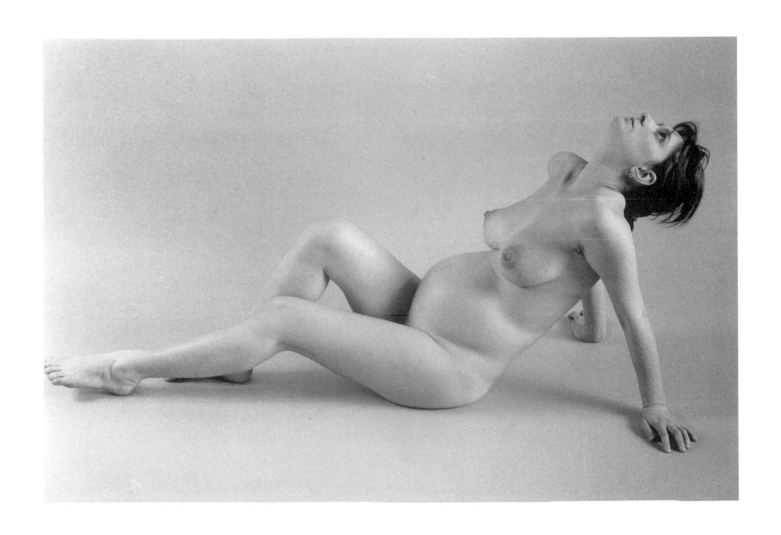

UNUSUAL
POSES

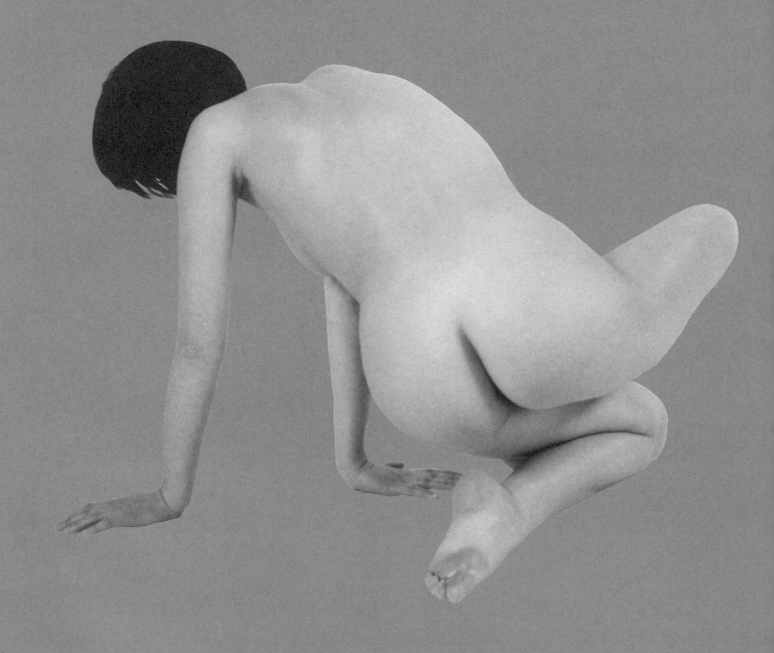

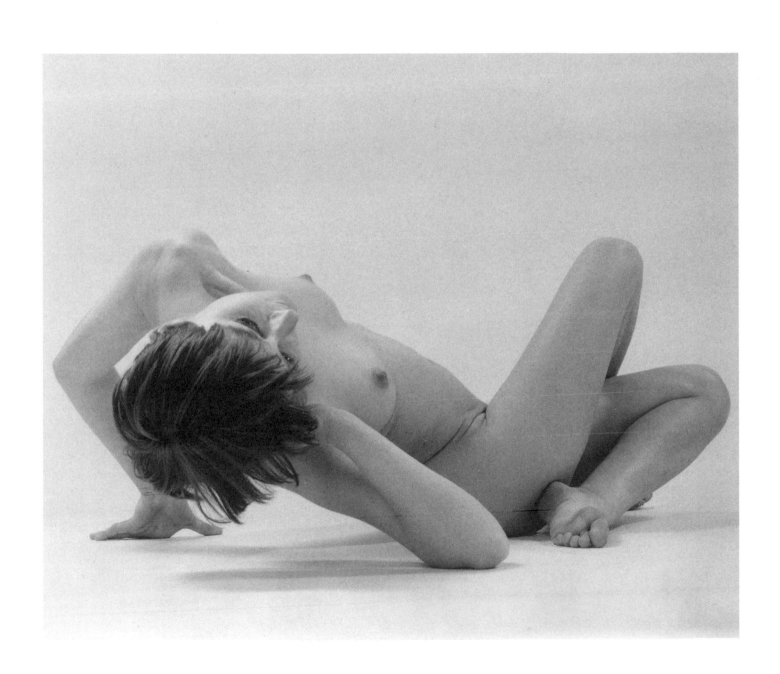

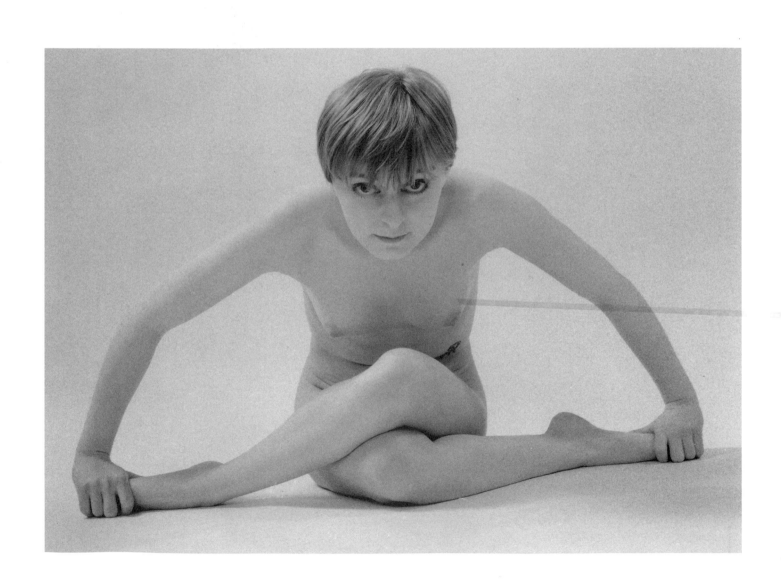

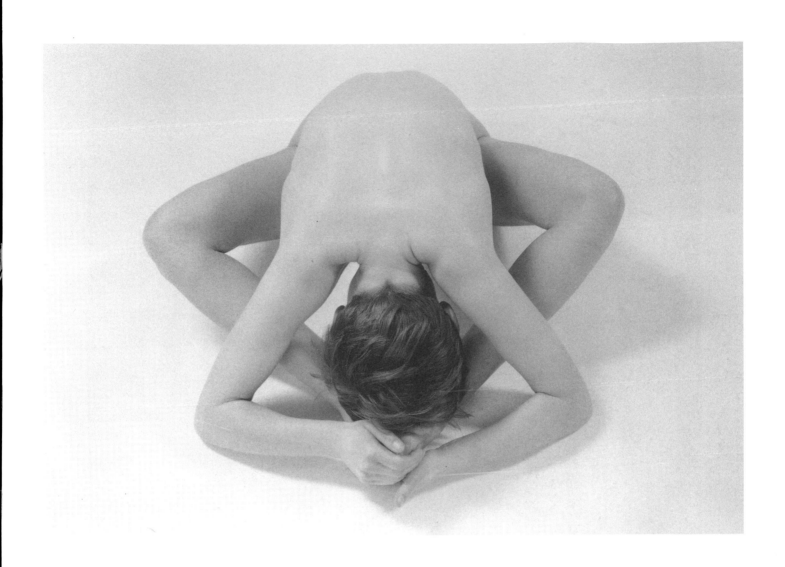

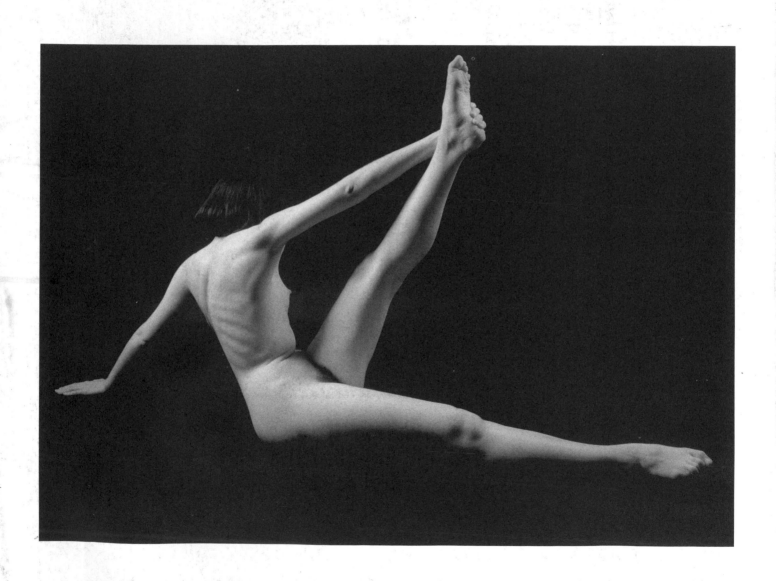

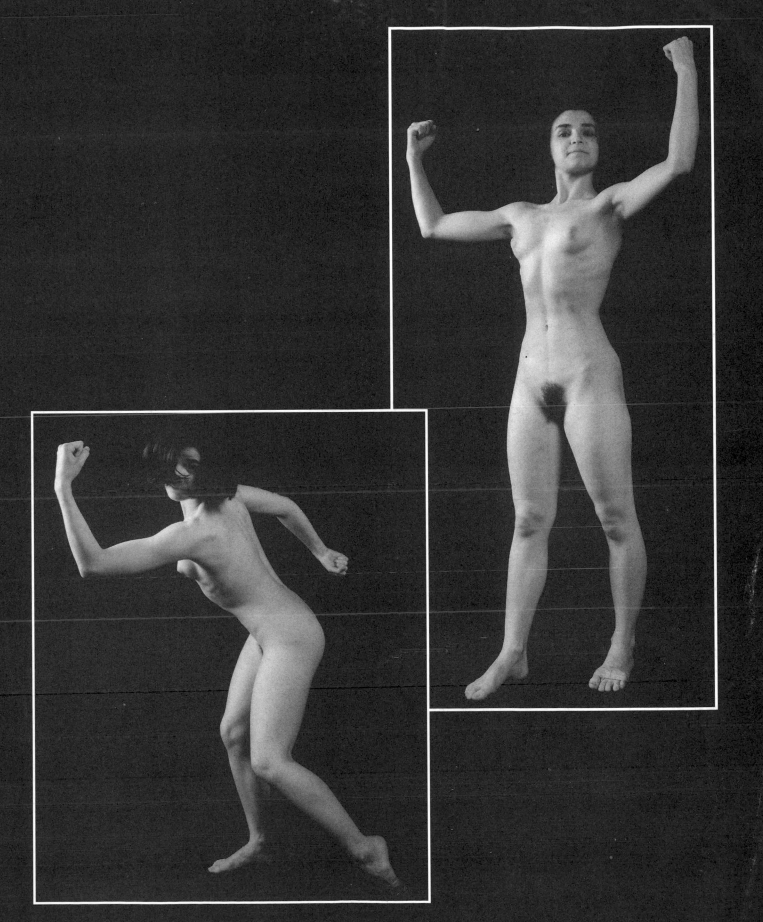